Wisdom With Understanding is Better Than Rubies

Lurine Karon Greenberg Fine Arts Collection

ENOUGH TO GO AROUND

ENOUGH TO

GO AROUND

SEARCHING FOR HOPE IN
Afghanistan, Pakistan & Darfur

Text and Photos by Chip Duncan

Foreword by Jennifer Buffett

SelectBooks, Inc.
New York

This edition published by SelectBooks, Inc.

For information address SelectBooks, Inc., New York, New York.

First Edition

ISBN 978-1-59079-198-1

The opinions and commentary expressed in this book are solely those of the author. Organizations and individuals portrayed in this book may feel differently and may not agree in whole or in part with the ideas or opinions of the author.

No effects have been used on the images in this book beyond traditional darkroom techniques now incorporated into computer software programs such as Photoshop or Aperture.

Interior book design by Janice Benight

Library of Congress Cataloging-in-Publication Data

Duncan, Chip.
 Enough to go around : searching for hope in Afghanistan, Pakistan, and Darfur / text and photos by Chip Duncan ; foreword by Jennifer Buffett. -- 1st ed.
 p. cm.
 Summary: "Through text and photographs a filmmaker/photographer chronicles three humanitarian missions undertaken between 2005 and 2008 by Save the Children in Afghanistan and by Relief International in Pakistan and Sudan"--Provided by publisher.
 ISBN 978-1-59079-198-1 (hardbound : alk. paper)
 1. Humanitarian assistance--Afghanistan. 2. Humanitarian assistance--Pakistan. 3. Humanitarian assistance--Sudan. I. Title.
 HV555.A3E56 2009
 361.2'6--dc22
 2009018964

This book was made possible,

in part,

by the generous contributions of

Colleen & David Martin,

M·CAM,

Charlottesville, Virginia

and

Cook & Franke S.C.,

Attorneys at Law

Milwaukee, Wisconsin

and

Michael Skipper

Contents

Foreword

In *Enough to Go Around*, Chip Duncan invites us on a journey through three of the most desperate and misunderstood places on the planet. Thanks to modern media's tendency to oversimplify the most complex subjects, we tend to view Afghanistan and Pakistan as thorny military problems, and their people as hardened terrorists. The images we are fed are so powerful that many of us do not pause to imagine the everyday lives of the women, men, and children who live there, who work to support themselves, and who dream of better lives. Any effort toward understanding the humanity behind the situation is usually drowned out by stories that make us fearful, and that separate us from any real understanding of our sisters and brothers in these countries.

It is exactly this fear that perpetuates a feeling of scarcity, of us-and-them, a fear which continues a vicious cycle of ignorance and inaction. What we need is insight and the inspiration to believe that something more is possible, that we are more alike than dissimilar, and that life should be less about competing and more about collaborating—that there is, indeed, enough to go around.

The gorgeous pages of this book reveal photos that truly surprise. The photos of wide-eyed, smiling children in Sudanese camps will surely stun you. They certainly surprised me! How can children in refugee camps find anything to smile about? Bearded men in turbans with warm, inviting eyes take us aback—they don't resemble terrorists or look angry. They communicate something that is very different than what we expect. They challenge and inspire us. We see in their eyes that which we recognize in ourselves—curiosity, concern and hope. The difference is that their lives take place where life hangs on a thread and death looms all around. Suddenly, families and children in Afghanistan or Pakistan who are living through disasters of all kinds become less foreign and more familiar.

Chip Duncan is an activist who uses art as his forum for change. A camera around his neck, and a superhuman tolerance for strenuous travel define a lifestyle that is not for the timid. Chip does this not because anyone has hired him to do so, but because his passion for justice for the most vulnerable people compels him. He shares his stories as he has lived them, and he breathes understanding into some of the simplest human

gestures and interactions. Maybe we, too, can be as moved as he is to use whatever gifts we have to nurture compassion throughout the world. Each photograph in this book reveals the imperative that Chip accepts on behalf of each of his subjects: *"Please tell the world I am here and I am not so different from you!"*

Chip and I have shared many conversations about the importance of empowering girls and women in the developing world. We consider ourselves fellow travelers in this regard. He uses art and I use philanthropy, and we feel a special kinship in our parallel life quests, striving to open our hearts and minds ever wider, believing that that is important to do, and encouraging people away from fear and towards understanding. Hopefully, we're both gaining wisdom in the process.

If this book inspires you to do one thing, may it be to *let go* as much as Abraham has in this book. You will read about what Abraham did with his modest lunchtime sandwich. His is a story of *just doing it* because Abraham thinks with his heart. For him, years of relief work in very challenging settings have built a strong internal reflex. His only option is to share. There is no internal debate. Whatever small act of kindness is possible to ease suffering, regardless of how its ultimate impact might be argued, he just does it.

We don't have an adequate word in the English language for this quality that lives in Abraham, but maybe one day we'll have to create it. Maybe this book invites it. The word would characterize the selfless ability to share and the trust that there is always enough for everyone.

But the first step is *believing that you are enough* and that no matter who or where you are, you have something unique and precious to offer the world to make it better. I ask you to believe that as you read this book, as I also ask this of myself every day. I invite you to peer through the window of this book into eyes and *worlds*. Consider the possibility that the people and places Chip will introduce you to on your journey together are not so different or so impossibly far away. There is much to see, experience and learn.

You, too, are an artist, a philanthropist, a listener, an observer, a heart-thinker, a storyteller, and a lover of people who you will never meet.

I dare you to discover that this is who you truly are.

—Jennifer Buffett
Co-Chair, Novo Foundation | *March*, 2009

Preface

In his book, *The Bottom Billion*, author Paul Collier lays out his case for growth and development in a thoughtful, engaging way. Collier is an expert on the challenges facing many beleaguered nations throughout Africa and central Asia, such as Afghanistan, Pakistan, and Sudan. The bottom billion he refers to are the roughly one billion people whose lives are constrained by poverty, disease, lack of education, and lack of opportunity in nations with economies and governments that are essentially stagnant. He makes the case, a case I agree with, that ignoring the bottom billion will only compound the complex problems we all face in the 21st century. He also addresses the consequences of ignoring the difficult challenges people face and the resulting hopelessness.

Collier writes:

> "...development is about giving hope to ordinary people that their children will live in a society that has caught up with the rest of the world. Take that hope away and the smart people will use their energies not to develop their society but to escape from it..."

While many parts of the world have enjoyed considerable progress during the past few years, hope can be elusive for people whose lives are defined by corrupt governments, lack of economic and natural resources, widespread disease, and decades of conflict and war. Afghanistan remains challenged by nearly thirty years of warfare, along with the inherent problems facing land-locked nations. Pakistan continues to confront divisions over faith and poverty as well as ongoing political struggles with neighboring countries. Sudan has suffered years of civil war between north and south, ethnic and religious conflict and, despite abundant natural resources that could help lift the population up, there's no end in sight to the genocide that plagues Darfur.

This book is the result of personal visits to Afghanistan, Pakistan, and Darfur. Unlike Collier's book and other notable books that deal with specific international policy issues facing developing nations along with the trappings of various forms of government aid, *Enough to Go Around* is experiential. It's told in the first person and uses photographs from each location to help document my personal experiences with humanitarian organizations and the people they serve. I visited each country as a filmmaker with the intention of documenting aid operations in the wake of crisis.

Thanks to my colleague Mike Speaks, I had the extra help I needed to be able to take still photographs of many of the people and places we were documenting. This book would not exist without Mike's contributions on location.

Both the difficult challenges facing people in crisis and the solutions to their problems are complex. While there are similarities among developing nations, there are also unique circumstances facing individuals, families, and communities. War and natural disaster present specific problems. Faith practices and the type of official government in a community may create conflicts. The abundance or the lack of natural resources and water also present difficulties that can be hard to overcome. The impact of disease and the quality of health care vary widely from place to place.

And the way poverty is manifest can vary significantly not just in terms of jobs, wages, and cost of living, but also based on climate and culture. When asked to define a common thread for those living in poverty my simple answer is this—it's the lack of opportunity or inability of someone to participate meaningfully in the same global society enjoyed by those who are not in the bottom billion.

This book, at its core, is simply about hope, the hope I found among the people living in these places with many hardships, the hope I witnessed among the aid workers for NGOs, and the hope that each inspired in me. With all that both are doing to rise up and to create an even better life for the next generation, this book seems a small thing to give back. But we are in this together—and if you're reading this, then you, too, have become part of my optimism.

"YOU MUST
BE THE CHANGE
YOU WANT
TO SEE
IN THE WORLD."

—Mahatma Gandhi

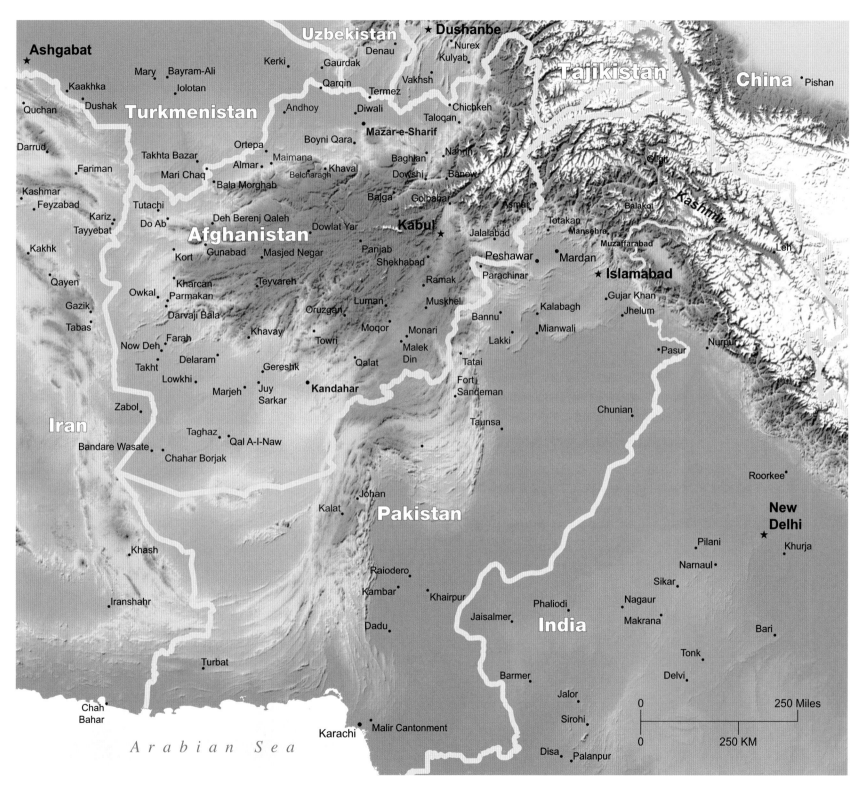

Map 1. Afghanistan and Pakistan

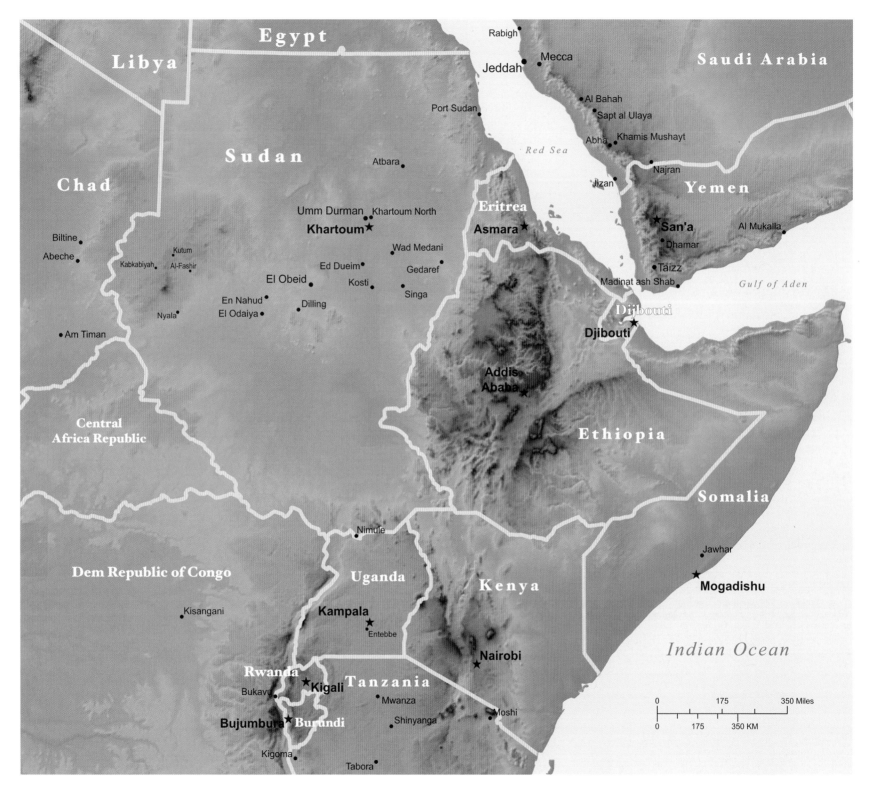

Map 2. Eastern Africa

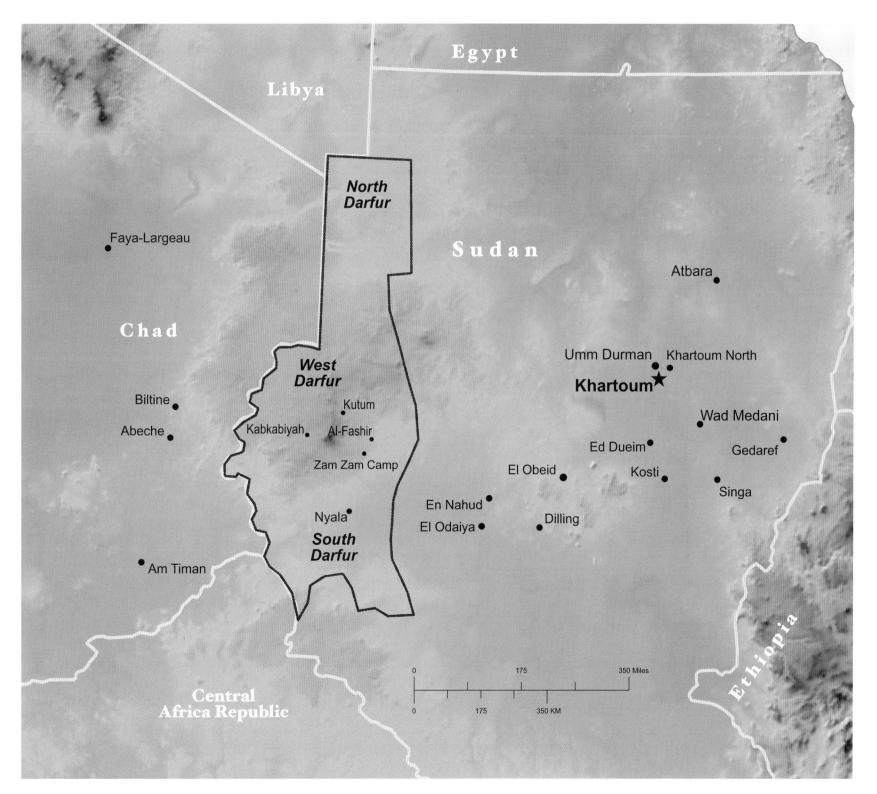

Map 3. Darfur region of Sudan outlined in red

Abraham's Sandwich

There's an old expression that says a lot about the place where I live: *America is just three meals away from anarchy*. For the best-fed, most prosperous, and often most oblivious nation in the world, three squares a day may not seem like too much to ask. But in many parts of the world, it's a feast worthy of only the holiest of days. Going without is a fact of life.

Maybe it's human nature to take such privilege for granted. Growing up in Iowa and Michigan with a stay-at-home mom, it never occurred to me that our middle class lifestyle was in any way unusual. I didn't question it, and I was more likely to complain about the over-cooked vegetables I was served each night than I was to be grateful for being fed at all. Like most people, I've had ups and downs, but I've never been without food, I've never been without shelter, I've never had to live with the daily fear that my sister might be raped by government soldiers, or that my brother might be forced into military service at twelve years of age. I've never had my house bombed by anonymous jet pilots or suffered injury at the hands of terrorists filled with hate for equally anonymous victims. I've never had to live with the loneliness and loss created by war or natural disaster.

During a career making documentary films, I've enjoyed unexpected opportunity and access. Opportunity sometimes presents itself. It can happen by showing up, by saying yes more than no, and by finding happiness and value not simply in money, but in the wealth of experience and relationships that happen along the way. Opportunity presents itself when we learn to trust our instincts and our curiosity instead of navigating away from life's experiences because of fear. Acknowledging the opportunity helps to create access, access that reveals the extraordinary beauty that comes from our diversity of race, culture, art, history, and place. Saying yes and embracing the unknown has allowed me to film Haitian vodou rituals, to photograph Swedish art museums, to traverse and photograph the Arctic National Wildlife Refuge from an inflatable raft, and to sit quietly filming cremation rituals at an ancient ghat in the holy Indian city of Varanasi. Saying yes has allowed me to spend days photographing the slums of Nairobi and to conduct interviews in the White House. What joy I experience in my professional life comes from recognizing the significance and importance of both.

For many years I managed to photograph with the detachment often associated with objective journalism, and it served me well. To document and to detach become almost synonymous. Detachment is both a choice (I shall not judge or manipulate) and a matter of circumstance (I will play within the reality of my subject). By shooting motion pictures in video format, I became a master at watching the world through a small black and white viewfinder. Doing so, especially in black and white, made it easier to imagine what I was photographing as somehow being outside my reality. Anyone who's photographed an event, regardless of the type of camera, can relate to the way that real becomes surreal for the photographer simply by looking through a lens. We're even trained to create our own reality by framing the action. We then focus reality further by considering how light inhabits the space we've chosen. We ask ourselves what's being said within the frame. If we're lucky, the story—or what's being said—has actual meaning, perhaps even universal meaning.

The camera also changes reality, especially when people are involved. Behavior shifts. I've filmed hundreds of hours of motion footage in spiritual places around the world—mosques, churches, temples, shrines—and no matter how small the crew, no matter how low impact we try to be in our work, the camera (and occasionally the sound equipment) always impacts the ceremony or prayer rituals involved. Some people become more animated, some less. Some shy away completely, some convince themselves our crew doesn't matter. For that reason, what we film becomes an approximation of reality.

A telephoto lens often has less impact on a person, animal, or event than a medium angle or a wide angle lens. Getting closer to shoot wider means having more impact on the environment. For some photographers this may be their intention. For me, the opposite is true. When I'm shooting, I prefer the kind of anonymity that comes along with familiarity, or from a subject's willingness to express feelings and thoughts without apprehension. It takes time, but when I'm lucky, I become background to the event. Time and space then become more subjective. Both amateur and professional photographers learn very quickly that their subjects are more likely to surrender to their true nature once familiarity is established. Whether it's a grizzly bear or partners at a wedding, achieving the point of surrender requires the photographer to inhabit their space and move within their rhythms.

Despite its advantages, detachment can have a downside. There's a fine line between knowing when to stay out of the way and when to become an active participant. After twenty-five years of capturing images, my learning curve no longer hinges on keeping up with technical changes, new film speeds, the digital revolution, or editing techniques. To get to the next level, I needed to learn how to put the camera down and to rely on different senses and sensibilities. I needed to learn to feel the place, the subject, the environment, and the situation. I needed to go back to something I'd lost along the way. That is, caring more about the people I was filming than the outcome of the image. Photojournalism requires quick thinking, a quick assessment of one's surroundings, a quick understanding of the mood and emotion of people and place. It's not the time to experiment with patience. Yet that was the experiment I needed. After the turn of the 21st century, things were starting to run together. Images were starting to overlap, and the sequence of events, whether at home or abroad, was starting to matter less than it had before. Something had to give.

Few things are more important to me than journalism in its myriad forms of expression. But for all it offers, the act of journalism has a way of wearing away the humanity of the journalist.

———

WE ALL SHIFT and change over time. For me, change was facilitated by a personal experience that followed September 11, 2001. It was not, by most measures, the understandable shift experienced by many Americans who felt the ground shake as the Twin Towers crumbled. There were no flags to be raised and, thankfully, no gut-starved need for revenge. The nations that spawned the criminals who brought down airliners filled with innocents had been run for too many years by dictators or royalists supported with enthusiasm by my own government. Whatever moral high ground we had on 9/11 was shaded by clouds accumulated

during many years of ignoring injustices in faraway places. Although it didn't seem that way at the time, I was blessed to be somewhere else, a faraway place where the fundamental challenges of daily life were too often informed by violence, hunger, disease, and premature death, a place where the word "hope" had more meaning than any place I'd ever been.

Ethiopia » September 2001

FIREWORKS FILLED THE night skies of Addis Ababa as my cabbie and I drove from the airport to the old bastion of expats, aid workers, and journalists, the Addis Ababa Hilton. It was September 10, New Year's Eve on the Ethiopian calendar, and after settling into my room, I watched from the small balcony as the skies lit up over the vast patchwork of rusted tin roofs that frame most of Addis. It reminded me of a war zone—the sort of night sky that veterans remember in their dreams years after returning home.

The next day was a holiday, but I managed to hire a driver to scout about town. I was in Ethiopia to work on two films: one a segment for a public television documentary on women's reproductive rights, the other a rafting adventure down the Blue Nile River. Addis was new to me and having a free day to scout was a luxury since the crew wasn't expected to arrive for two more days. The only person in Addis I'd had any contact with before the trip was the country director for the non-profit NGO Save the Children. Though it was his day off, Dennis Walto suggested we meet for lunch to discuss logistics. Save the Children, an international NGO (non-governmental organization) with a more than 75 year history, had agreed to let us film their field work in the Oromia region of southern Ethiopia. It was work that included educating villagers about reproductive health and contraception. Dennis had the easy manner of any veteran traveler—eyes in the back of his head, a stomach lined with stainless steel, an easy smile, sharp wit, and the acute ability to know what to take seriously and what to surrender palm up for the local gods. He was also very well versed in the politics and culture of Ethiopia and East Africa.

After lunch with Dennis, the driver asked me if I'd like to drive past the American Embassy. Normally I'd have said "no," but two things came to mind. First, I really didn't have anything else to do. Second, it wasn't long before my visit that the American embassies in both Tanzania and Kenya had been blown up by terrorists. Since I was just one country to the north of Kenya I thought, "Why not get a glimpse of what the security and atmosphere looked like in Addis following those attacks?" Underwhelming, it was, to say the least. Late afternoon on an Ethiopian national holiday meant closed markets and empty streets. The sounds of family gatherings—blaring boom boxes and squealing children—echoed from the crowded neighborhoods. Other than a few Ethiopian guards lounging around outside the main gate, there was really nothing to see. The huge cement bunkers that surround American embassies today weren't in place yet and the few passersby I saw could have cared less about the goings-on inside.

Back at the Hilton by 5:00 P.M., I threw my knapsack on the bed and flipped on CNN. But it wasn't the normal punditry and sunny chitchat about fashion and weather. The anchors were doing the balancing act between calm reporting, uncertainty, fear, and shock. Tower One of the World Trade Center had been hit. The live camera insert over their shoulders had a long angle shot of billowing smoke on the Manhattan skyline. Less than a minute later, without a clue as to what was going on, I watched live from almost 5,000 miles away as a jetliner crashed its way through Tower Two. Surreal, yes, we all felt it. For many viewers, including me, it was among the most profound and immediate experiences of death one could imagine. It wasn't at all like my father's slow death from illness. It wasn't at all like reading a history book about the Civil War, the Holocaust, the fire bombing of Dresden, or 100 days of horror in Rwanda. We weren't watching a mushroom cloud climb a distant horizon above an enemy made faceless by war or years of propaganda. Many of us were feeling, in that instant, the immediacy of death and the loss of innocence. Yes, it could have been one of us in that airplane. But that wasn't the feeling this time. It wasn't about personalizing things. It was the feeling that nothing as seemingly innocuous, routine, or meaningless as a domestic business flight would ever be the same again. It was the feeling that a small handful of terrorists with a big window to the world had just managed to win the one battle they could win—instilling fear and uncertainty in place of security and a little blind faith in business as usual.

Perhaps most of all, it was the blunt, vivid depiction of the ultimate weapon of mass destruction: the human imagination. We all had to quietly ask ourselves whether there's really any difference between the will to kill with a hijacked jetliner versus a nuclear bomb. Is there really any difference between lobbing compressed hydrogen at a professed enemy versus the brutal murder of 800,000 Tutsis using only machetes for weapons? Time, which has only a self-perceived beginning and end in the act of mass killing, seems the only difference. How instant, how dramatic, do we want the killing to be? And what level of fear do we hope to unleash upon our audience, our enemy in our quest for submission or self-proclaimed victory?

Normal became abnormal in that moment the way it does when we lose control of our car on an icy road. It was the moment when sound failed to find its way out of our bodies because our throats were constricted by the awful convergence of brutal reality, hatred, shock, and disbelief. In that moment, it didn't matter what their grievance was or how much injustice they may have suffered. The terrorists had just committed a crime of extraordinary violence the world would never forget. Their cause, however comprehensible, did not justify their means, nor did it invoke the sympathy they may have hoped for. Although we may keep killing ourselves in new ways and record numbers, in conflicts most people can't name and for reasons most of us can't fathom, we are, most of us, still horrified by that distinctly masculine and desperately arrogant part of our nature. Still, for as long as we have claimed to want peace, our friends have become our enemies, our enemies our friends, in a cycle of violence that creates the strangest of bedfellows. We have cheered our warriors, warriors who are too often the victims of failed intelligence and failed leadership in the ballet of political dancers.

WE ALL HAVE our 9/11 stories and a consequence for many of us was transformation. Our routine had been broken, our sense of security destroyed. The obvious question—what now?—created an opportunity for collective and individual response and became a challenge for each of us to put our most fundamental beliefs into action. My own distress on 9/11 was coupled with the realization that I was completely alone and a very long way from home. With that in mind, I sat for a moment pondering what to do. The phone lines weren't cut off yet and I made a brief call to my office and encouraged everyone to go home. Then, like virtually everyone in America and millions more around the world, I watched hour after hour of up-to-the-minute coverage. By three in the morning I was exhausted by jet lag and completely uncertain about what lay ahead for America, for the world ... and for me.

A president with an itchy trigger finger isn't my idea of a good thing and I couldn't help but remind myself that I was situated right between Sudan and Somalia, two hot spots on the terror list. President Clinton had sent cruise missiles into Sudan in August 1998, and Somalia, home of the infamous *Black Hawk Down* incident, was in anarchy. I made a call to the airport and found out that all flights to the U.S. were cancelled. Had I wanted to leave Ethiopia at that point, Europe was as far as I would get, but those flights were filled and giving seats on a standby basis only.

After a few hours of restless sleep, I woke up and went down to the hotel restaurant. There were very few Americans in the hotel but I did have a brief conversation with a woman from USAID. She'd been told that there would be a briefing at the U.S. Embassy later that day for Americans located in Addis Ababa.

Back in my room, I phoned a nearby guesthouse on the chance that a fellow traveler named Mike Speaks just might have arrived in town. Mike was slated to guide our adventure trip on the Blue Nile. The desk phone rang eleven or twelve times before someone answered. Mr. Speaks, they said, had arrived an hour earlier and was in his room. They'd find him and have him call me back. When the phone rang about ten minutes later, I became the bearer of news for Mike. During a layover, he'd slept on the floor of the Nairobi airport after a long flight from Alaska to Kenya and had, like a lot of international air travelers, missed the news. There was no television at Mike's hotel so he headed over. We flipped back and forth between CNN and BBC News and discovered that no one had any idea what was going on. Reports were that the president was somewhere over Nebraska in Air Force One and the vice president was, well, in a bunker ... perhaps.

Mike and I had traveled together in some difficult places, including Burma, Bhutan, India, Peru, and the Arctic. But the world of upheaval thrust upon millions of people on 9/11 presented an entirely new challenge for everyone, including us. We were cut off from normal communication. Phone service to the States was iffy and expensive. The Internet at the hotel was an old dialup that sent and retrieved messages slower than a teletype machine. So we discussed our options.

Our first decision was to attend the embassy briefing. At the minimum, we wanted to make sure we were still welcome in Ethiopia for at least as long as our visas would allow. If the situation back home became worse, we wanted to know what our options were. The visit to the embassy didn't last long, however,

because I'd brought along my camera to document the meeting. This was clearly a story, and as a journalist, it seemed like a situation I couldn't miss. There were roughly 300 Americans inside the embassy compound in a briefing area. When a Lt. Colonel spotted my camera, which was slung over my shoulder in the off-position, I was promptly thrown out. No cameras allowed. When I suggested I'd be happy to leave the camera at the front desk and just listen to the briefing, I got the tight grip on the arm and an escort to take me outside. So much for being an American citizen. Mike and I waited on the street outside the embassy for roughly an hour, then got a report on what had been said from Dennis and his Save the Children colleagues who'd been inside. The short version? Not much. Americans in Africa on 9/11 were pretty much on their own. The folks back home, it seemed, had much bigger fish to fry than to worry about aid workers and a few journalists in a country America hadn't paid much attention to since the decline of the Soviet Union and the seeming end to the Cold War. (The events of 9/11 were soon looked upon as an opportunity for the U.S. to create a strategic alliance with Ethiopia. With Sudan on one side and Somalia on the other, the Bush Administration pushed harder for a friend in the region.)

Within a day of the collapse of the World Trade Center towers and the grounding of all airlines, it was clear that our film shoot on the Blue Nile was history. The few collect calls Mike and I were able to make confirmed what we suspected—it would be weeks before anyone else scheduled for our trip would be able to fly in to Ethiopia.

On the other hand, there was nothing stopping us from booking a domestic flight south into the Oromia region to film

segments for the documentary on women's reproduction rights, *In A Just World* (PBS, 2002). It took a few days to coordinate logistics with Dennis and to book seats on the twice-weekly flight. Mike agreed to help out as a production assistant and after a 90-minute flight from Addis Ababa, we landed on September 15, 2001 on a dusty gravel airstrip in the city of Negele.

———

ABRAHAM BONGASSI GREETED us with a huge smile and a strong handshake. The field director for Save the Children, Abraham had worked for years on humanitarian missions throughout sub-Saharan Africa. He knew the challenges facing the Oromia region as well as anyone in the world. Poverty. Climate change. Hunger. Lack of education. Inadequate health care. High infant mortality. Low life expectancy, especially for women. To complicate matters, the Oromia region is populated by nomadic people whose livelihood is supported primarily by their livestock. Conflicts with neighboring countries and sustained periods of drought had taken their toll, on people, their animals and the crops each needed for survival.

Once Abraham's pleasant greeting had turned to logistics, we noted that soldiers in camouflage outfits living in camouflage tents lined both sides of the long runway. They'd been hard to see from the air, but they were a strong indication that the airfield was a hard target for local rebels. Ethiopia had rocky relations with neighboring Somalia and Eritrea so the state of "high alert" had been the norm for a generation (sadly, it still is). Mike and I climbed into Abraham's old 4x4 Land Cruiser and headed to the Save the Children offices for a briefing. We'd planned on four days with visits scheduled to clinics throughout the region. Since

I'd never worked alongside an NGO before, I didn't know what to expect. Exuding confidence and seeming delighted by our visit, Abraham was easy to defer to. With dusk approaching, there wasn't much to see. Tomorrow, he said, would be the big day.

In the tiny room at the local guesthouse, I briefed Mike on the limited equipment we had at our disposal. Like our fellow crew members, most of the gear we needed never made it to Ethiopia. We had no tripod and were forced to use the back up DV camera vs. the high-end digital gear. There was a slew of tape stock we couldn't use, a very limited supply of DV tape we could use, no lighting gear, no headset, and only the back up shotgun microphone with a faulty windscreen. We'd make do.

On the personal front, Mike and I were both taking standard precautions for malaria, and we'd brought along our elaborate first aid kit. We had a few energy bars and water purification tablets. We were prepared to sleep anywhere and eat whatever came our way, but none of that made our trip to the region easy to comprehend. For those of us who visit places like rural Ethiopia only on rare occasions, it's easy to be overwhelmed by the suffering instead of inspired by the pockets of hope and human spirit.

Following a modest dinner, Mike and I walked around the dirt streets of Negele. The sun was setting, the light was beautiful, and the few carts and bicycles kicked dust from the dirt road. Most of the adults we encountered were shy and quick to retreat inside their houses. But to the children, we were the most entertaining thing happening that night. An amateur magician, Mike performed his slight-of-hand tricks, evoking both wonder and the universal language of laughter. And several kids found

the courage to run up and touch my bare forearms. According to Abraham, I was probably the first blond-haired person they'd ever seen.

As darkness fell and we returned to the guesthouse, Abraham told us that the population of Negele was both growing and shifting. No one knew for sure how many people lived in town, but estimates were as high as 35,000 people. The city had been a crossroads for nomads for centuries, and as resources in rural areas became scarce, Negele, like much of Ethiopia, was gaining in population.

The next morning began early. Abraham drove up in his 4x4 with a second vehicle behind him. He explained that the roads were impassable at times and that each vehicle was capable of off-road travel. Each had extra fuel and radios and the reason for traveling in twos was simple—if one vehicle broke down, the other would get us back to Negele. It was protocol.

Within just a few minutes of leaving the guesthouse, we were following a two-track aimed, albeit indirectly, to the west. At times, there appeared to be no road at all, but Abraham knew where he was headed. The countryside was desolate, the vegetation dried brown or dead, and the few houses we passed along the way seemed randomly situated. The best of them had foundations made of mud bricks, but most were little more than thatched huts. Some had tattered plastic for walls, some had rusted tin for rooftops. As we drove, Abraham explained more about the challenges facing the people. In simple numbers, the life expectancy in Ethiopia is 52 years. Nearly one out of ten children die before the age of one, a number that's fifteen times greater than that of Japan, central Europe or the United States.

Roughly 80 percent of Ethiopians live on less than two dollars per day. The population is among the fastest growing in the world and the average number of children per female in rural areas is 6.4. At the time of our visit, only 6 percent of Ethiopian women were estimated to use contraception nationwide, with a much smaller percentage in rural areas. Promoting reproductive rights and providing reproductive health services as part of a comprehensive approach to health care is, truly, a matter of life and death for women throughout much of the developing world.

Before arriving at the first clinic compound, the data was just that—data. Without a human face, it's hard to imagine how difficult it is to live in real poverty, poverty in which clean water is a luxury, electricity a fantasy, and regular health care non-existent. Even finding a midwife for a pregnant woman is all too rare. Thousands of women die during childbirth each year. I'd filmed in slums around the world and some very difficult spots in Haiti, Burma and India, but nothing to that point rivaled southern Ethiopia. Beyond a few Save the Children outposts, there were virtually no resources for immunizing children, combating dysentery or malaria, providing reproductive health care or educating children.

About ten miles from our first stop, Abraham slowed the vehicle down for a young mother who was running toward us as fast as possible. Her two-year-old son held her hand, trying hard to keep up, and she cradled a baby girl in her arms. They were the first of several women and children we picked up along the way. It was part of the routine, however occasional. They'd spot the Save the Children vehicles, often the only ones passing by in weeks, and hail them to hitch a ride. They knew that getting to the clinic was their only chance to bring their children in for basic immunizations and a physical check up. By the time we reached our first clinic, both vehicles were packed full.

Upon arrival, Mike and I began filming at the tiny outpost. It was just a few uncluttered cement block buildings in which Save the Children doctors, nurses, and assistants had gathered to administer shots and nutrition packs for the more than 200 women and children who'd gathered there. The small courtyard was full of women in beautiful, multi-colored sari-style outfits, most carrying at least one child. The sound I remember most is crying babies, infants desperate for food, fearful or confused by their unfamiliar surroundings, or simply reacting to their first needle in the buttocks. Some were examined for a cough or fever, while others were given food supplements. Virtually all the children were weighed and measured, their data recorded by hand in soft-cover journals as a barometer for their next visit. The dedication of the workers was inspiring and Abraham's positive spirit was contagious, but I remember wondering at the time how many of the children would never make it back. How many would die from malaria, dysentery, or malnutrition? I questioned one of Abraham's colleagues whose answer helped plant seeds for me, seeds of hope. It was the present that mattered, he said. We do it now because it's what we can do, and we hope it makes a difference in their future.

——

TWO HOURS LATER, Abraham reminded us that we had more stops planned for that day. It was already after 1:00 when we headed off to the south on yet another unmarked passage. The countryside had loads of character: ravines, hillsides, and red sand

cliffs with deep washes that hadn't seen regular flooding since the rains disappeared a generation ago. Oral history from the area suggests that a drought cycle that was once twenty-five to thirty years is now two to three years. In short, the old trees had been cut long ago for firewood or building material and new trees and shrubs have little chance of survival. What was once a rich landscape for growing crops and grazing cows, goats, and camels now provides next to nothing of value. The few trees we did see perched randomly along the roadside were either dying or dead. Although the soil was rich, there were no patches of land green with corn or soybeans and no apparent gardens next to the homes we passed.

After roughly an hour of driving, Abraham pulled to the side of the road with our other vehicle close behind. It was time for lunch and Abraham's colleague brought out a small cardboard box of sandwiches and purified water. There was a sandwich for each of us, a small white bun with a thin spread of butter, and a few tiny pieces of chicken. Enough to get by, I thought.

Like everywhere we'd been that day, there were a few random people walking nearby. For Westerners on a schedule used to cutting corners to get somewhere fast, it was unusual for us to see people simply walking by, but it was apparently quite normal for the region. A few carried tools or a bag slung over their shoulder, but most appeared to be going nowhere in particular while carrying little to nothing. A middle-aged man happened across the road and was walking fairly close to our small entourage. He wasn't paying much attention to us, nor were we to him. But as he passed close, Abraham tore his small sandwich in half and gave it to the man. The act of sharing wasn't miraculous. After all,

Abraham was a humanitarian aid worker. He was used to seeing suffering and knew how to manage his own needs quite well. What was remarkable, however, was that the man wasn't trying to make contact with us. He wasn't begging and Abraham didn't seem particularly conscious of the generosity of his own action. Abraham's ego wasn't in the game. He wasn't looking for attention or gratitude. He didn't have to think to himself, "Maybe this fellow is hungry and needs some food." Of course the man was hungry. Of course he needed food. The beauty of the moment was that Abraham didn't have to think about sharing his sandwich. He simply did it. Sharing without thinking about it was as natural to him as waking up in the morning.

A continent away, the Andean people of South America have a word for Abraham's innate generosity. They call it *ayni*.

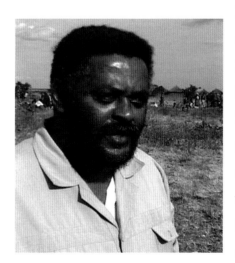

*Abraham Bongassi,
Ethiopia,* 2001

It's a Quechua word that doesn't quite translate into English. Yes, it's sharing, but it's more than that. It's sharing as a natural act, sharing without thinking "I need to share." It's sharing without consciously thinking you'll be rewarded for doing so. It's knowing there's enough to go around— always. While Abraham may never have heard the word *ayni*, it was part of his culture, a culture he'd created around himself by being true to whatever notion of higher purpose he believed in.

BY THE END of our four days in the Oromia region, I found myself as far removed from the tragedy of 9/11 and the politics of America's response as I could be. Word had percolated throughout Ethiopia of the World Trade Center attack and everywhere I went I was greeted with condolences and support. As a 6′ 2″ middle-aged male of Swedish and Scottish descent, I do tend to stick out in parts of rural Africa, and people who had nothing wanted me to know how sorry they were for America's loss and how much they hoped for our recovery. I was grateful, but couldn't help but think about how sheltered America had been during my lifetime. The injustices and inequalities plaguing much of the developing world are neither occasional nor random; they're constant, day after day, year after year. And many are the direct result of centuries of colonialism and, more recently, Cold War politics (which had been especially true in Ethiopia) as well as divisions over ethnicity and religion. As tragic as 9/11 was and as much as I, too, grieved for the losses America faced that day, my visit to southern Ethiopia had further awakened me to the reality that much of the world suffers profound challenges regardless of whether it's part of the North American or European consciousness. Hundreds of millions of people endure daily hardships most Westerners can't imagine. They do it without complaining and usually without even the remotest sense of real security. Yet even in the worst of circumstances, there is hope.

— ⋙ —

AS A DOCUMENTARY filmmaker, highlighting stories of the disadvantaged or issues of social justice had been part of my career from the beginning. But Abraham had helped inspire something more, something I hoped would become so routine for our company that we wouldn't need to think about it; we'd simply do it. We'd use filmmaking to tell more stories from the developing world, stories that emphasized, when possible, the richness, intelligence, diversity, and beauty that permeates cultures all over the world. When possible, we'd use our resources to support NGOs in their work in crisis zones. We'd do what we could to use media to help empower women and girls, the one proven solution to a bright future in challenged parts of the world. The commitment is shared by our entire team and the work continues.

At the same time, I began a professional journey that allowed me to explore a new medium, still photography. I'd been shooting motion pictures for more than two decades, but in 2003 I picked up a still camera and chose to interact with subjects in a new way. Shooting stills is considerably less intrusive than motion photography. It doesn't require heavy tripods, large cameras, sound and lighting equipment, and larger crews. Both have their advantages, but shooting stills has opened new opportunities for the ways I'm able to navigate challenging places. More importantly, still photography is allowing me to interact with people in a more intimate way. When filming motion pictures, the camera is often distant from the subject and often has a sort of omniscient point of view in the completed documentary. Eye contact between camera and subject is a rarity. With the exception of some interview techniques, cinematographers and editors often work hard to avoid shots where direct eye contact occurs. It can, in some cases, make the medium of film or television too "real." That's especially true when the cinematographer is using specific effects, such as changing film or video speeds to distort time, in an effort to alter the perception of reality. By contrast, the still

photos in this book involve a close proximity between photographer and subject, often with only a few feet of separation between the camera and the person being photographed. Shooting in this style involves a relationship between two people that rarely, if ever, happens with a motion camera. Composition, light and depth of field are still important, but trust plays a much greater role in making an interesting picture.

There are many ways to photograph natural disaster, war, and genocide. Journalistic images reflecting the horror and the tragedy of each play a significant role in telling these important stories. I've taken a different approach. The images I've included are based on my experience in each country around shared values of love, family, joy, hope, compassion, faith, and humor. Those elements of life—symbols of humanity amid pain and crisis— were found throughout my visits to Afghanistan, Pakistan and Sudan. A mother's love and compassion survives crisis and circumstance, a child's innocent joy makes life worth living, and the gentle, smiling faces of Muslim men help to dismiss stereotypes based on ignorance and fear.

This book, which is dedicated to the thousands of humanitarian workers who ask for little and give so much of themselves every day, is my attempt to put a human face on some of the world's most difficult places. Northern-based NGOs working in developing countries and local NGOs from the global South are working tirelessly every day to create new opportunities that enhance and build on the hope that's innate within so many people living through war, genocide, disease, abuse, and the myriad hardships of poverty. For much of the early 21st century, my government ignored real diplomacy. Yet

at the same time, thousands of humanitarian workers associated with both giving and teaching have been messengers of inclusion, hope, and inspiration. And individual generosity from people around the world, from personal checks to volunteer missions building homes or schools, continues to make an extraordinary statement about the fundamental decency of so many who have resources to spare.

Yes, humanitarian aid is not a panacea. There are genuine pitfalls to over-reliance on aid regardless of who provides it or where it comes from. A refugee camp that becomes a long-term home, or worse, a virtual prison, has failed to become a solution to the underlying problem. Camps in places such as Palestine, Somalia, or Congo have long outlived their purpose. Their security is gone, their residents and their needs often forgotten. A society that can't provide for its own long-term security and independence is not a solution to anything. Suffice it to say here that long-term solutions cannot be accomplished by NGOs alone, especially with the extent of government corruption that too often accompanies aid. Their work is just one piece of a much bigger puzzle still being put together, ever so slowly.

Despite the often-misplaced priorities of the West, people in need are not forgotten. In every slum, in rural areas blanketed by poverty, and in the aftermath of every manmade and natural crisis, teachers, nurses, doctors, engineers, guides, drivers, administrators, and social entrepreneurs can be found doing what they can, and usually wishing they could do even more. Most are not limited or encumbered by politics or religious differences … and most are quick to share their sandwich without a second thought.

WHAT FOLLOWS IS a chronicle of three separate humanitarian missions from 2005 through 2008. Each was inspired by unique circumstance. In each case, our goal was to document critical areas of need and to use film as a vehicle for fundraising. When I left Ethiopia in 2001, I had no idea I'd be returning to work with Save the Children in Afghanistan. Likewise, when I returned from Afghanistan, I had no idea that I'd be headed to Pakistan or Sudan alongside Relief International. That those three countries now dominate much of the news and foreign policy of the United States was not a motivation. Documenting the devastating impact of war, genocide, and natural disaster on women and children was the reason each trip was made. In each nation, I made a personal decision to search for images and stories of hope amid the chaos and destruction. That someone can still smile and share—two common denominators among the people in these three nations—continue to inspire me to this day.

Tribes and Tribulations

Afghanistan April 2005

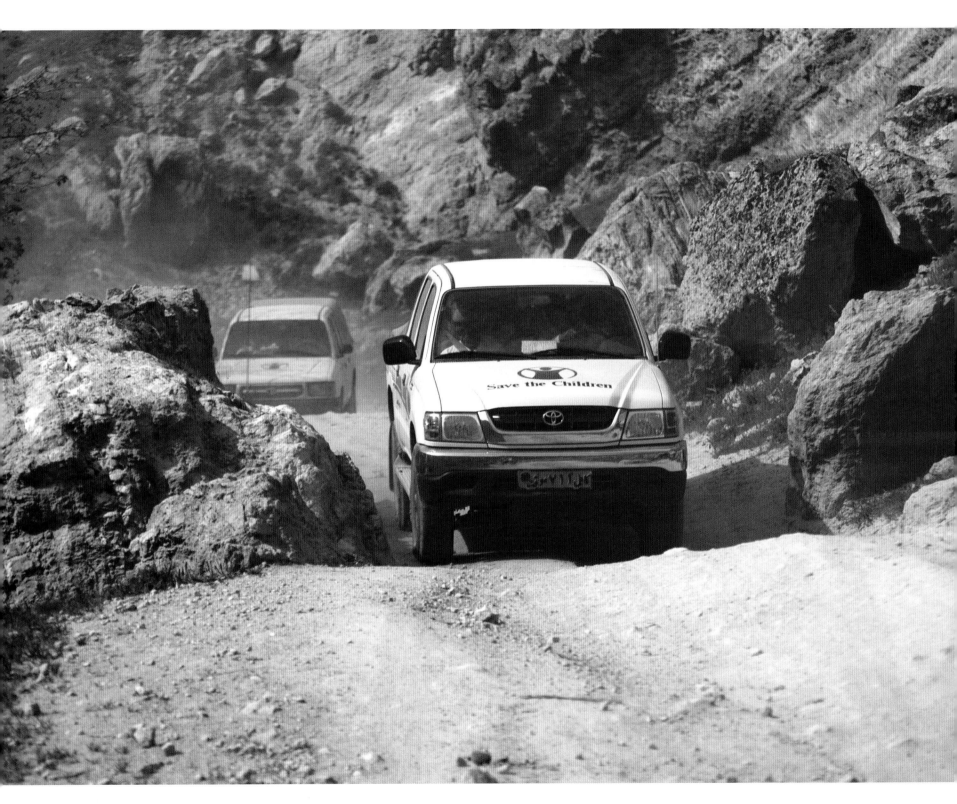

Road to Belcharagh, Afghanistan

ithin weeks of 9/11, and in response to the terrorist attacks on the United States, American and British forces invaded Taliban-controlled Afghanistan. The initial invasion force was mainly comprised of aerial bombing runs. Within a year, however, it represented twenty-seven nations and deployment of more than 14,000 troops in support of *Operation Enduring Freedom*. As recently as late 2008, coalition forces exceeded 43,000 and represented as many as forty nations. (At the time of this writing, President Obama has pledged both additional troops and support for civilian services.)

The first troops arrived with their related arsenal of jet fighters and ground attack vehicles setting both Taliban and al-Qaeda forces on the run into the desolate mountains bordering Pakistan. Even though the war continues today and the leaders of both the Taliban and al-Qaeda remain alive and un-captured, the assault did result in the coalition-backed government of Hamid Karzai.

Much has changed in Afghanistan during eight years of NATO-backed war, some things for the better, some for the worse. The area in and around Kandahar and much of east and southeast Afghanistan remains locked in a type of guerrilla warfare with resurgent Taliban forces. The annual harvest of poppies and the related export of opium continue to thrive (a 2008 U.N. report indicated that the harvest had decreased by 6% from the 2007 harvest, although some of the decline was due to severe drought). Solutions to the problem of the poppy harvest that may have seemed simple, such as aerial spraying, are complicated by real-life difficulties facing local farmers, many of whom face an annual debt to tribal leaders or drug lords. In other words, the people hurt by crop eradication are often impoverished farmers indebted to those who process the poppies and sell the drugs at extraordinary profits. The troops and local government might get rid of a season's worth of poppies, but the local farmer's debt remains, as do the consequences for his failure to pay back the drug lords who loaned him money for spring planting of the only crop producing relative profit. Reducing demand, which has little to do with the Afghans, would help enormously. So would cleaning up corruption within the current Afghan government, corruption that is often directly tied to the poppy harvest and opium production.

At the same time, parts of the north and west enjoy a relative calm unknown during a generation of fighting that left behind as many as 400,000 casualties. Relative, in this case, means that life has improved for some people compared to years spent under the rule of the Taliban, and before that, a civil war, and before that, the Soviets vs. U.S. backed Mujahideen, and, well, you get the drift. Yes, there are still terrorist car bombings and regular attacks on innocent people, embassies, and businesses in and around the capital city of Kabul. Yes, the southeast and border areas near Pakistan are still rife with conflict and violence. Yes, the countryside, even rural areas near Kabul, remains filled with as many as 5 to 7 million land mines from years of fighting among Soviet, Mujahideen, Taliban, and NATO forces. And yes, the vast majority of Afghans are still living in stifling poverty with few, if any, financial or educational resources.

Afghanistan has one of the highest maternal mortality rates in the world. More than 1,500 women die out of every 100,000 births. For every 1000 Afghan children born, 157 die within

the first year. By comparison, fewer than 7 out of 1000 children born in the United States die within the first year. Those children who survive face challenges that include malnutrition, disease, stunting, illiteracy, a lack of basic life skills, and forced labor. Arranged marriages for juvenile girls remain a huge problem to overcome and, though the situation has improved in some areas, many girls still lack the opportunity to go to school. Following too many years of forced submission—or worse, torture—the empowerment of girls and women has a long way to go before it becomes part of the national consciousness.

The prospects for sustained freedom and peace are daunting and understandably difficult for many Afghans to comprehend. In a nation with a life expectancy of 44 years, most Afghans have never known life without war and violence. For anyone under 30, Afghanistan has been a battleground throughout his or her entire life. Before NATO forces, before the civil war between the Taliban and the Mujahideen, Afghans witnessed a decade of fighting between the Mujahideen and the unwelcome rule of the former Soviet Union.

Afghanistan is a nation comprised largely of tribes and fiefdoms that have long-defied national rule. International trade and cultural exchange that flourished there began more than 2,000 years ago along the infamous Silk Road and continued into the middle of the 20TH century. But it was never easy. Today, remnants of the Silk Road can be seen in northern Afghanistan, especially in the Bamiyan Province. Bamiyan Province made headlines in 2001 when the Taliban, in a shocking display of arrogance and disdain for cultural and spiritual understanding, blew up an archeological treasure called the *Bamiyan Buddhas*.

But they didn't stop there. Few governmental regimes have treated women and girls worse than the Taliban did from 1996 through 2001. Women were not just dominated by men; they were frequently tortured or killed for minor infractions in what Taliban extremists referred to as "Islamic Law." Their interpretation of the *Quran* was a stretch even for the most conservative Islamic governments. For example, wearing nail polish could result in a woman having her toes or fingers cut off. Showing up in public without wearing the *burka* could result in a woman having her nose sliced flat against her face. A woman accused of adultery was punished by death, usually by stoning in a public place, a practice that continues today in parts of rural Afghanistan even after the fall of the Taliban.

———

AS 19TH CENTURY British author Rudyard Kipling once observed, Afghanistan can't really be conquered. He even said that Afghanistan was where great powers go to die. What Kipling noted I saw with my own eyes. It is simply too diverse, and ground travel too difficult, for even a national government to exercise total control, let alone that of a colonial power or foreign military. Cultural and ethnic autonomy often thrives within the confines of a river valley, but rarely exports over the mountain. Although there are widely-held beliefs in Islam, the degree of devotion from one place to another is no different than it is for Christians in the United States or Jews in Israel. Some folks are religious, some aren't. Many who are religious are moderate, some are fundamentalist, and some fall into the category I would call extremist. Most trade (outside of opium) is local or, at best, regional. In other words, interaction, trade

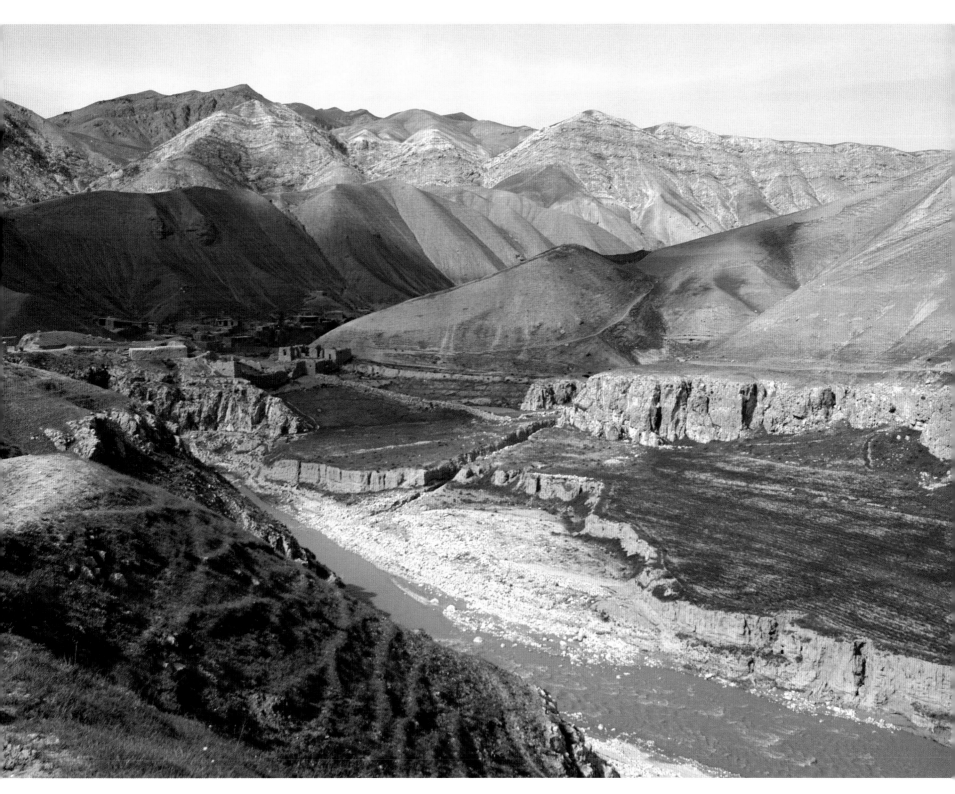

Village along road to Belcharagh

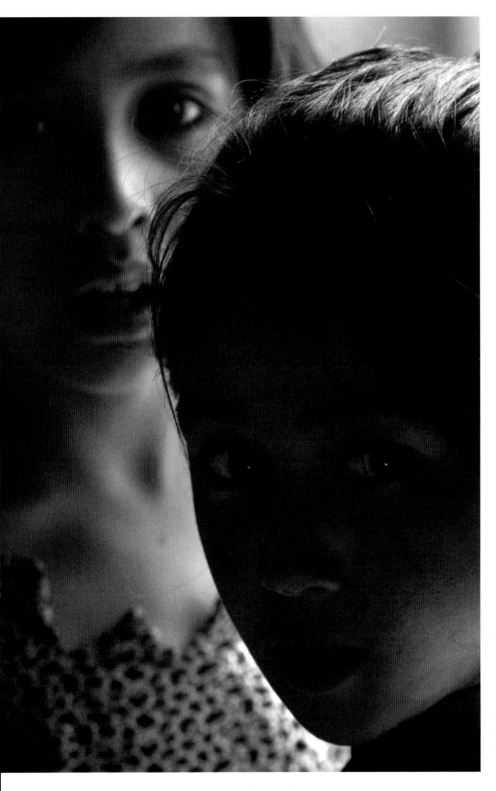

Afghan children near the village of Belcharagh

or communication in a national or international context is rare for the average Afghan.

After many turbulent years as a would-be British colony, Britain lost the third Anglo Afghan War and Afghanistan declared its independence in 1919. It had taken a little less than a century for the Brits to figure out that trying to rule Afghanistan was like owning a pet cobra. The bite wiped out British forces on several occasions. Afghanistan was ruled by monarchy (constitutional monarchy was introduced in 1964) until 1973 when the forty-year reign of Mohammad Zahir Shah came to an end. Zahir's cousin and former Prime Minister, Mohammad Daoud Khan, overthrew the monarchy while Zahir was in Italy seeking medical treatment. Daoud declared himself president and declared Afghanistan a "republic." Considered a progressive and a modernizer, Daoud had his share of problems. But he did endorse a constitution in the mid-70s that recognized women's rights. Perhaps not surprisingly, Daoud died in a coup in 1978, shortly before the Soviet invasion.

Though far from flourishing, tourism was a significant industry throughout the 1960s and '70s, especially for adventurers, backpackers, and overland travelers en route to Pakistan or India. Afghanistan offered an ultimate high having little to do with snow-capped peaks. Then and now, what Afghanistan may lack in terms of infrastructure or conveniences, it makes up for with the beauty of its landscape and the friendliness and hospitality of the vast majority of its people. Thanks to the minority, however, security is the most significant issue facing foreign travelers as well as those who live in Afghanistan.

Today, there are few roads in Afghanistan, no rail system, and only a miniscule commercial airline industry (two jetliners at the time of my visit). The lack of infrastructure is due, in part, to more than a generation of warfare. After Soviet departure in 1989 (Kipling was right, even the Soviet superpower failed), the Taliban rulers showed contempt for modernizing Afghanistan. Even today, improved roads, bridges, power plants, and power lines along the main highways are targets, easily destroyed by one side or the other. The result is that there are very few routes for trade or communication and very little in the way of utilities for water or power outside of major cities. The communities that cluster in the valleys that course the Hindu Kush and Himalayan mountains ringing the north and east are isolated and inaccessible much of the year. Access to any of the resources taken for granted in the West, including abundant food, clean water, schools, transportation, and security, presents extraordinary challenges to rural Afghanistan. Even the climate, which includes blistering heat in the summer, snow and ice in winter and flash flooding in the spring, presents obstacles that have long kept Afghans from communicating or traveling much beyond their home turf.

It's also worth noting that the flash flooding that plagues mountainous regions brings with it an unusual phenomenon called "mine migration." In other words, flash flooding each spring uproots landmines and moves them randomly from place to place. It's nearly impossible for local villagers to create a reliable system for identifying and avoiding hidden killers set during the past thirty years.

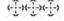

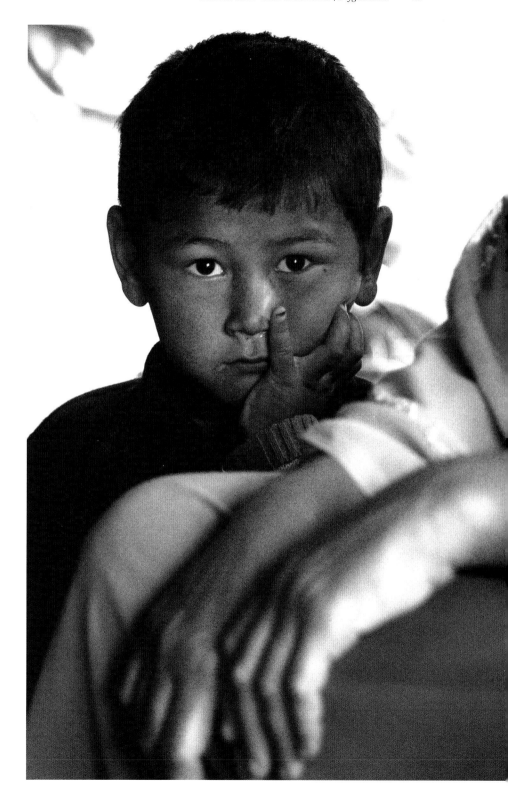

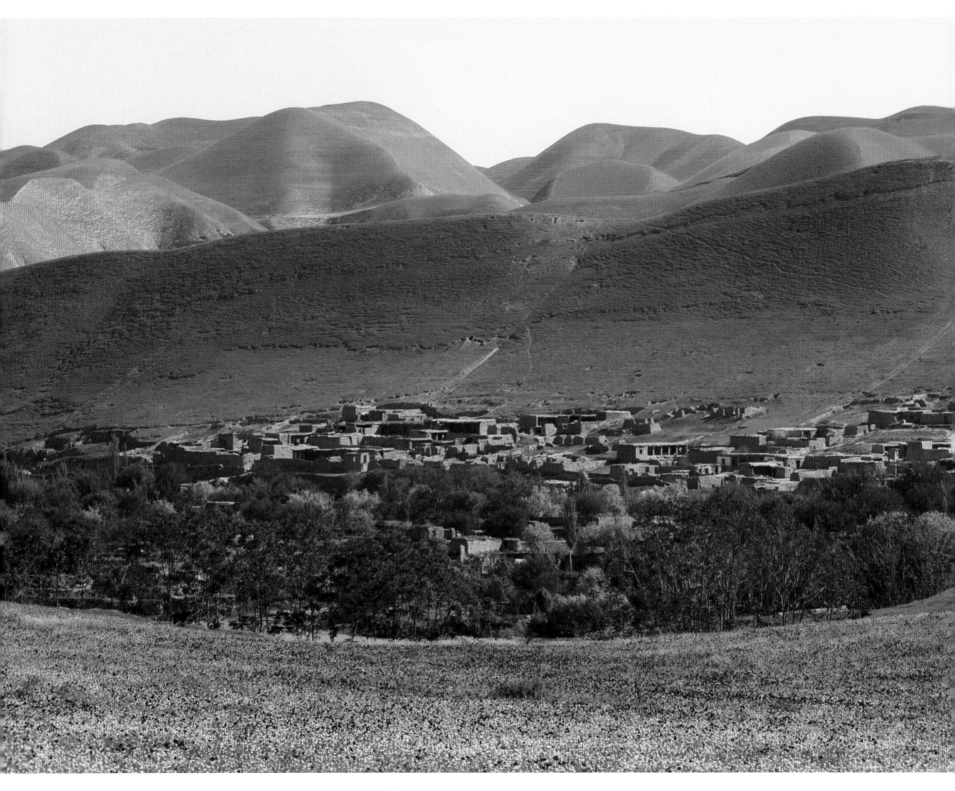

Village framed with poppies

OUR SMALL DELEGATION, which included the celebrated British actor Ben Kingsley, Michael Speaks, and me, arrived in Kabul on April 17, 2005. Following my experience in southern Ethiopia in 2001, I'd maintained a close rapport with Save the Children's Dennis Walto. I'd told Ben about my experience in the Oromia region and without a second thought, he volunteered to join me in a field mission for Save the Children. With Dennis' help, we made the trip to coincide with publication of the *2005 State of the World's Mothers Report* (an annual report produced by Save the Children to commemorate Mother's Day and detail the enormous challenges facing mothers and children throughout the world). In 2005, Afghanistan was considered one of the most dangerous places in the world to be a child. Unfortunately, it still is.

Our job was part diplomacy, part documentation. As guests of Save the Children, we spent our first day in briefings on security and cultural protocol including roughly two hours with renowned Afghan scholar, writer and former Afghan Finance Minister, Ashraf Ghani. For security reasons, our visit to various work sites would not be announced in advance. There had been recent attacks on aid workers, notably the 2004 killing of five members of the Doctors Without Borders team, and like virtually all humanitarian workers, we would be traveling unarmed. The only additional security we were provided, due mainly to Ben's celebrity, was a retired British special forces security agent named Phil. Phil had served in various conflicts around the world, including Afghanistan. He had a genuine love for the place and the people and was well versed in both security and local customs. He carried a satellite phone, which he indicated might get us some kind of helicopter airlift in the event of a vehicle break-down or random attack. As had been the case in Ethiopia, we'd be traveling in a caravan of two white 4x4s with a Save the Children logo clearly visible on the hood and side of the vehicles.

We had one overnight in Kabul at the InterContinental Hotel (no, that's not a typo, it's the hotel owner's cryptic way of trying to make customers feel they're part of the upscale hotel chain even though the hotel is quite dreary). The hotel, which sits atop one of the high points in Kabul, had been a target for years, most recently as the temporary home of journalists and the diplomatic community. Each of our rooms was marked with bullet holes from the recent conflicts. Given its vantage point overlooking Kabul and its guest list, it's now heavily guarded against attack. Walking beyond the cyclone fences that surround the hotel was considered very high risk for foreigners, and other than ex-pats, a few dignitaries and hotel workers, there wasn't much to see inside. Mike and I did manage to shoot some video footage from the small west-facing balcony in our room. There are beautiful, snow-capped peaks surrounding Kabul and I remember thinking that, under better circumstances, it might look like Salt Lake City. The difference is that a brown haze caused by the burning of large quantities of diesel fuel often cloaks Kabul. The power grid has been destroyed often by soldiers or invaders from all sides, so electricity was and still is a luxury. Those who can afford it use diesel-powered generators.

————

THE NEXT MORNING we were off to the northwest on a ninety-minute flight on an eight seat, twin engine U.N. airplane with two pilots. We landed on a dirt airstrip in the city of Maimana for the start of a journey overland that would include Belcharagh and

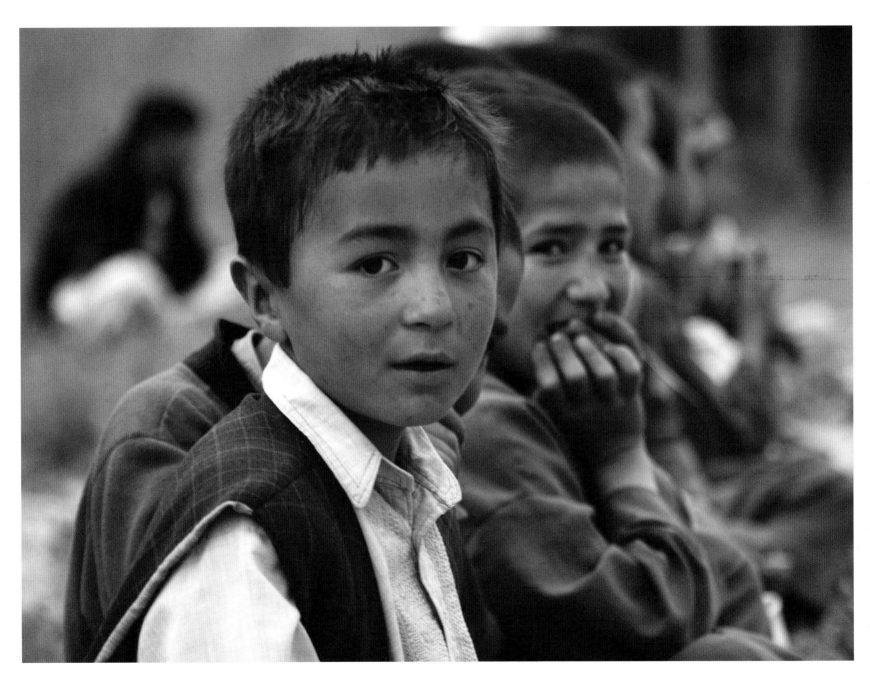

School boys near Belcharagh

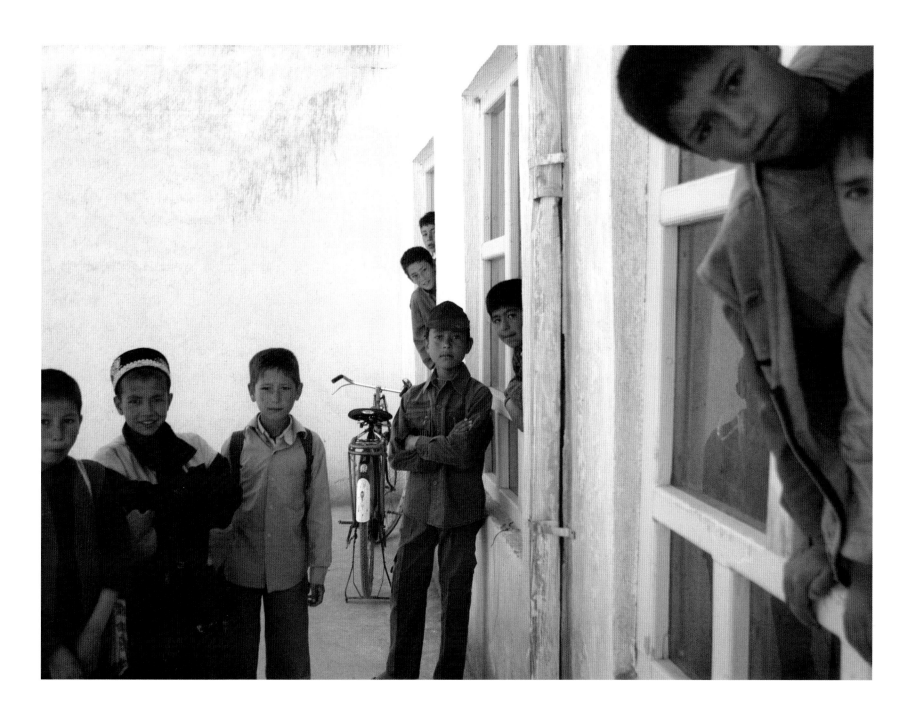

several other remote villages upriver from Maimana as well as Andhoy and Mazar-e-Sharif. During the next week, we drove more than 1500 kilometers in two 4x4s across a barren landscape of makeshift roads on which camels and donkeys far outnumbered motorized vehicles.

In each location, we started by sharing tea with the local official in charge. Most had had little to no contact with Westerners except the occasional NGO worker. Most did not have computers or Internet and with one exception, they had no idea who Ben was or the nature of his celebrity. They were, however, up-to-speed on most things related to soccer. Radio has long been the source for news and information in Afghanistan, albeit controlled by the government, and soccer still manages to unify the nation more than anything except, perhaps, religion. The protocol during each meeting was fairly simple—sit on a carpeted floor, drink tea from a chipped cup infused with a more than ample amount of sugar, then listen to the local official expound for several minutes about how "great" things were going. In some cases, local leaders used our visit to request additional help in terms of humanitarian assistance. Some asked for direct assistance from the United States. The requests would at first lean heavily on the Save the Children staffers with whom they were familiar followed by appeals made directly to Ben (the noted "elder" of our group) or delivered directly to my cameras as if I had live feed to CNN.

The hospitality seemed genuine and with one exception, the officials were especially gracious. On the few occasions we were served food, it was a combination of oranges and a delicious spicy rice dish filled with raisins. Without exception, that same rice

dish was the staple of our meals with the occasional addition of lamb. Breakfast was Nescafé instant coffee or tea with hard-boiled eggs.

After we'd paid our respects and re-explained the documentary nature of our visit, we were off to the tiny villages and private homes where Save the Children had been working for years, including during the reign of the Taliban. Getting from place to place was a lesson in patience and faith. On several occasions, our drivers took us across terrain where there was no discernable road. We also traveled for several miles by driving straight up a low-flowing riverbed. But in each case, they found their way.

The most unique stopover was also the only place on our journey where we experienced genuine tension and uncertainty about our mission. On the day-long trip from Maimana to Andhoy, we passed from a mountain ecosystem into a desert of rolling, treeless hills. Shortly after noon, we could see an oasis in the distance. I remember thinking it looked like something out of an old Hope-Crosby movie because the trees sprang up out of nowhere. There was a source of water, to be sure. As we drew closer, it was clearly a small village that was literally formed from the intersection of two roadways (using the term "roadway" loosely). What may have looked like a Hollywood set from a distance was actually a village more raw, real, untouched, and authentic than any place I'd ever been. The central square surrounded a well and was circled by people who were selling their goods in the hot midday sun. It was, by and large, a friendly place where commerce seemed more important than fighting, religion, or politics. Still, our convoy of two white 4x4s with white flags

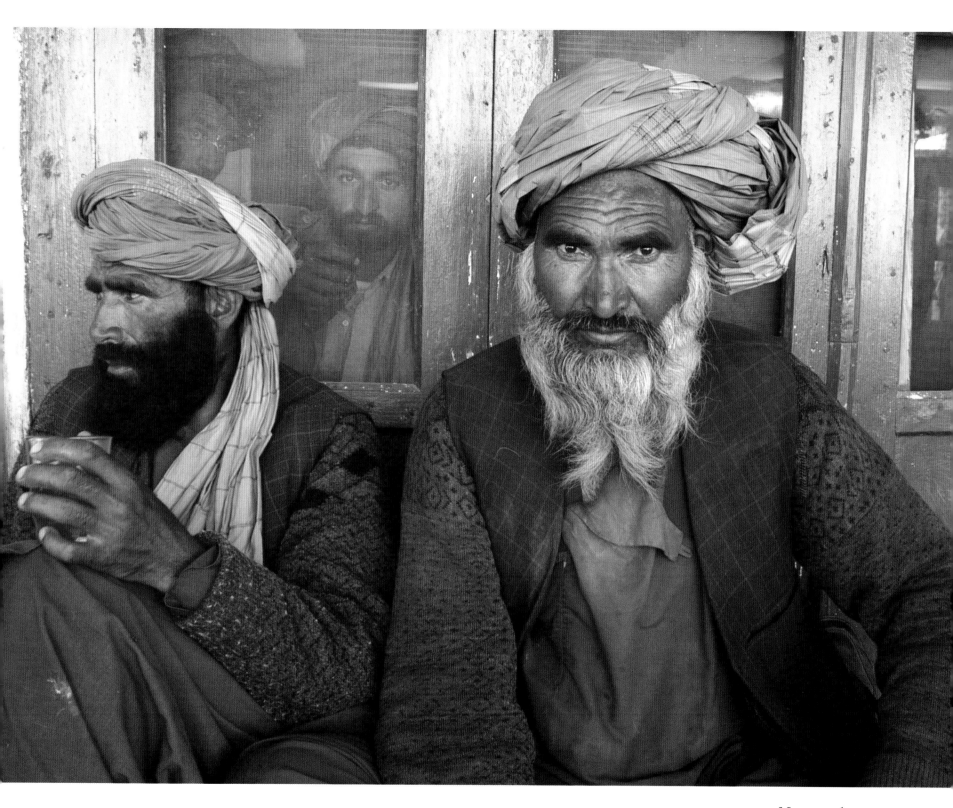

Men at teahouse

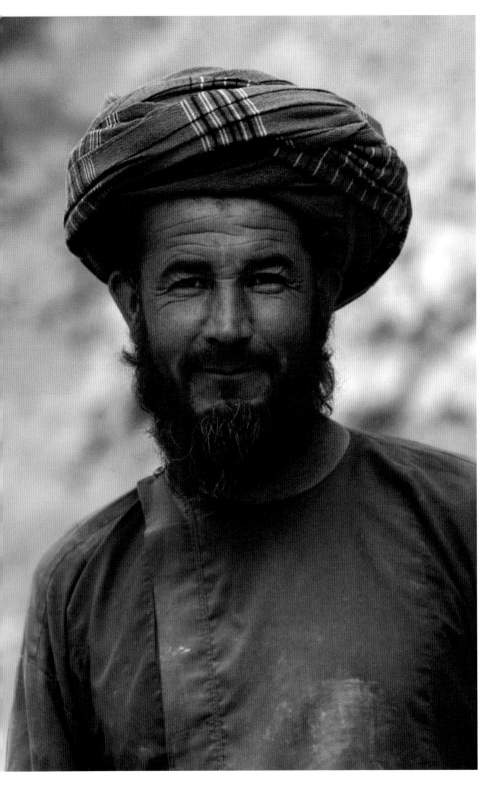

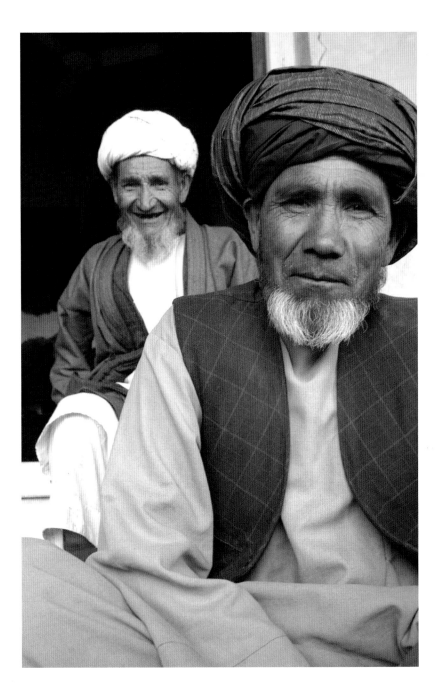

Friendly faces near Maimana and Andhoy

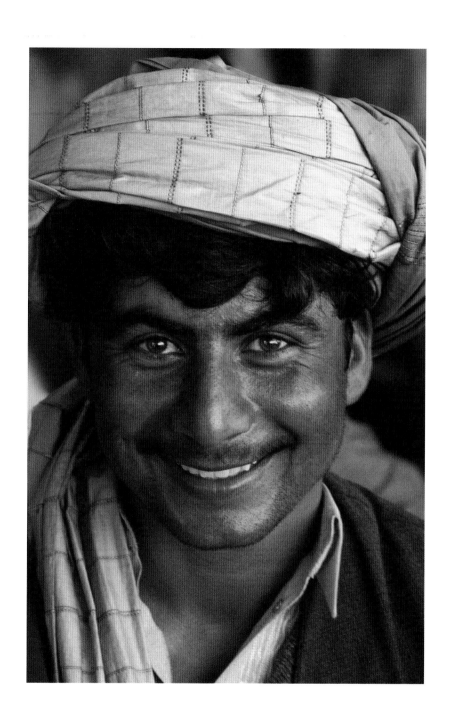
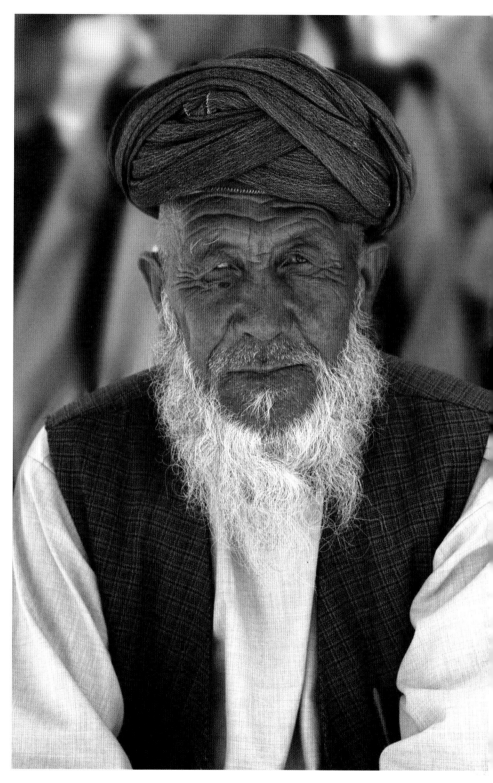

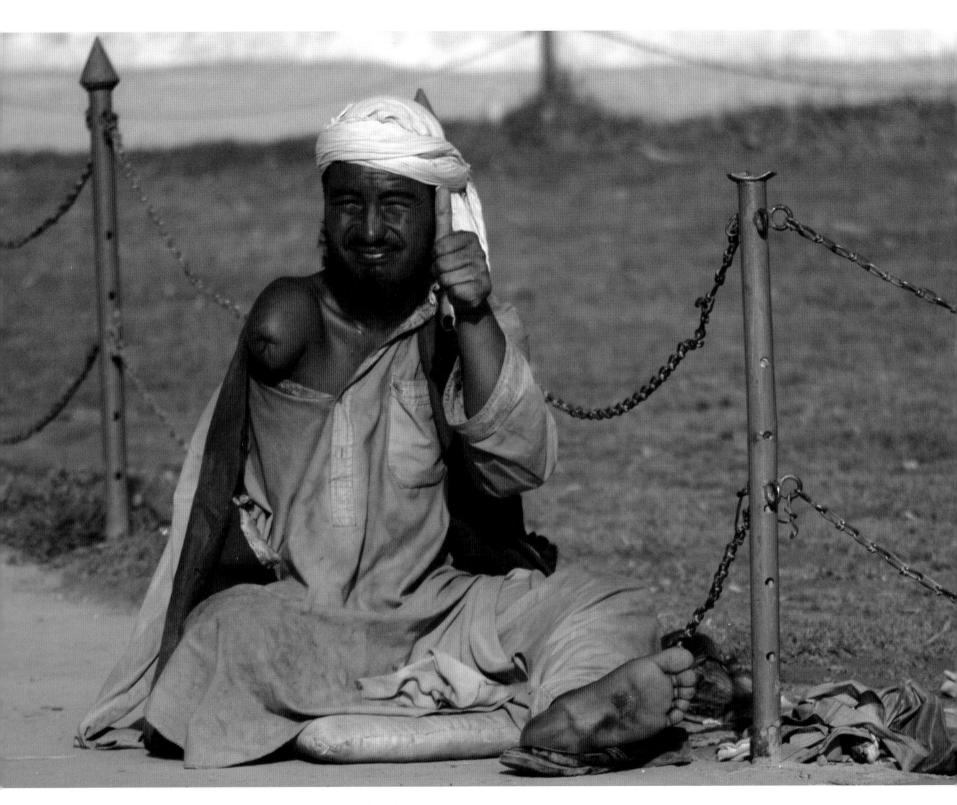

Thumbs up–outside the Blue Mosque, Mazar-e-Sharif

and Save the Children logos was not the norm and we soon became quite a spectacle.

It was lunchtime and our hosts had planned for us to stop here to eat. We parked in front of an open-air tea-house with an outside barbecue pit. The cook was roasting lamb kabobs and the place smelled fantastic. There were long, wide tables along the front of the restaurant with a fabric awning to block the sun. The inside was screened, and most of the forty or so men who were dining were sitting on the tables, their legs crossed. In other words, what I'd mistaken for tables were actually more like platforms or chairs.

Within seconds of stepping out of our vehicles, I could feel tension. It escalated quickly when one of our drivers accidentally locked his keys in the truck. Phil, our lone security guy who'd been fairly inactive until now, was trying to remain cool while surveying the place. He and I quietly discussed one particular man we felt could pose a threat. The fellow didn't appear armed but his body language suggested we were unwelcome. We were conspicuous and were made to feel more so by the universal stares we received. I made a point of leaving my video camera in the vehicle because it creates a stir no matter whose neighborhood I'm visiting. At the same time, it's situations like this that test whatever philosophy we all use to navigate the world. For that reason, I kept my still camera dangling over one shoulder and in plain sight. Like my fellow traveler Mike Speaks, I make it a point to smile and walk with confidence in difficult situations and this location was no exception. I tried to remind myself that I was the stranger—quite likely more strange than anyone who'd passed through in weeks—and that there

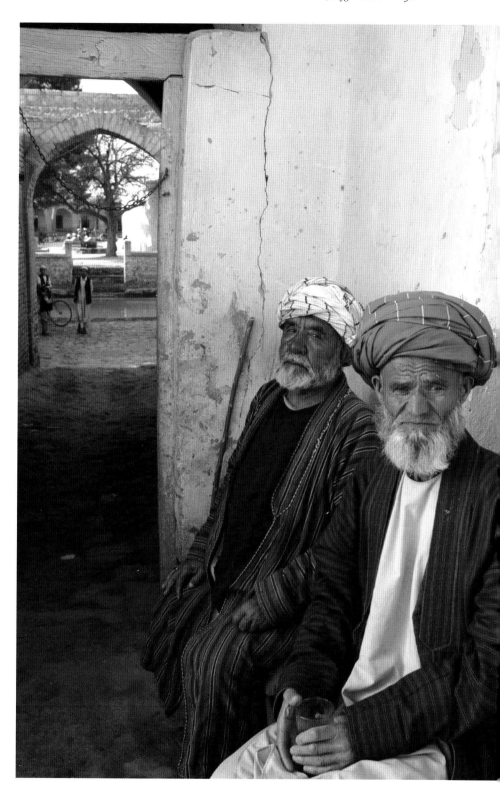

Outside mosque near Maimana

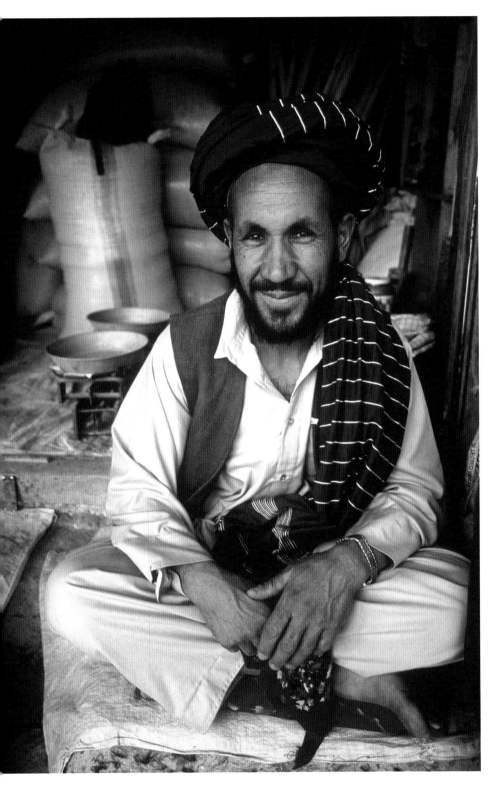

Afghan Merchant

was absolutely no reason for them to trust me. Open body language and gestures of friendliness were the only options we had for creating mutual comfort.

What did make things difficult was that there were no women or children anywhere to be found. Kids are always an ice-breaker but in this case, we had only attitude and good intentions to go on. Complicating matters a bit was that both of our Save the Children hosts were women. They were used to navigating in the male-dominated world of Afghanistan and it was their bold example that we were following. If they weren't going to show fear, how could we?

It wasn't long after we'd sat down that the cook took our order. Within seconds, we had tea, followed almost immediately by a plateful of kabobs. Commerce is commerce. Mike, who'd spent more time in this part of the world than the rest of us, was the most outgoing with the other men sitting around us. He offered a kabob to the most serious looking men in the group and we watched their demeanor change. It wasn't long before we were all sharing a towel to wipe the grease from our hands and clinking tea glasses in a friendly toast. I showed one of the men how my camera worked by pointing it at myself from arm's length, snapping the distorted image and then showing it to him on the digital viewing screen. Their curiosity was aroused and they agreed to be photographed. They sat up straight and posed with the most serious expression they could muster. It wasn't anger or disdain that came through in the photo; it was pride.

Within minutes, several men at the tea house wanted to be photographed if only so they could see their picture in the

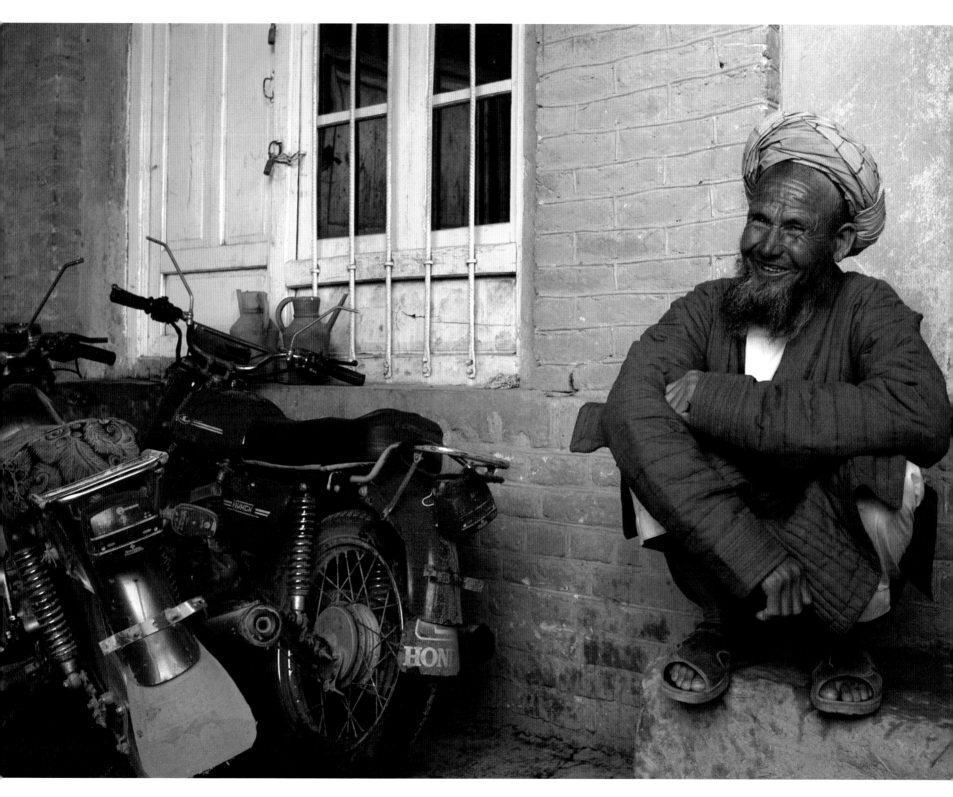

Carpet Seller near Andhoy

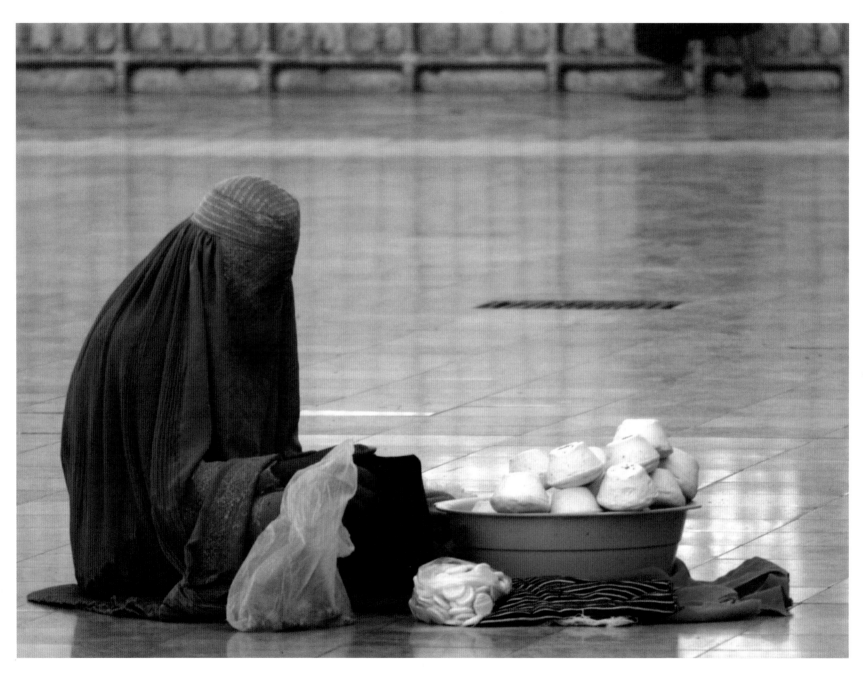

Woman selling soap–Blue Mosque, Mazar-e-Sharif

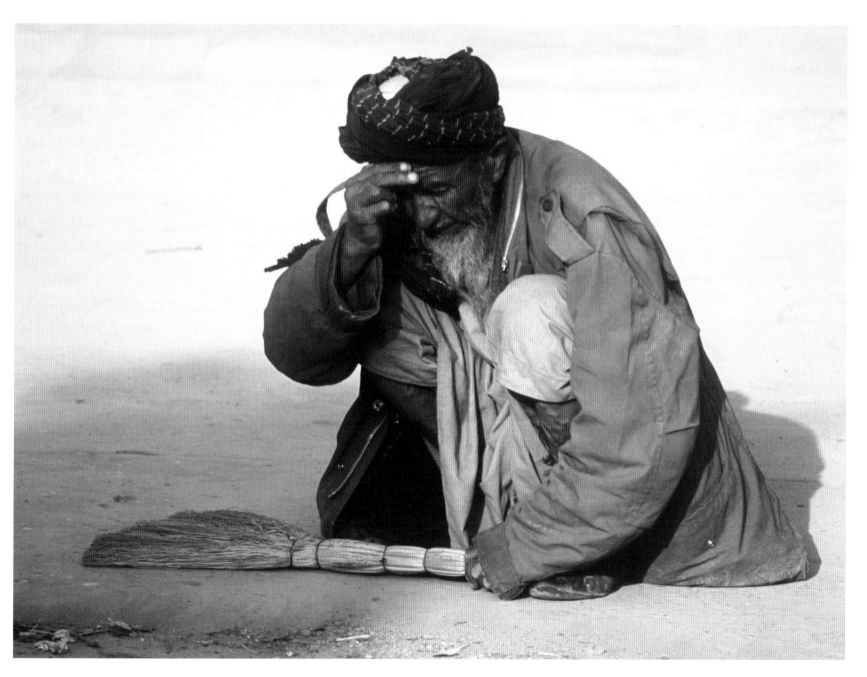

Sweeper praying–Blue Mosque, Mazar-e-Sharif

viewfinder. What had seemed a tense situation that could have turned ugly was, for a few moments, simply fun.

Knowing when to leave is a good thing at any party. So with the keys safely removed from the vehicle, we headed off toward Andhoy.

———

HELPING TO MEET the most basic human needs in a war-torn country presents unusual challenges. In Afghanistan, the scars are everywhere and can't be denied. The roadsides are littered with broken or disabled military equipment dating back to the Soviet invasion and every community is filled with the remnants of homes and buildings destroyed in the fighting. During a visit to a hospital in Andhoy, the main building was nothing but a pile of rubble leftover from a bombing. Doctors were still seeing patients in two adjacent buildings, but their usable equipment was shockingly limited. An old x-ray machine sat idle, waiting for replacement parts. A dentist was working without painkillers or anesthetic. As had been the case in Kabul, electricity was iffy at best. The remote, temporary clinics used by Save the Children in Ethiopia were better equipped than the facilities in northern Afghanistan. Still, it did not stop the doctors or nurses from showing up each day. Some help, they realized, was better than no help.

Then and now, the humanitarian work being done by Save the Children includes building schools, providing nutrition and basic health resources, and teaching hygiene and basic reproductive health. Since the fall of the Taliban, Save the Children has also created training programs for midwives to service the many areas where women have had no adequate maternal care. We were able to document the first graduating class of midwives at a training center just north of Mazar-e-Sharif.

Mazar-e-Sharif, which had been the site of more than a few battles between the Taliban and the U.S.-backed fighters of the Northern Alliance, is a sprawling city of 300,000 that has long been a crossroad for trade and culture in northern Afghanistan. It's as ethnically diverse as any city in Afghanistan. Mazar-e-Sharif is also home to one of Islam's holiest shrines, the Blue Mosque, also known as the *Shrine of Hazrat Ali*.

For most of our travel across the north, we'd spent the night in anonymous guesthouses with little more than simple comforts, such as a pad to sleep on, an outhouse, a small kitchen for heating water and boiling eggs. But during our short stay in Mazar-e-Sharif, we spent the night in a room on the sixth floor of a six story walk-up hotel that was completely unremarkable in every way. The only exception was the friendly hotel manager who made a point of asking what we'd like for breakfast. Our choice included eggs, coffee, and tea. He was kind enough to ask how we'd like our eggs. When we said, "fried" he said, "no, sorry." When we suggested an omelet, he said "no, sorry." Boiled? "Yes, very good." He was pleased we'd finally made the one choice he could accommodate.

It may seem counter-intuitive, but I, like many travelers in war zones, feel safest in a guesthouse. Hotels are such easy targets for anyone with a grudge. But Mazar-e-Sharif didn't feel threatening. The streets of Mazar-e-Sharif were full of activity during our brief stay and most people went out of their way to be friendly. As had been the case in Andhoy, we were free to walk around and to make acquaintances on the street, in the shops, or at the Blue Mosque.

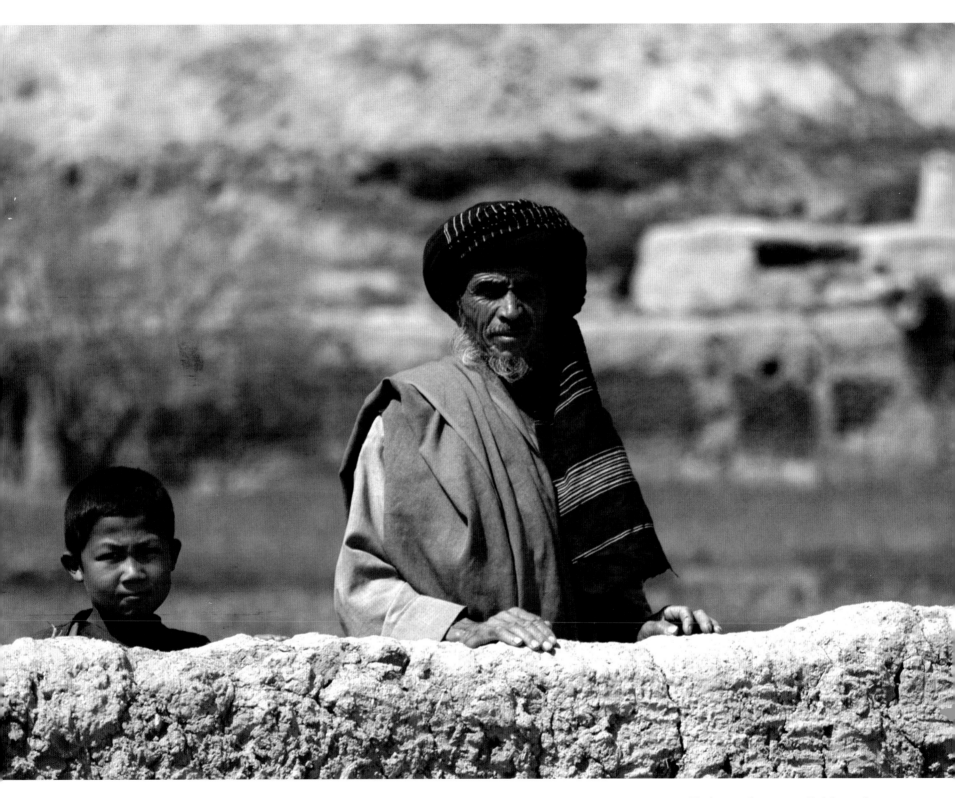

Father and son near Belcharagh

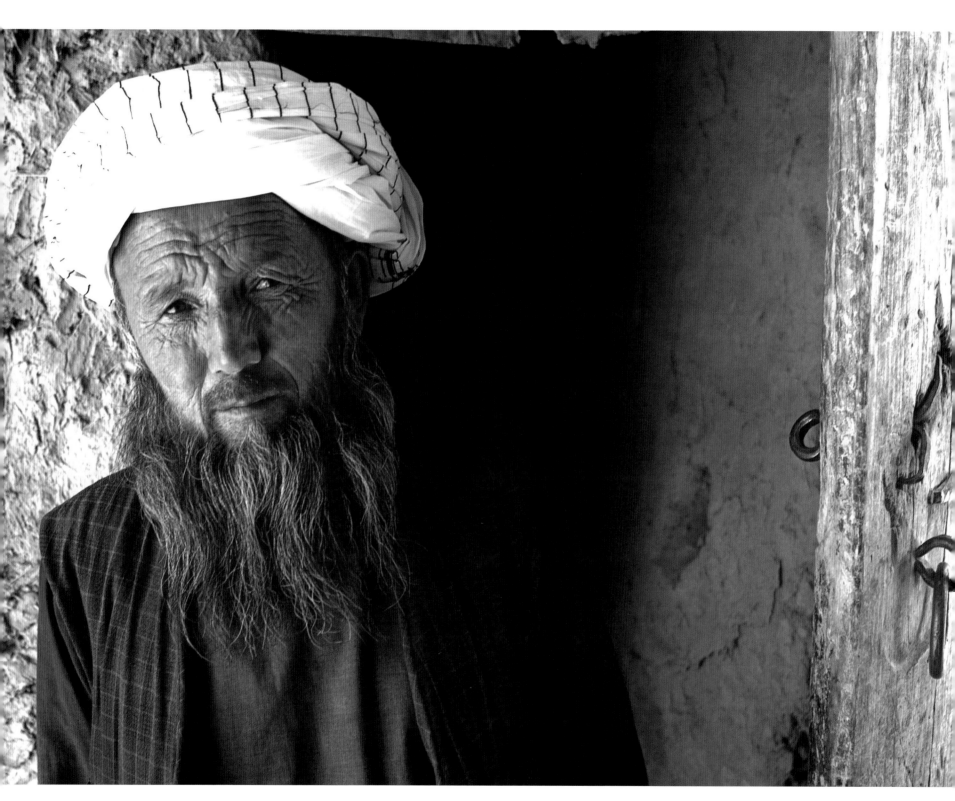

Posing in the shadow—near Maimana

Save the Children had an office in Mazar-e-Sharif which meant there were local workers. It was a chance to meet Afghans who'd been providing humanitarian services for years under conditions few can imagine. At nightfall, our hosts took us out to one of the very few restaurants open for dinner. It was a quiet place but it had the décor of a casino: flashing lights at the entrance, twinkling holiday lights dangling from the trees, an ornate fountain that didn't work and a swimming pool without water. We were told it had been the finest restaurant in the city before the Taliban came to power.

The human scars are hard to ignore anywhere in Afghanistan. Finding a family untouched by the loss of a loved one to an explosion, a death or injury from battle or wounds suffered from a landmine, is nearly impossible. Danger was and is a part of everyday life. During our dinner, I sat next to one of the Afghan workers for Save the Children. While the group ate and chatted, Masood shared his story with me, mostly in a pained whisper. He had lost three brothers during the civil war with the Taliban. With his city in virtual lockdown due to days of street fighting, he and his wife had run out of food for their children. He knew if he went to the market alone, he'd be killed. So he did what may seem unthinkable, he took his 3-year-old daughter with him in his arms. Together, he thought, they'd be safe. There were some morals, he said, even in war. No one wanted to shoot a young girl. He was able to save his daughter's life because she saved his.

Masood's story is not unique. Rather, it's sadly commonplace. For more than thirty years, it's been impossible to avoid the politics or realities of war in Afghanistan. During our visit, we saw considerable progress along with a staggering need for more and

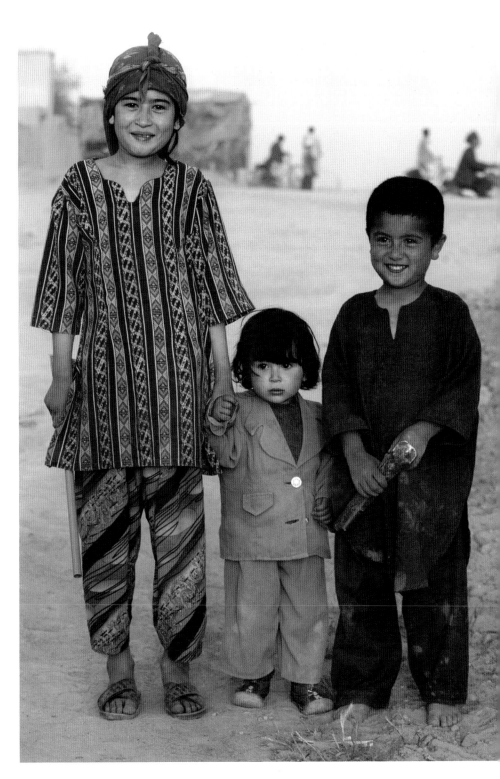

Neighborhood children

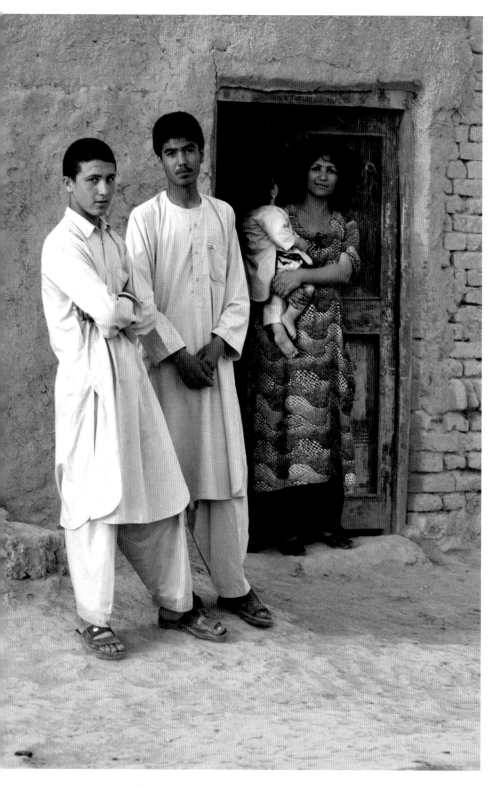

North Afghan family

faster assistance. The extreme difficulties there include massive corruption at all levels of government, a continued insurgency by Taliban and al-Qaeda fighters and a genuine need to overcome obstacles as basic as health care, education, clean water, and energy. Most of all, the challenges to be met that I witnessed while visiting Afghanistan related to both the domestic and international vision for the future. There is hope—ample and abundant—but there's also a tremendous need for a sure and steady movement toward a common goal that creates security, economic independence, individual freedom, and the right of self-determination. What may have seemed a common goal in 2001 was somehow lost and almost insignificant by the time of our visit. Today, the question of what Afghans want and whether it can be achieved remains in flux, as do the politics of American involvement and the alliance that controls the fate of Afghanistan. One needs to look no further than the resurgence of fighting in 2008 to see that previous policy initiatives, corruption, and lack of military focus have thus far led to failure.

Magnifying the predicament facing the U.S. and allied forces is the staggering and ongoing civilian death toll. The argument goes that the loss of innocent lives is to be expected as an occasional, unfortunate consequence of aerial bombing. But many analysts suggest the loss of civilian lives reflects a failure of intelligence gathering on the part of the NATO alliance. In my own experience, it's the result I worry about most. Yes, it's about the loss of innocent lives, but it's also about the changing will of the people of Afghanistan. As we approach a decade of American-led occupation, one has to wonder about the commitment of those

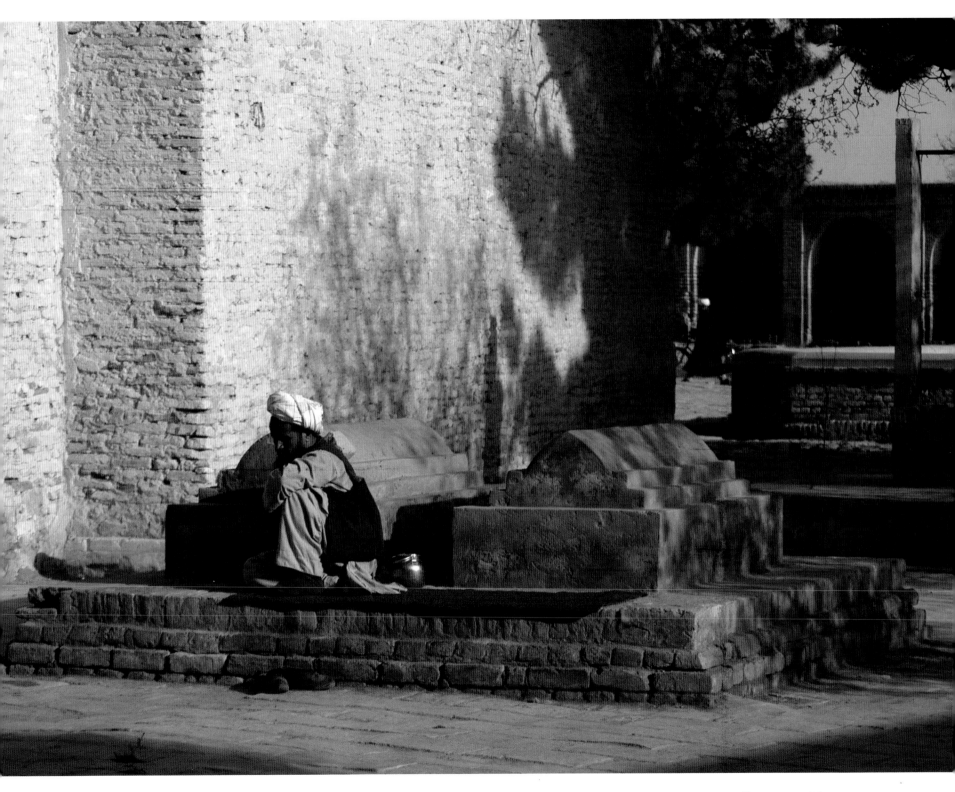

Man reflecting outside mosque

Children at home in north Afghanistan

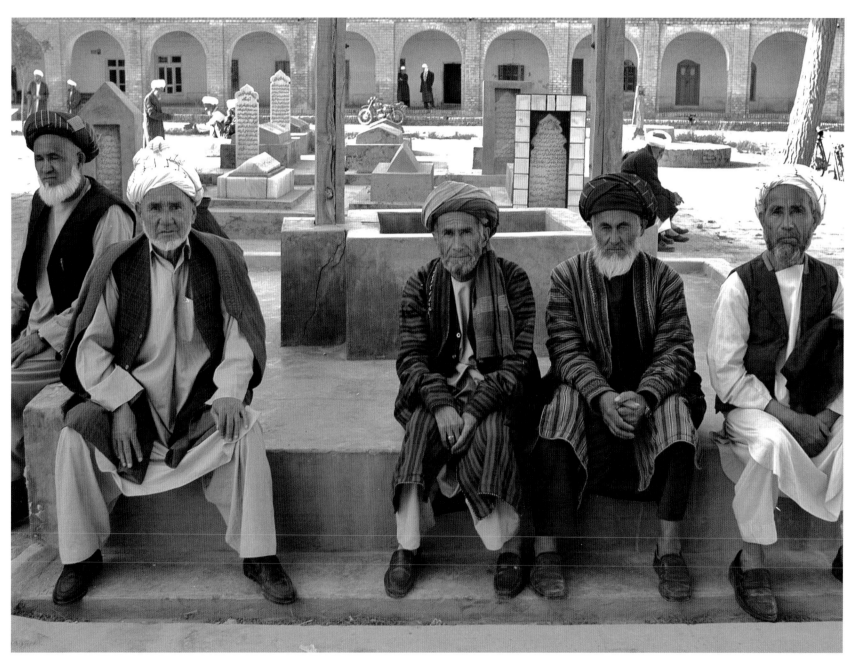

A gathering of men near a north Afghan mosque

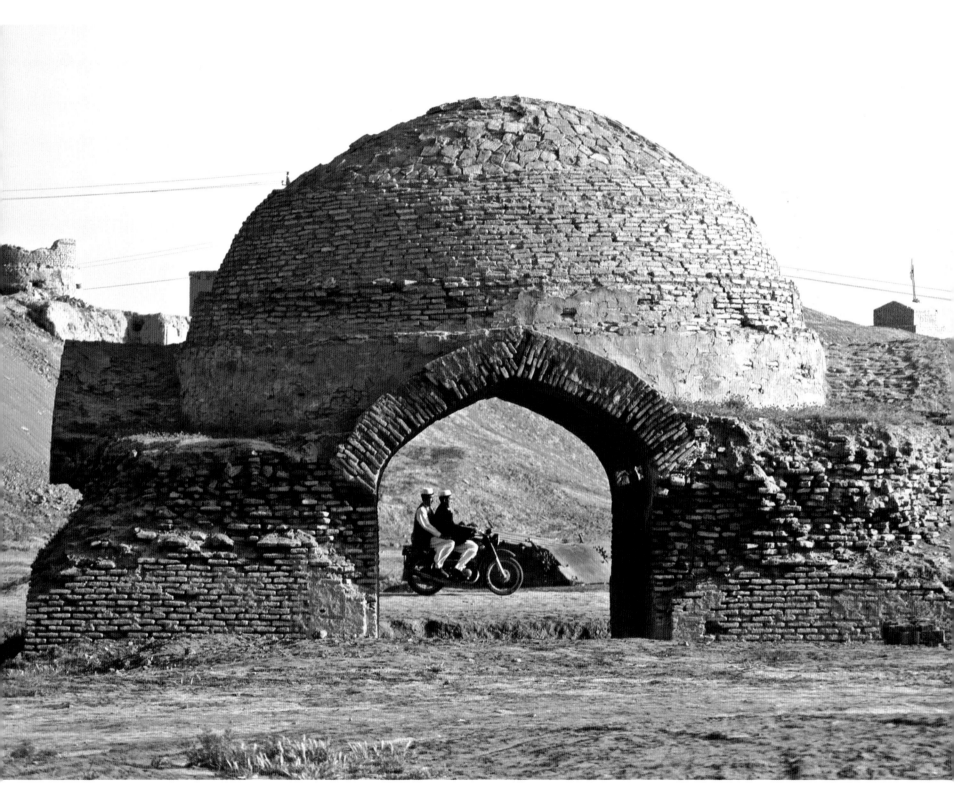

Motorcycle in arch—Andhoy

who've lost innocent loved ones to the fighting. If they can't trust the U.S. and its allies, then where will their allegiance ultimately reside? When and how can the conflict be brought to an end so that self-rule can be restored to the people of Afghanistan?

———

UPON OUR RETURN to Kabul, we were invited to a farewell dinner at the Save the Children offices. The driver who picked us up at the hotel had rigged a beat up cassette machine to his car radio and an old Billy Joel song was blaring so loud the speakers were rattling. It was one of several tapes he and his brother had stashed away for safe keeping during the reign of the Taliban. Playing music was legal again. The driver was excited to share his knowledge about artists like Joel or Pakistan's acclaimed Nusrat Fateh Ali Khan … and he couldn't wait to get his hands on some hip-hop. I've long been a believer in art and music as a bridge toward cultural understanding, and his celebration of the freedom to listen to artists of his choice was, indeed, a signal of hope.

Just a few yards from the Save the Children offices, we stopped to buy our hosts some flowers from a local merchant. His shop was adjacent to one of the only Internet cafes in Kabul. It would be unremarkable except that same Internet shop was blown up just two weeks after we'd departed Afghanistan, killing two people.

———

OUR FLIGHT DIDN'T leave until late on our final day, a Saturday. We headed north once again on a roughly fifty-mile drive to a village near the American military base at Bagram to document the first day of classes at a local elementary school. In addition to our group, we brought along an executive from the World Bank who'd been stationed in Kabul for roughly a year. It was the first time he'd been beyond the city limits.

Save the Children had been instrumental in rebuilding the school and a staff that included women. On the day of our arrival, girls of all ages were attending for the first time since the fall of the Taliban. Most had never attended classes before. As soon as we'd arrived, the ceremony began. Four or five dignitaries made speeches and, although I couldn't understand the language, at least two were clearly not excited that girls would be attending school. Still, they were, and the very last speaker to address the crowd was a 12-year-old named Roshan. In English, her name means "light." She spoke softly, her head barely visible above the podium. Several people in the crowd had tears in their eyes, including a few of the men.

After clearing security at the Kabul Airport, we were sitting in the beat up lounge area. It was crowded and uncomfortable but everyone was making the best of it as we waited for our flight to Dubai on Arianna Airlines, the Afghan-based carrier. Suddenly, there was commotion near the metal detector. It turned out to be a group of Americans from an NGO that was providing wheelchairs to the disabled in Kabul. The reason for the commotion was that two members of the group were not just distributing wheelchairs. They needed them for their own mobility and the security staff wasn't quite sure how to get them through the metal detectors. Once they were inside, I chatted with one of them, a college student volunteer from Philadelphia. He'd been in a chair his entire life and there was nothing, and especially not a war in Afghanistan, that was going to stop him from helping others who needed the same mobility that had enhanced his life.

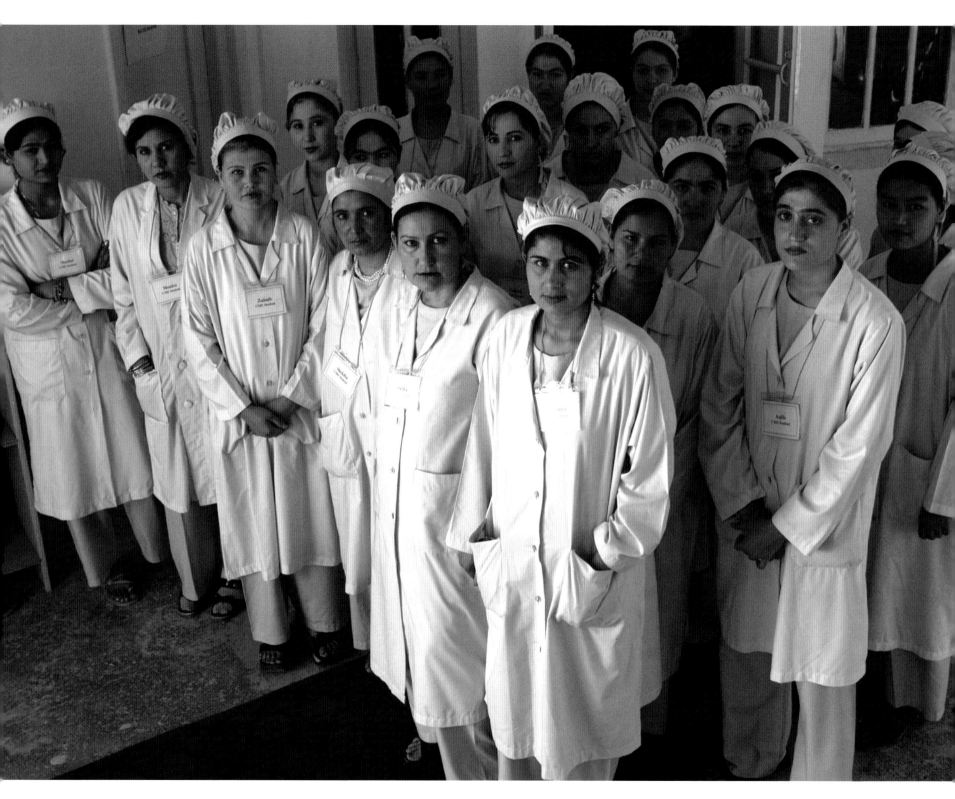

Graduating midwives

DURING THE BRIEF few weeks after our departure, sixteen humanitarian aid workers were killed in Afghanistan. Thirty-one were killed in 2005 alone. At this time, kidnapping and killing of aid workers continues to pose a significant challenge that compromises several NGOs in their ability to facilitate assistance. Save the Children, Doctors Without Borders, C.A.R.E., the International Rescue Committee, and Relief International are among those groups that continue to provide services in Afghanistan, often meeting great need at great risk. From 1997-2005, more than four hundred separate acts of violence were committed against aid workers worldwide involving nearly one thousand victims and more than four hundred fatalities. Afghanistan, Sudan, Iraq, Congo, Chechnya, Palestine, and Somalia are among the more dangerous locations for aid workers.

Finally, as a personal observation that may speak more loudly through my pictures than with my words, I'm a believer, after many years of international travel, in the fundamental goodness of the vast majority of people. We are all both trapped and liberated by our upbringing, our religious beliefs, our education, our life experiences, and our cultural traditions. In any short visit to a faraway place, it's especially difficult to navigate matters of faith and culture. The maps that get us from point A to point B can't help us plot a course through generations of warfare, the nightmare of rape, the devastating hardship of natural disaster or the impact of a life spent in a refugee camp or slum.

The question we must ask ourselves is whether we're visiting a nation in peril to observe and respect what we witness while assisting those in need, or whether we're there to try to force change or push a political or spiritual agenda. My goal, as one

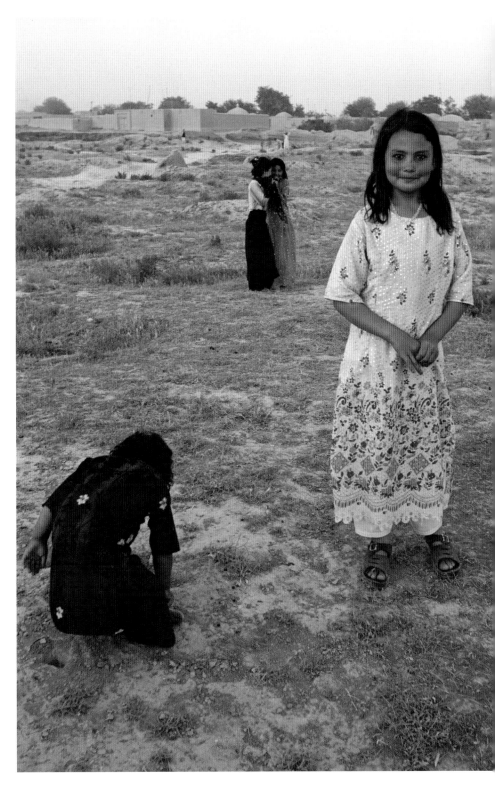

Neighborhood children

born with a well-defined curiosity, is to observe and to learn, to build bridges of understanding and friendship, and to communicate and document what I witness for people who may never have the chance to visit the countries first hand. That was the goal behind our missions to Afghanistan, Pakistan, and Darfur. While it may be contrary to notions often expressed and at times manipulated by political leaders, it's my personal goal to navigate the world without suspicion and fear. My reward in Afghanistan, expressed here in images of hope, was to find so many playful, endearing children, so many loving parents, so many friendly and smiling men. The commitment and perseverance of the workers for Save the Children, many of whom had been working in Afghanistan during the rule of the Taliban, was an inspiration.

Sleeping with the Dead

Pakistan February 2006

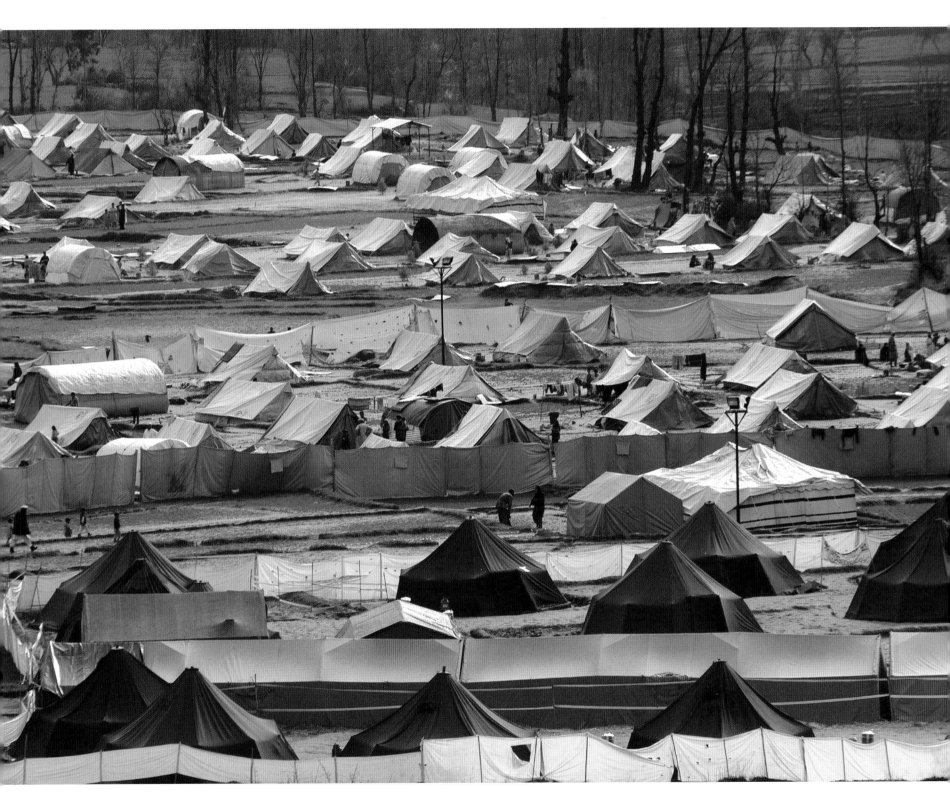

Refugee camp near Mansehra, Pakistan

A Hollywood reception really is as far from northern Afghanistan as one can get. But that's exactly where I found myself during November of 2005 when Dr. Salman Naqvi and I struck up a conversation about humanitarian aid. Salman had just returned from Pakistan where he worked alongside the Relief International team to provide emergency care following the devastating earthquake just a month earlier. Like most Americans, I was well aware of the ravages of the tsunami that had devastated people, homes, and livelihoods throughout the Indian Ocean area just ten months earlier. Like most Americans, I'd watched endless hours of coverage of the tragic hurricane that wiped out much of the American Gulf Coast in late August. Both the tsunami and Hurricane Katrina were huge natural disasters that left millions of people either dead or displaced. And, like most Americans, I knew little to nothing about the earthquake that devastated northern Pakistan.

The easy question is why? Why did the media respond so overwhelmingly to the tsunami and Hurricane Katrina but not to the earthquake in Pakistan? Why were there outpourings of support, even benefit concerts, for both events and nothing for Pakistan? In the case of the tsunami, events happened in and around tourist areas familiar to many Americans. It was a catastrophic event to be sure, and it happened during Western holidays when political news often takes a hiatus. It certainly deserved the coverage and the outpouring of support.

Hurricane Katrina occurred in front of our own eyes—live and in color, 24/7. We knew it was coming, we knew it would be deadly, and we knew, fairly quickly, that too little was being done by our government to avoid disaster. It was both a nightmare to many and a tragedy of errors on our own doorstep. It certainly deserved the coverage and the outpouring of support.

By contrast, events of the early morning of Saturday, October 8, 2005, in northern Pakistan had a tough time making page one, and an even harder time staying there. Perhaps it was because Americans, along with much of the rest of the world, were worn out. Perhaps it was because Pakistan, though an ally by some standards, is an Islamic nation caught up in many Americans' fatigue over and fear about all things Muslim. I don't know the answer, but I do know that Dr. Salman Naqvi, a successful doctor living in southern California, heard the call and made it to his ancestral home just days after the devastating quake. His story was an inspiration and within minutes of meeting each other, we shook hands, confirming our shared commitment to document the aftermath of the earthquake and facilitate fundraising for the ongoing efforts of Relief International.

Pakistan » February 2006

NO ONE KNOWS exactly how many Pakistanis died on or shortly after October 8, 2005, but the numbers are grim. It was a sunny, beautiful autumn morning in and around Pakistan's densely populated Northwest Frontier Province and Azad Kashmir. Most children were in school. Because it was during the Muslim holy month of *Ramadan*, many women and men were still in their homes. The earthquake hit at 8:50 A.M. Registering 7.6 on the Richter Scale (roughly equal to the 1906 San Francisco earthquake), the earthquake was felt as far away as the Afghan capital

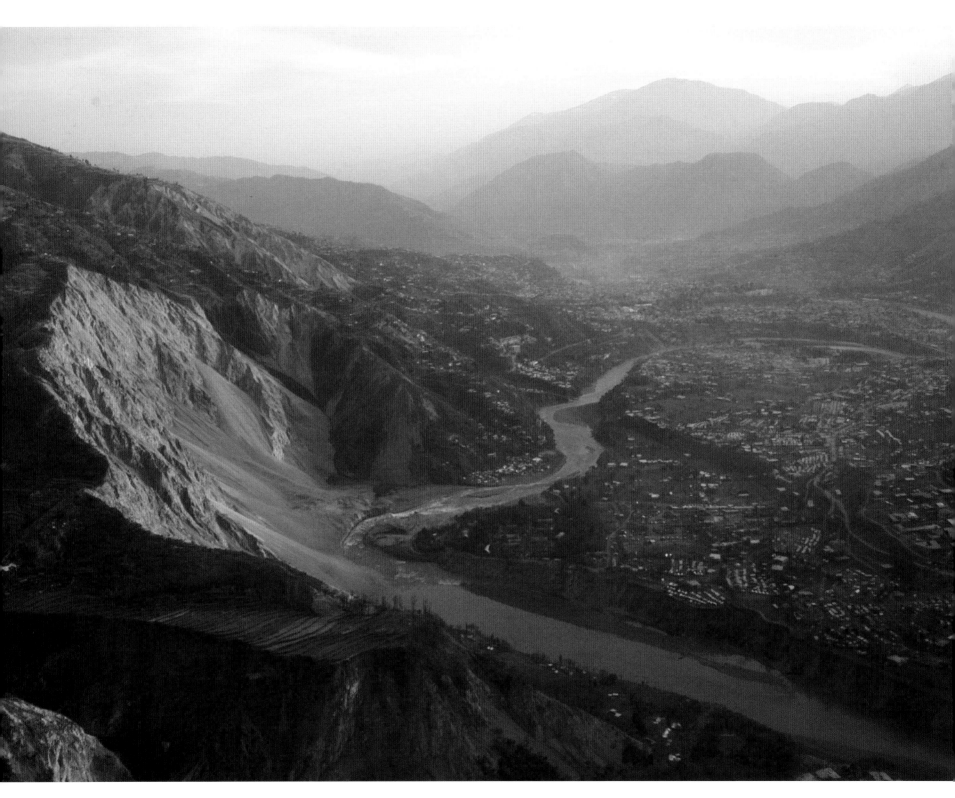

Earthquake epicenter—city of Muzaffarabad

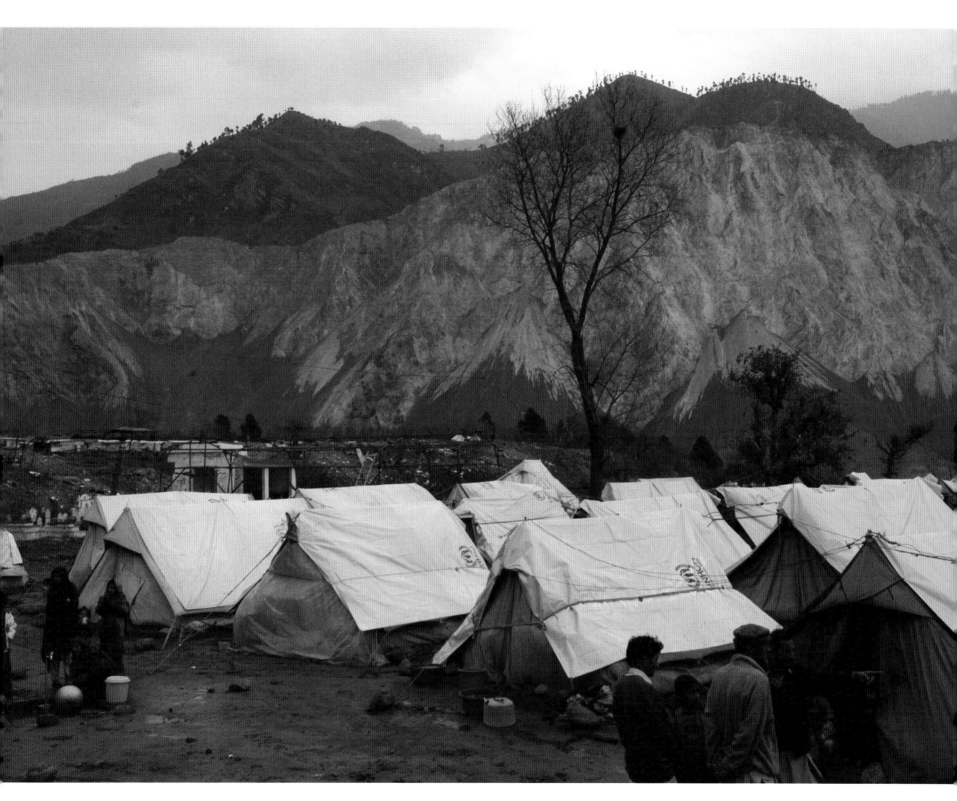

Refugee camp near epicenter

Children in camp near Mansehra

of Kabul. Muzaffarabad, a bustling tourist city in the Himalayan mountains northeast of Islamabad, was the epicenter. In just 85 seconds, schools, homes and businesses collapsed. Approximately 75,000 people lost their lives, among them, an all too-high percentage of women and children. As many as three million people lost their homes and millions more were directly impacted.

AMONG THE MANY international NGOs providing support after the quake, Los Angeles-based Relief International was doing outstanding work in Pakistan. With the help of CEO Farshad Rastegar and Dr. Salman Naqvi, we put together a trip slated for early February 2006. Our mission would once again include actor Ben Kingsley and Mike Speaks. Both volunteered to help document the damage and relief effort and to work on fundraising for Relief International. Ben's notoriety for his movie portrayal of Mahatma Gandhi in the 1982 Richard Attenborough film *Gandhi* would be a plus in Pakistan. In addition, Mike had spent several years living in the area around Muzaffarabad as an international wilderness guide. He knew the area well and had his own business contacts throughout the region. That said, no trip to Pakistan is easy for Westerners and logistics, especially in regions challenged by war or disaster, are often uniquely complicated.

For example, who knew the streets of Islamabad would erupt in fury over a Danish cartoonist's depiction of the prophet Mohammed just days before our schedule departure? Despite weeks of preparation, our visit was postponed for security reasons. Two weeks later, once things had settled a bit, we were off. Pakistan was not considered a war zone but tensions did run

high, especially in the western regions bordering Afghanistan and in Azad Kashmir, which borders India. Conflict was a part of life.

Our landing in Islamabad was marked by new protests as well as new terrorist threats to Western hotels, including the Marriott Hotel where we were camped out during our brief stay in Islamabad. Security was high in and around the hotel and, as had been the case during my stay in Addis Ababa years earlier, security staff checked each vehicle thoroughly before we were allowed to enter the driveway. Before entering the hotel, we were also asked to pass through metal detectors and our equipment was routinely searched. Islamabad, which as the capital of Pakistan is filled with government buildings, has instituted the highest levels of security in the country. Still, random acts of terror are sadly commonplace in Pakistan. Four people were killed during an explosion outside the Marriott Hotel in the city of Karachi just one week after our departure. More than 50 people were killed and 250 injured when terrorists blew up the Marriott Hotel in Islamabad during September 2008. Yes, the same hotel that had accommodated our delegation during 2006 is now completely gone.

———

AS HAD BEEN the case in Afghanistan, day one for our delegation was spent mostly in briefings about security and protocol. In this case, however, our escorts would be both the Relief International team and quartet of Pakistani soldiers deployed by Major-General Farooq Ahmad Khan. Major-General Farooq was a bit of a national hero thanks to his skilled and highly organized supervision of relief efforts following the earthquake. With considerably less money and far fewer resources than those provided

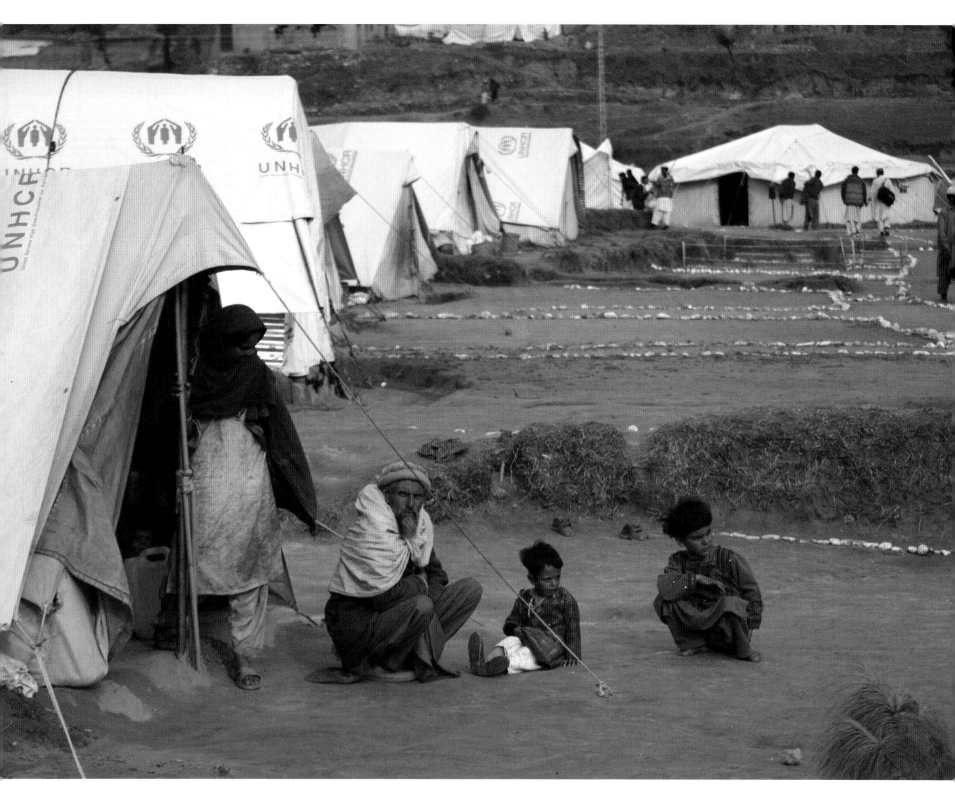

Camp near Mansehra

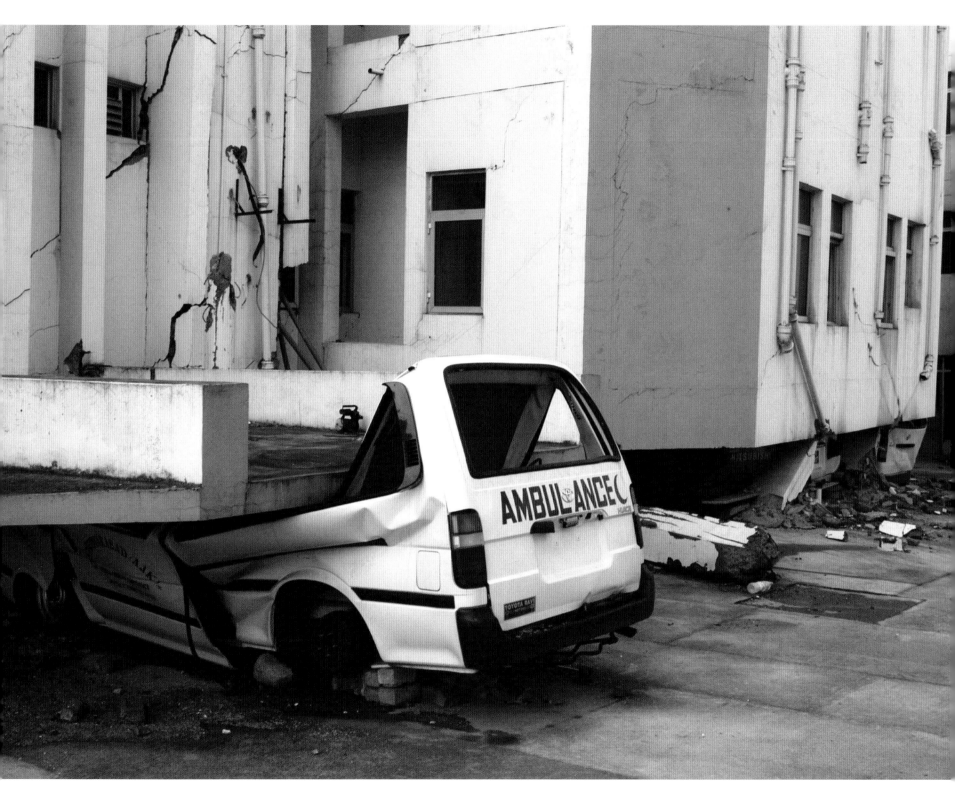

Hospital in Muzaffarabad

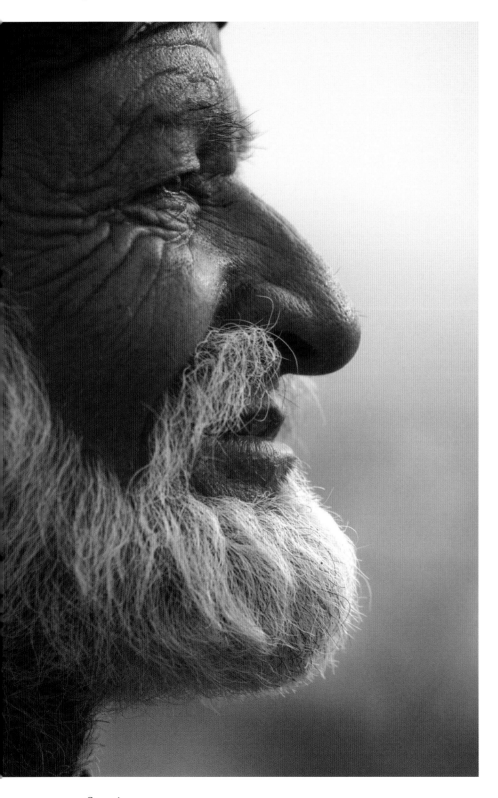

Survivors

during the Asian tsunami or Hurricane Katrina, Major-General Farooq and his colleagues managed operations for scores of international NGOs and thousands of volunteers from around the world as they convened under one common goal: saving lives by providing medical care, food, water, and temporary shelter. Thousands were saved by their quick action and organization.

We also had brief, separate meetings of a more diplomatic nature with then Prime Minister Shaukat Aziz and then President Pervez Musharraf. The meetings were part briefing, part protocol, part friendly effort to allow everyone to rub elbows with everyone else. The meeting with Aziz, whose practical job description was more international business and foreign affairs, took place in Islamabad. The meeting with Musharraf, who maintained his status as both president and general at the same time, was in the adjacent city of Rawalpindi. Although it may seem counterintuitive, the offices housing Aziz were quite modern and stylish (read 'more conducive to meetings with the international crowd'), while the residence and offices of Musharraf were older and more mundane (read 'relate to the common man').

Neither meeting will go down in the annals of diplomacy but it was interesting to witness this awkward teatime with little to do but present gifts and take photographs. In the case of Aziz, he spoke like a man who'd worked internationally for most of his life. Even his accent was almost indiscernible. He was well versed in all things American and European. Most importantly, our half-hour with Prime Minister Aziz gave us a chance to talk up the work being done by Relief International and to reinforce the value of Pakistani government assistance in working with international NGOs.

It was also interesting to spend a few minutes in the presence of President Musharraf. A powerful general in the Pakistani military, Musharraf obtained power in a bloodless military coup in 1999 when he tossed out the elected Prime Minister, Nawaz Sharif. Within two years, he had become America's supposed ally in the so-called "war on terror" until his resignation in 2008. During our meeting, Musharraf was affable but stiff. His body language and upright posture suggested either a man of extraordinary protocol or someone who was managing back pain. Given his age and military background, I'd bet on protocol. He was also surprisingly calm for a political figure roundly despised by so many of his country's citizens and in a nation so overwhelmed by turmoil. I remember wondering what would take priority in his days' work. The battle against terrorists and the hunt for Osama bin Laden in the mountains to the west? Maintaining the security of nuclear facilities? Political battles over the failed judiciary system? The opening of the Freedom Bridge connecting the two halves of Kashmir in the effort to build diplomatic relations with India? Rebuilding schools, homes and hospitals in the earthquake devastated regions? Suffice it to say, a half hour with our delegation must have been like a walk in the park for the president.

Speaking of the '99 coup, Pakistan is not exactly known for stable government and Musharraf's rule was anything but stable. He was forced out of office in 2008 after a prolonged fight with the Judiciary and an outcry from his citizens, especially lawyers. Overcoming instability in Pakistan is tough, in part because Pakistan is a relatively new country making what appears to be a genuine but often failed attempt at democracy. Thanks to the British colonists who'd ruled over what is now Pakistan until

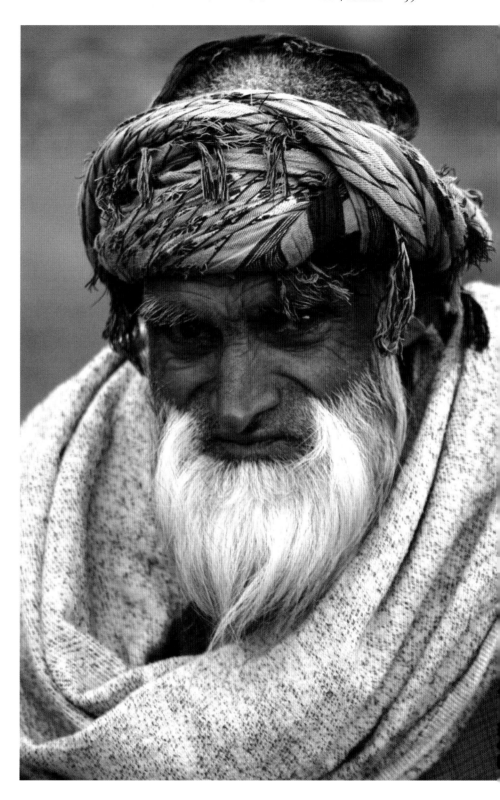

Damaged cemetery near Muzaffarabad

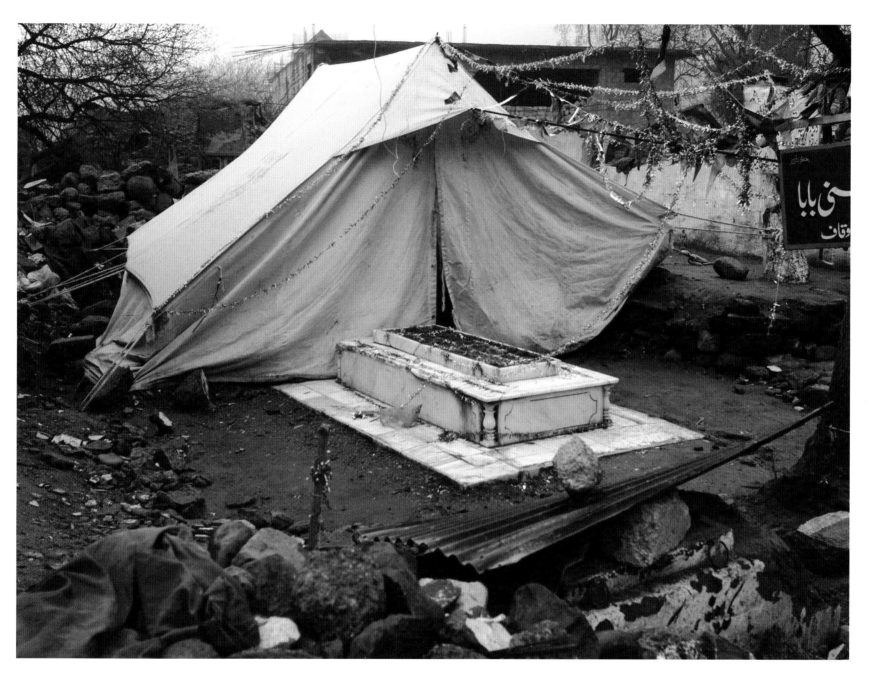

Makeshift grave in city center—Muzaffarabad

shortly after World War II, the lines that make up modern Pakistan are both awkward and arbitrary. The short version of the story is that Mahatma Gandhi, Jawaharlal Nehru, and Muhammad Ali Jinnah (along with millions of lesser known freedom fighters) were among the leaders of the movement for independence from the British in the 1930s and 1940s. But the goal of dividing the Indian sub-continent into separate nations presented enormous challenges based on ethnicity, culture, language and religion. It wasn't easy for people then and it's not easy now.

Still, in mid-August 1947, they achieved a version of their wish along with all the complications, whether intended or not. The Indian sub-continent, under British domination for approximately 200 years, was divided into Pakistan and India. What was then called East Pakistan achieved full independence in 1971 (with the aid of India) and is now called Bangladesh. When I say complications, I'm referring, mainly, to the decision to divide several key provinces including Bengal, Punjab and Kashmir under the authority of Pakistan or India instead of one or the other. The result is that none of the three nations have ever been completely satisfied with their boundaries or the division of the provinces. Ethnic and religious tensions remain along with disputes over natural resources. More than a few wars have been fought since partition, including years of ongoing battles in the Himalayan mountains of Kashmir, often across glaciers at more than 15,000 feet in elevation!

Additionally, between 500,000 to 1 million people died during the partition alone. By some estimates 2 to 3 million more are "unaccounted for." The American Civil War, the deadliest conflict in American history, resulted not in separation but in unity. By contrast, the division of the Indian subcontinent resulted in separation and independence, at a staggering cost to human lives and property. It involved the largest migration of people in human history. An estimated fifteen million people moved from their homes to be part of whichever nation they perceived would best protect their religious beliefs. Some went willingly, but many went because they were terrified of what would happen if they didn't relocate. More than seven million Muslims moved from what is now India to Pakistan. More than seven million Hindus and Sikhs moved from Pakistan to what is now India. During the migration, millions of people lost their lives, their livelihoods, their land, their possessions, and more. Families then and today remain divided by border crossings. And tensions among the three nations remain high.

Pakistan, which was created as a Muslim state and has a Muslim constitution, became a republic in 1956. Zulfikar Ali Bhutto (Benazir's dad) ruled as a civilian from 1971–77 when he was disposed by the military under General Zia ul-Haq. But he wasn't just deposed, he was also hanged after the Pakistani Supreme Court ruled four to three in favor of execution (he had been charged and convicted of killing the father of a dissident politician in 1974). To the chagrin of many, General Zia imposed *Sharia*, an Islamic legal code. General Zia died during a midair explosion on a military aircraft in 1988. Voters in Pakistan then elected their first female Prime Minister to lead the country, Benazir Bhutto. Bhutto was also the first elected leader of a Muslim state. The Oxford-educated Bhutto and Nawaz Sharif bandied power back and forth through the 1990s before Musharraf took power in the '99 coup.

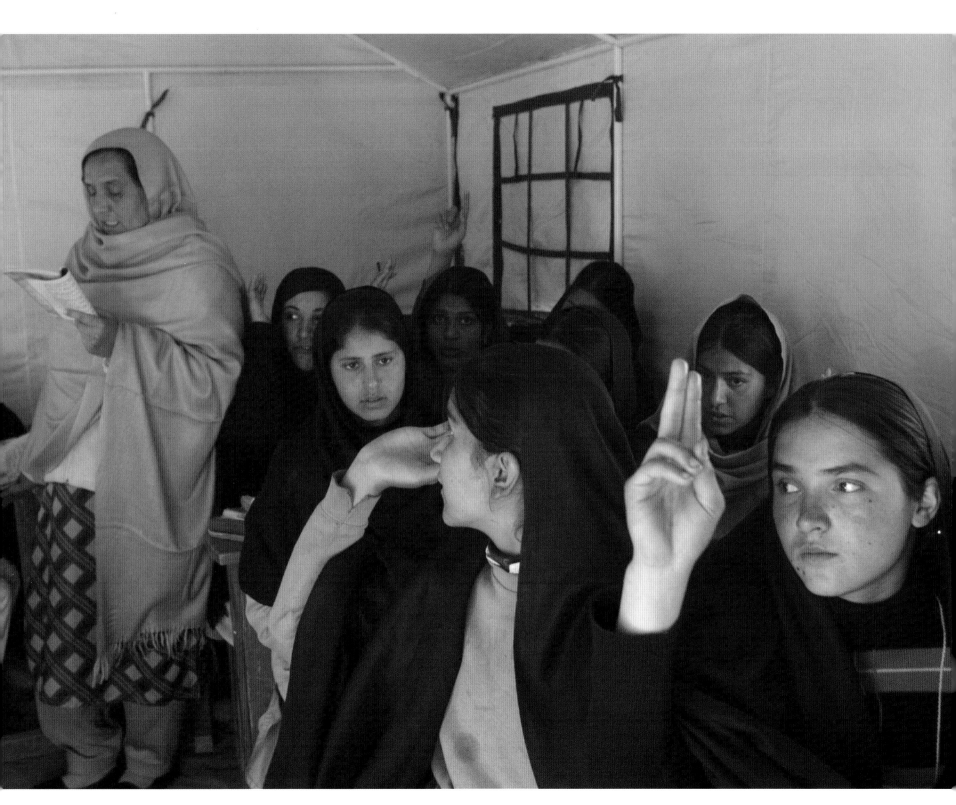

Temporary school room in Azad Kashmir

Eid Day memories among the rubble

Recent history doesn't bode much better for real democracy in Pakistan. Benazir Bhutto, who was challenging Musharraf and others for the presidency, was killed in an assassination attempt while running for office on December 27th, 2007. The exact cause of her death remains in dispute. Her husband, the controversial Asif Ali Zardari, was elected in her place during 2008.

——

UNLIKE THE CHALLENGES facing Afghanistan or Darfur, two man-made crises fraught with policy and human rights issues related to war and genocide, international politics played little to no role in our mission to Pakistan. After two nights at the Marriott, we were off by car to the city of Mansehra on the outskirts of the most heavily damaged quake areas. We stayed at a Relief International guesthouse in Mansehra that had survived the earthquake. It was our home for all except one night of our journey into the devastated areas.

During the next week we visited refugee camps in and around Mansehra; most housed many thousands of displaced people. We witnessed the complete devastation of Balakot, a city the government has since decided is too far gone to be rebuilt. And we spent a full day and night in the nearly uninhabitable city of Muzaffarabad. A once-thriving community of roughly 90,000 people and the administrative capital of Azad Kashmir, Muzaffarabad was laid to ruin. Entire mountainsides had crumbled, houses were torn off hillsides and both the Jhelum and Neelum Rivers were diverted in places due to massive rock and mudslides.

Complicating matters was the typical rain, snow and cold of a Himalayan winter at high elevation. Most people were living in tent camps supplied by the government, the U.N., and various NGOs, some in communities above 10,000 feet. By the time we arrived, the tent camps were operating much like cities with temporary schools, temporary mosques, temporary clinics, and a smattering of start-up commerce with a black market in everything from food and clothing to auto parts and wheelbarrows.

As a former television news photographer, I'd witnessed devastation before, but nothing on the scale of the Pakistan earthquake. Roads were impassable. Bridges were gone. Hospitals had crumbled. Schools were reduced to piles of mud, brick, splintered wood, and metal. Homes were split in half, framed by jagged cracks several meters wide or crushed beneath the weight of an unsupported roof.

A few miles from Muzaffarabad, I spent more than an hour walking in and at times climbing over the rubble of a village near the epicenter of the quake. I'd been told that shortly after the quake, widowers would spend long hours combing through the rubble, searching for remnants of lives lost so abruptly. They would search for hours, alone, wandering. On this day, months after the quake, I could see two men walking alone, separated by hundreds of yards, lost in their thoughts. What were they thinking? I wondered. How did they cope with the sudden loss of a wife, a child, a father, a mother? What meaning were they searching for? What hope could they find living in a tent, their possessions gone, livelihood lost, their family a memory? What comfort did they find in returning, day after day, to the rubble of their former homes?

I sat on a painted green slab of cement. The cold began to sink in as rain washed away whatever energy was left from generations of memories. There were no recognizable structures, just

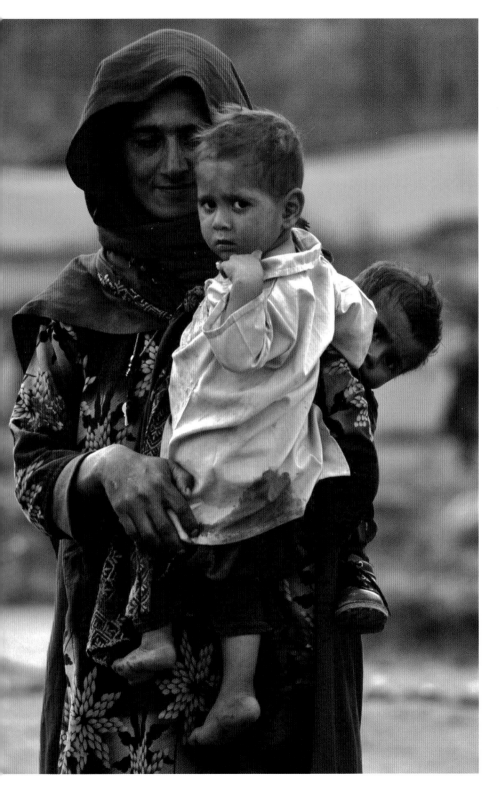

Mother and children in camp near Mansehra

piles of rubble sprinkled with personal possessions—a broken plate, a random shoe, a wedding photo, a bent headset, a crushed child's toy, a holiday card celebrating Eid Day. Life had stopped abruptly in the middle of a beautiful Saturday morning four months earlier.

WHILE STAYING OVERNIGHT in Muzaffarabad, we booked rooms at the only hotel still standing. I use that term "still standing" loosely because while the hotel had a couple of rooms for rent, they did not have hot water and the electricity came from a gas-powered generator. I've stayed in too many bad hotels, but this wasn't bad, just unusual. When Mike and I walked to the door of our room we couldn't help but look to the right and left down the long hallways. On each end, the walls were missing completely. It was a cool winter night and a slight breeze was blowing the thin plastic sheeting taped and stapled to the abrupt ending of the hallway. The sides of the hotel had crumbled and been swept into the river. The balcony overlooking the river, a feature that had drawn tourists to the hotel for a generation, was also gone. Our room had a small space heater, a broken shower, and walls that wore the deep cracks of the earthquake. With the cracks in the ceiling and the dribble of rain finding its way inside and along the walls, we unplugged the space heater, opting instead for the one safe decision we could make.

As we toured by road and in a helicopter provided by the Aga Khan Foundation, it quickly became clear that virtually all of Azad Kashmir and the Northwest Frontier Province hadn't fared much better than Muzaffarabad. Every time a seemingly intact building would catch our eye from a distance, we'd find, on closer

inspection, that it was cracked and sagging beyond repair. In some places, makeshift graves had been constructed, in others existing cemeteries had been unearthed or ravaged by deep crevices carved through the broken earth. Paved roads were pot-holed and cracked; gravel roads were sloping off hillsides, most impassable. Most schools were gone, and most hospitals had been too damaged in the quake to provide any kind of emergency support. Hundreds of doctors, nurses and teachers had been killed. During a stop in Balakot to survey damage, we interviewed two teenage sisters, Sadia and Rabia. They'd been in their three-story school when the quake hit. Feeling the first tremor, Rabia's teacher had yelled at the students to run for their lives. The teacher, along with 325 of the 450 students, died instantly under crumbling slabs of concrete.

We visited hundreds of recently turned graves watched over by widows and widowers with lost expressions. What does some-one do today, this day and the next, when their home and family are suddenly gone? We watched very young kids playing in the rubble of Balakot and the refugee camps in Mansehra, their world too new for the devastation of the earthquake to seem like any-thing more than an adventure. And we met other children, usu-ally somewhat older, sitting alone, still in shock. Their limbs had healed, their head wounds were gone, but their hearts and souls were scarred forever.

At a distant camp in Azad Kashmir, our entourage toured a school where the buildings had fallen, the walls and ceilings in rubble. Relief workers had helped get things back to normal with makeshift classrooms under blue tents provided by UNICEF. Several of the students greeted us with a song and the principal

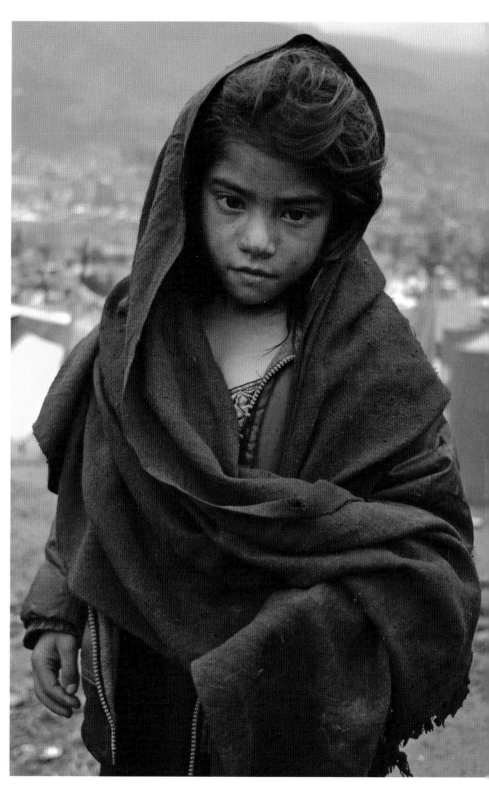

Displaced by the earthquake—near Muzaffarabad

Sadia and Rabia in the rubble of their schoolhouse—Balakot

Earthquake damage

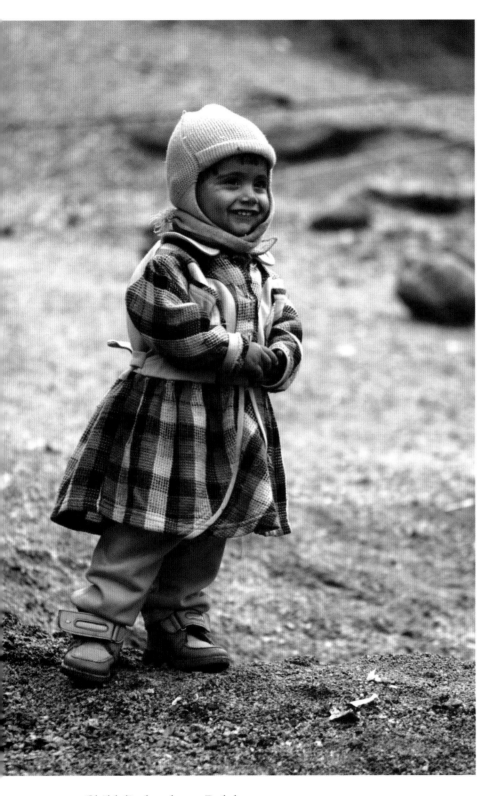

Child displaced near Balakot

did all he could to provide tea and hospitality on the lawn near the debris of the fallen school building. As I filmed the students and teachers in several tents, everything seemed normal in so many ways. Good kids, hard at work learning math, English, writing skills and studying the *Quran*. But I noticed one young girl who sat outside the tent on a rock pile. She was alone, wearing a stocking cap and a dirty sweatshirt with her Mickey Mouse book bag. She was watching the classroom as if she wanted to be a part of it but wasn't sure how to fit in. Perhaps uncertain what to make of my intentions, she watched me photograph the classroom with intensity but without a definable expression.

Then, for the first time in a week, our group separated as if circumstance dictated we follow the beat of the village. Ben and Mike moved from tent to tent with Major-General Farooq, inspecting the progress of a community working to overcome the challenge of a fallen schoolhouse. At the same time, I decided to sit down next to the girl. That was it; we just sat. And sat. Dr. Naqvi and his colleague Laila Karamali stood near a new cemetery a hundred yards away, giving comfort to a widow who shared her grief. After about twenty minutes, I stood up to leave. Before going, I motioned to her with my camera, my little pantomime request to take someone's picture when we can't speak the same language. She didn't respond either way—no affect, no expression. I sat back down about two feet away. When I raised my camera, she offered a flat but forward look straight into my lens. If it's possible for two people to speak clearly to each other without talking, we did. I took her photo. For reasons I can't quite articulate, I couldn't find a way to include it here. It's as if she was

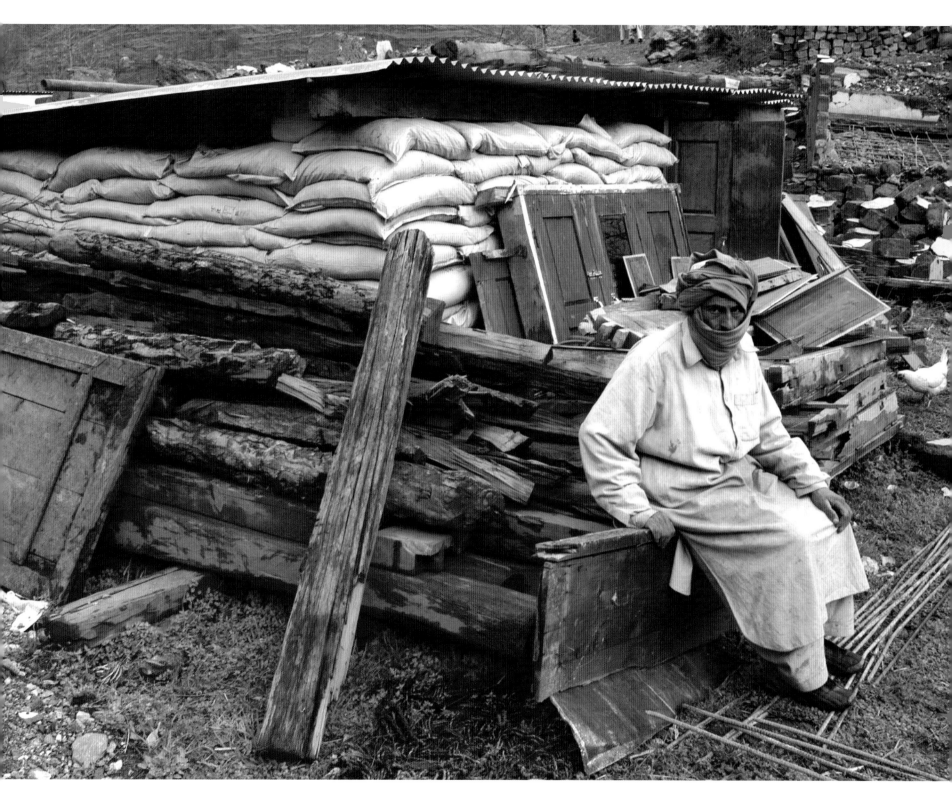

Makeshift shelter—Northwest Frontier Province

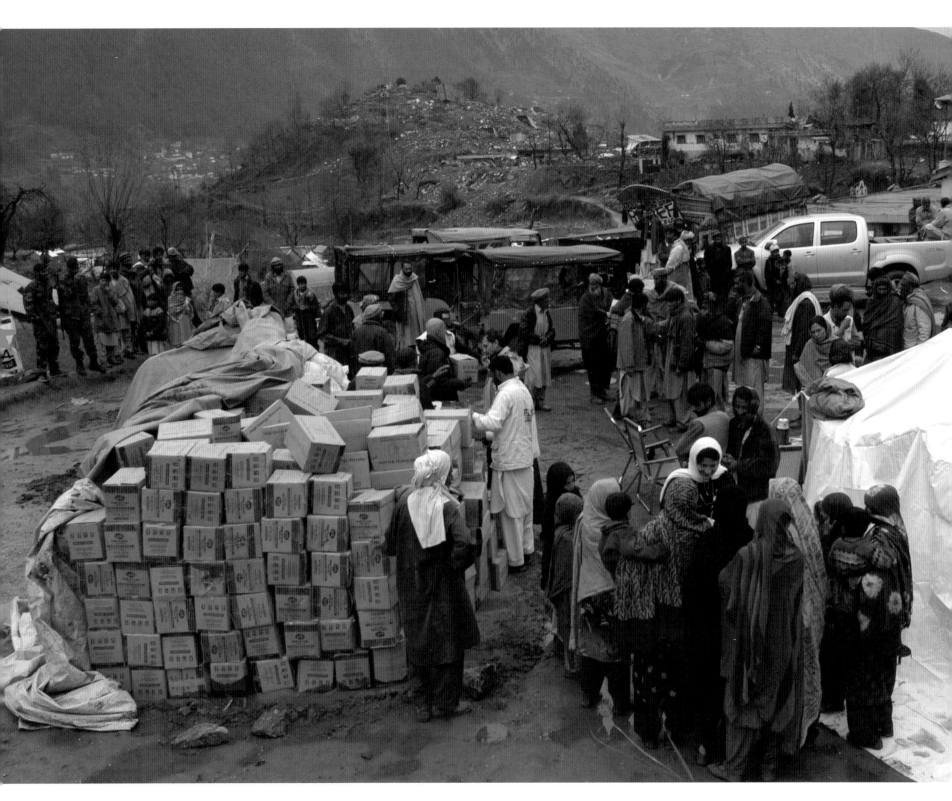

Food distribution in Balakot

letting me make the picture to motivate my own hope, rather than capture her lack of it. I have it framed and hanging near my office desk. She looks at me every day, a reminder of who's out there and how it's going. Sometimes better, sometimes worse.

———

DURING OUR VISIT to various camps, I was impressed by the vast number of NGOs operating in the field even without significant resources. Many were familiar, such as Oxfam, Save the Children, Relief International, and Doctors Without Borders, among others. But what was equally impressive was that both Saudi Arabia and Cuba had sent in fully equipped medical teams and had set up tent clinics. In the case of Cuba, they were still operating a full clinic months after the earthquake and, wisely, they were well staffed with female doctors. Given the traditions of Islam, many injured women refused to be treated by male doctors at the time of the quake. Among the nations that responded, Cuba had no previous diplomatic relations with Pakistan. They have since opened an embassy in Islamabad.

———

IN THE REFUGEE camps during our few days in Pakistan, I photographed Dr. Naqvi at work alongside the team from Relief International. We were a very long way from that reception in Hollywood. Laila was a trained social worker and she attended to many who expressed their grief in a quiet, disarming way. Both Laila and Dr. Naqvi have family in Pakistan and both felt a strong sense of responsibility to be there. It was, for each, their second time visiting the quake zone in less than four months. From a practical standpoint, relief efforts had shifted from emergency care to long term care and the needs were different. Even in the

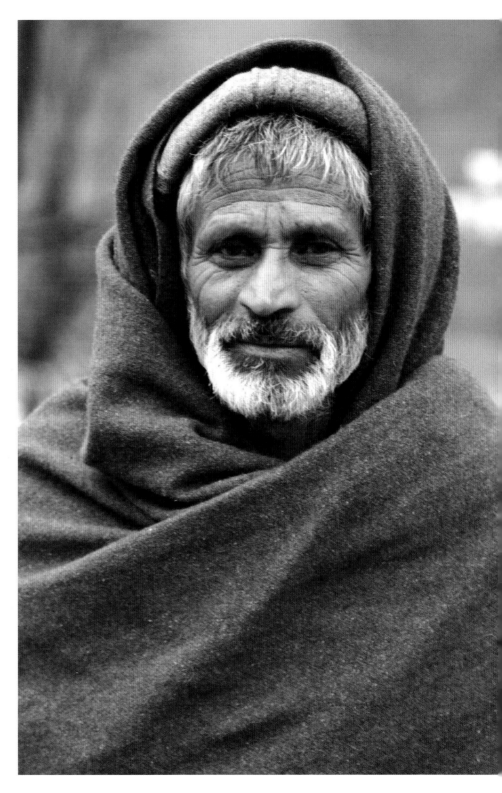

Friendly face among those displaced by the earthquake

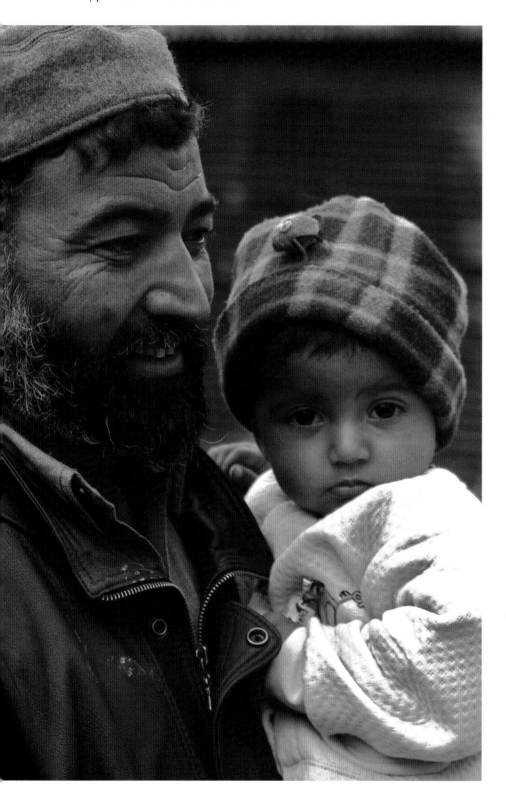

middle of winter, efforts were already underway to create the resources people would need to rebuild and relocate back to their villages. That took the form of developing micro-loan programs, replacing livestock, rebuilding schools and hospitals, and constructing temporary, earthquake-resistant shelter.

Like many NGOs that responded to the call, Relief International had been in the field every day since October 8. The disaster created a need far greater than any single aid group could handle and, unlike the huge financial outpouring of support for victims of the tsunami and Hurricane Katrina, the resources were limited. Comparisons to other disasters and the global response may be inadequate in telling the story here. Suffice it to say that much of the world missed this one.

THE PHOTOGRAPHS SHOW the destruction and devastation following the earthquake, nearly four months after that horrific day. Since that time, much has been accomplished in helping the victims of the earthquake return to some level of normalcy. Prior to the quake, the people of this region, though often poor, were well educated and had a bright future. The infrastructure, especially roads and schools, were fairly good before the quake and much has been restored. It was also an area well known for its dislike of America and American foreign policy related to Afghanistan and much of the Middle East. Emotional, political, economic, religious, and philosophical ties to members of the Taliban and al-Qaeda are considered significant in this region.

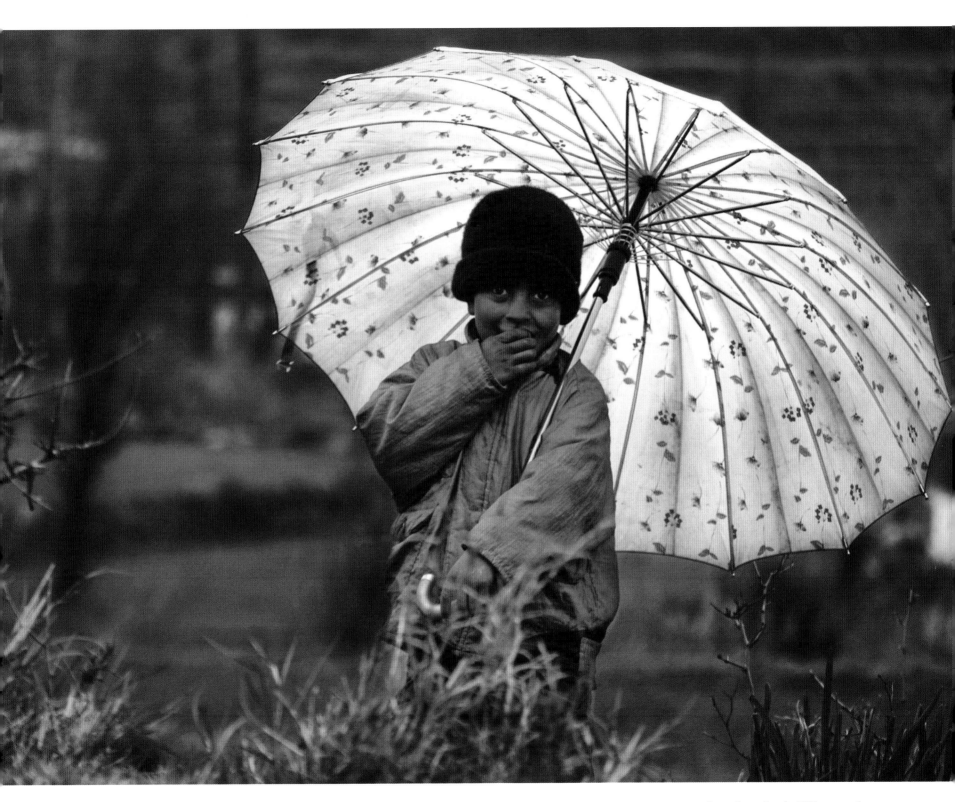

Survivor in the Winter rain

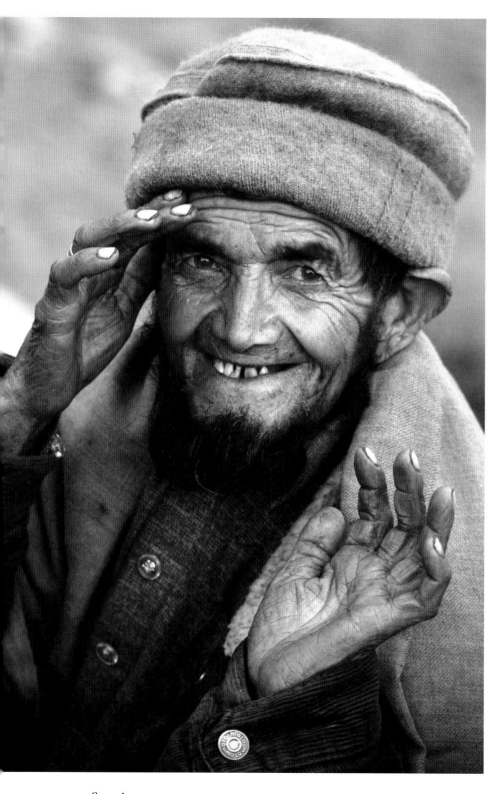

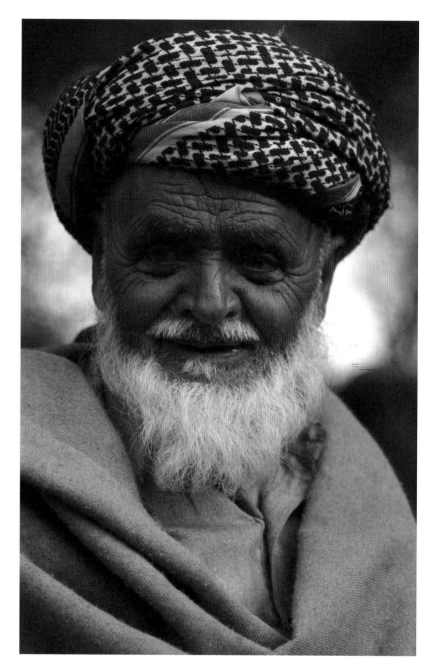

Survivors

It's worth noting that shortly after the earthquake, American helicopters, many deployed from Afghanistan, flew into the Northwest Frontier Province bringing food and medical supplies. In all likelihood, their route took them directly over villages in the mountainous areas that U.S. forces claim are harboring al-Qaeda. Still, they were, for the most part, welcomed with open arms by the victims of the earthquake. Though some might argue that the U.S. response was not enough, the aid was warmly received as was the equally important symbolic gesture of compassion. In that moment, the people of northwest Pakistan were not the "evil doers" and America was not the "evil empire." Providing aid was the right thing to do, and while it may not have been the intention, the diplomatic impact was significant.

During our visit, we too were greeted warmly by everyone we met. What happened in Pakistan could happen anywhere and the gesture of support, compassion and kindness goes a long way toward humanizing those with whom we may appear to have little in common. I will never forget my colleagues in Pakistan—Salman Naqvi, Laila Karamali, Gulnaz Zohrabbekova, Ben Kingsley, and Mike Speaks—in all the moments when they held the hand of an orphaned child, embraced a widowed farmer, or nursed the physical or emotional wounds of women who'd lost their family and their livelihood. All our differences simply melted away.

Land of the Fur

Darfur 2007

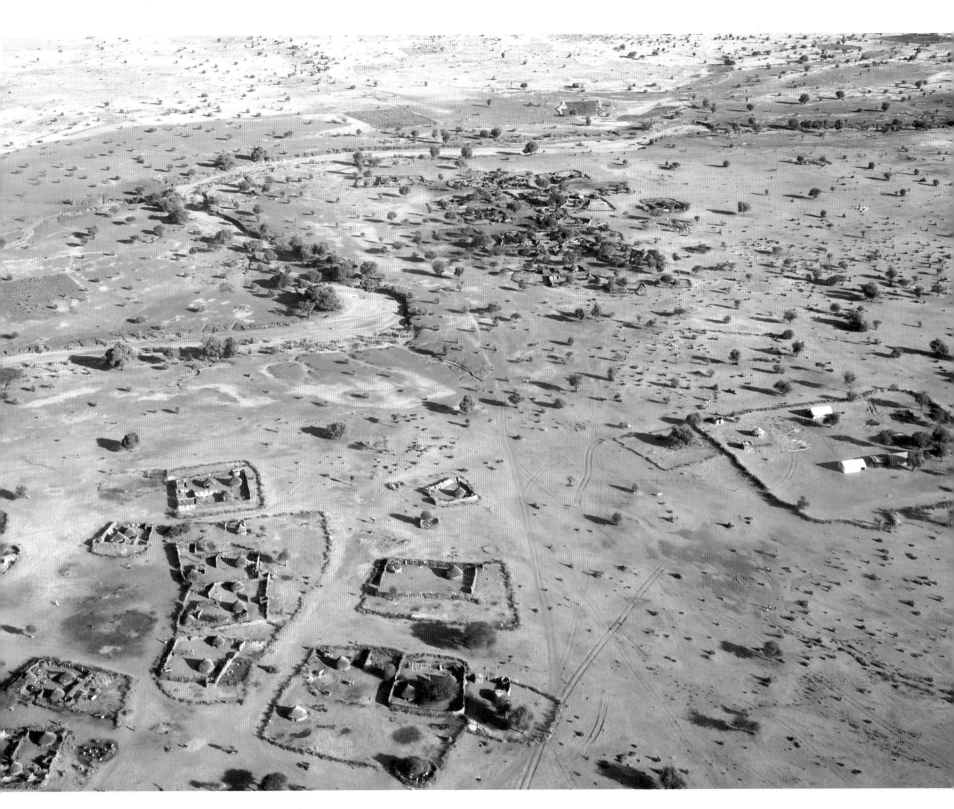

Aerial view—village in North Darfur

Nairobi, Kenya » 2007

Sometimes things just take an unexpected turn. Such as, say, heading off to document genocide in Sudan and traveling via Kenya just as Kenya is erupting in post-election turmoil of its own. I'd prepared myself for Sudan, read up on the struggles in Darfur, and prepped for the sort of low profile life required for survival in a war zone. I was traveling as lightly as possible, had stocked up on anti-malarial pills, bought the perfect new pump for purifying water, purchased a few gifts for my hosts, and left behind a beautiful Midwest winter for the heat and desert winds of Sudan.

Nairobi was supposed to be a safe haven en route, a city where I'd worked previously and established friendships. In general, I'd found Nairobi to be a pleasant enough place and, by most standards, safe (although it may deserve its reputation for street robbery). On previous visits, I'd spent time photographing in Kibera, one of the largest slums in Africa, and had developed a fondness for both Kibera and the city at large. But when I arrived on New Year's Eve, the city was in a virtual lockdown. Riots had erupted two days earlier when the incumbent president, Mwai Kibaki, had allegedly rigged the results of the December 27th presidential election. Many election officials and international observers were supporting the claims to victory of his challenger, Raila Odinga. The violence that erupted reflected anger over the results, but it was more than that. Kibaki is Kikuyu, Odinga is Luo, and the two tribes have been at odds for years. The Kikuyu, which account for roughly 22% of the population of 37 million, have been the ruling party in Kenya since Jomo Kenyatta overthrew the colonial power (yes, Britain) to create an independent nation in 1963. The Luo represent roughly 12 percent.

In much of Africa, when colonial powers reverted government control to the locals, they did not leave the country. Rather, they continued long standing trade and commerce in an effort to make maximum use of the infrastructure and resources they'd developed. Doing so meant continuing to nurture long standing relationships with the people who were assuming power. Class systems that had developed during colonialism often continued with the new rulers. In the case of Kenya, resentment between the Luo and Kikuyu can be traced back to the establishment of Kikuyu power during the independence movement from Britain. Despite Kenya's reputation for relative security, the violence and protests that began after the late 2007 presidential election were not a new phenomenon. In fact, Oginga Odinga, father of the rival leader Raila Odinga, had squared off against President Jomo Kenyatta a generation earlier with a similar outcome.

By the time I arrived in late December, several people had been killed in the fighting and police had imposed a nationwide curfew. My flight in on KLM was nearly empty since most tourists were fleeing the country, not heading in. I'd booked myself at a hotel I'd used previously and the hotel driver was there to pick me up on arrival. After an eerie drive though an empty city, I got to the hotel just before midnight. Any New Year's celebrations I might have anticipated a week earlier were cancelled, along with reservations for most of the hotel guests.

I was slated for two nights in Nairobi before heading on to Khartoum and then Darfur. After a couple of weeks in Sudan, I was supposed to head back to Nairobi for two more weeks of work on a separate film project.

On New Year's Day, I contacted a close friend, Salim Amin, son of the famous African photojournalist Mohammed Amin. Salim is among the most prominent journalists in Nairobi and he invited me to join him in his coverage of the riots and post-election turmoil that had gripped the entire nation. We spent the day with several bureau chiefs and foreign correspondents traveling from ministry to ministry for press conferences and making occasional passes near Kibera, the slum where most of the opposition was taking refuge. The day was uneventful in Nairobi, but the level of tension was extraordinarily high. By mid-afternoon, there were reports that 45 children had been murdered in a church fire in the northwest city of Eldoret, a massacre eerily reminiscent of the atrocities in Rwanda in 1994.

I'd given up my news photo career years earlier but it wasn't long before the adrenaline kicked in, and there was a stable of news photographers everywhere. Still, I was nothing more than an observer and after a full day on the town, I headed back to the hotel to prepare for my flight to Sudan. The wounds between the Luo and Kikuyu were long and deep and there were rumors everywhere that the conflict might escalate into full blown civil war. As my new year began, I remember sitting in the peace of my hotel room pondering whether to stay on as a working journalist in Nairobi or continue on to Darfur as planned. Things were complicated further when reports surfaced that a U.S. diplomat had been gunned down in his car on a city street in Khartoum.

It was only the second killing of an American diplomat in Khartoum in a generation, but it put all NGOs on immediate alert, including Relief International.

After a phone conversation with the RI offices in Los Angeles, I made the decision to continue on to Sudan. On a purely practical level, it had taken weeks to obtain my travel visa and reissuing it for another time would be difficult. Any official interaction with the Sudanese government is delicate at best. It was clear that nothing would be resolved quickly in Kenya and if the danger for Americans increased in Sudan, I could always catch a flight back to the chaos of Nairobi.

Darfur, Sudan » 2008

SIX HUNDRED PEOPLE a week. That's how many displaced people were arriving in the Zam Zam refugee camp near Al-Fashir, Sudan during my visit to North Darfur in early 2008. And that's on top of the estimated 40,000 people who were already there. And that's just one of many refugee camps in Darfur and along the western border with neighboring Chad. The numbers challenge comprehension and defy explanation.

On this square mile of deforested planet earth called Zam Zam, displaced women, men, and children who have lost everything are forced to find a way to survive every day. Water is a problem, food is a problem, and leaving the camp to find firewood for cooking, an occupation that so often falls to women or adolescent girls, can literally lead to rape or death. The land itself is bleak and desolate, a flat plain prone to heat waves and flash

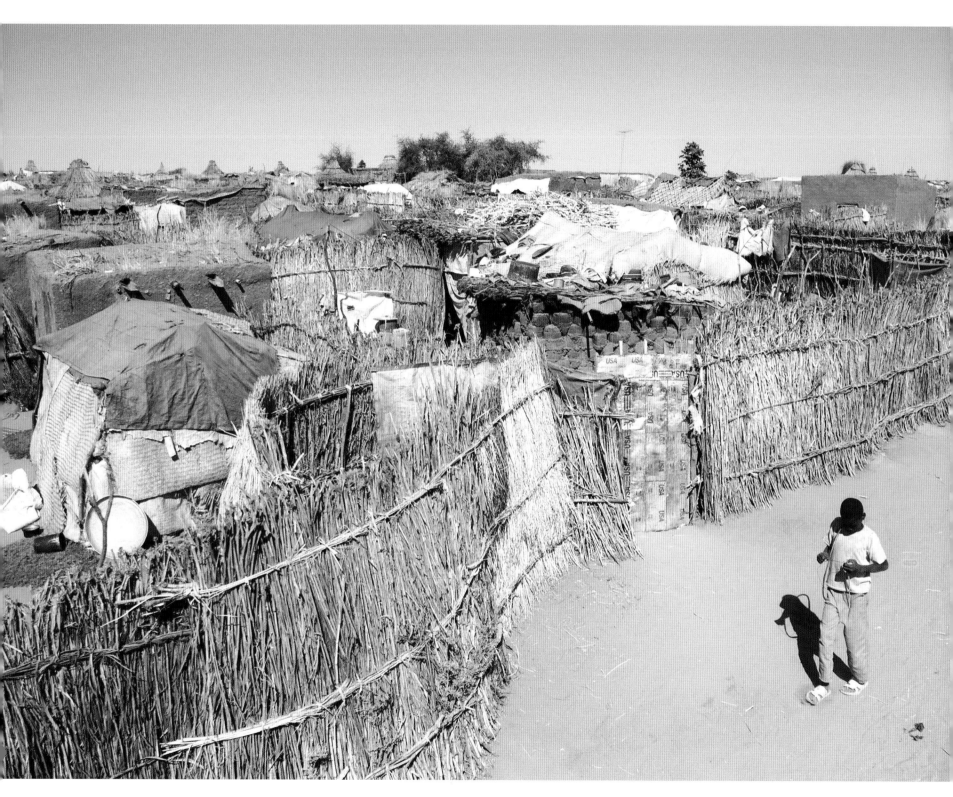

Zam Zam Camp

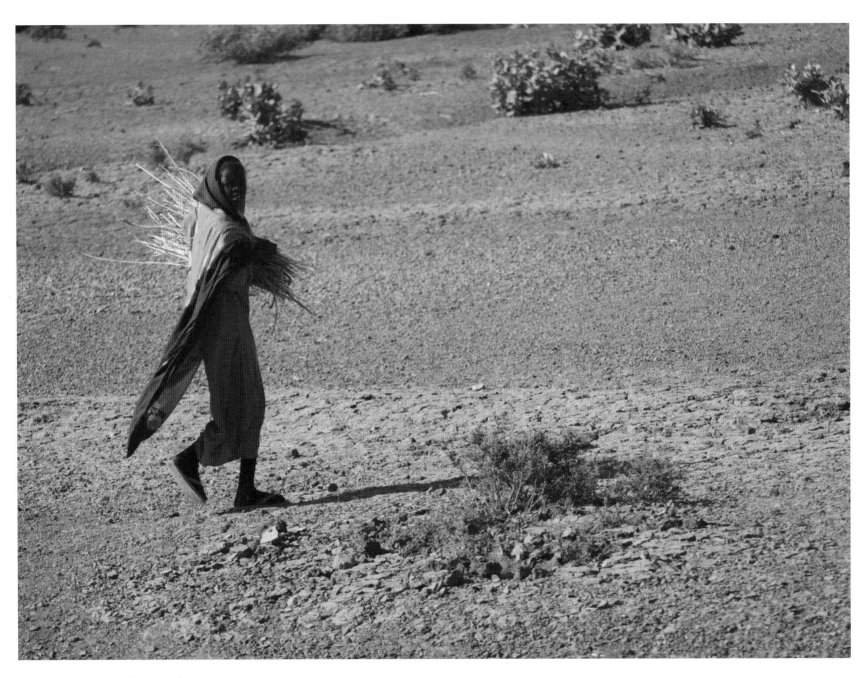

Woman retrieving firewood

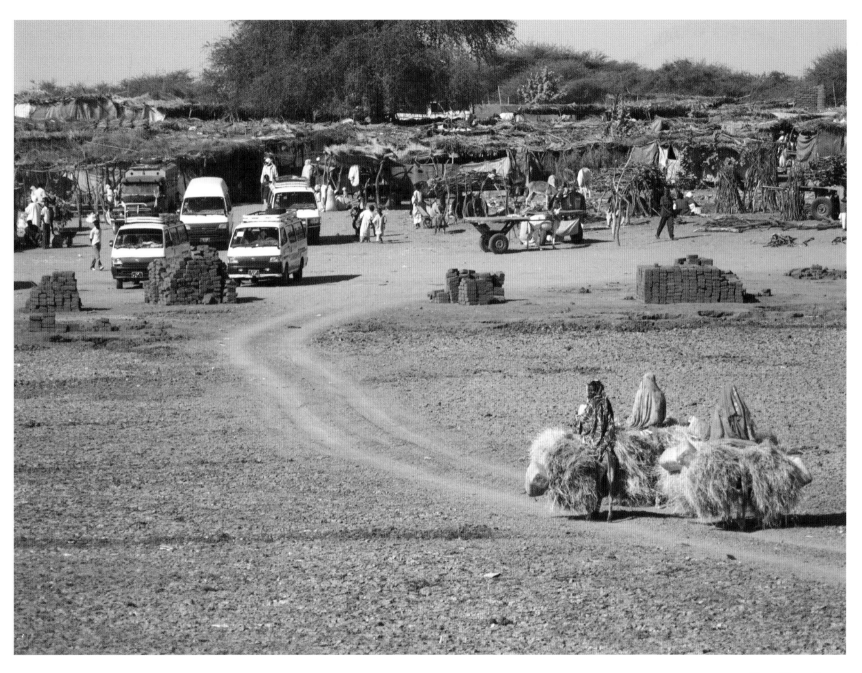

Zam Zam Camp

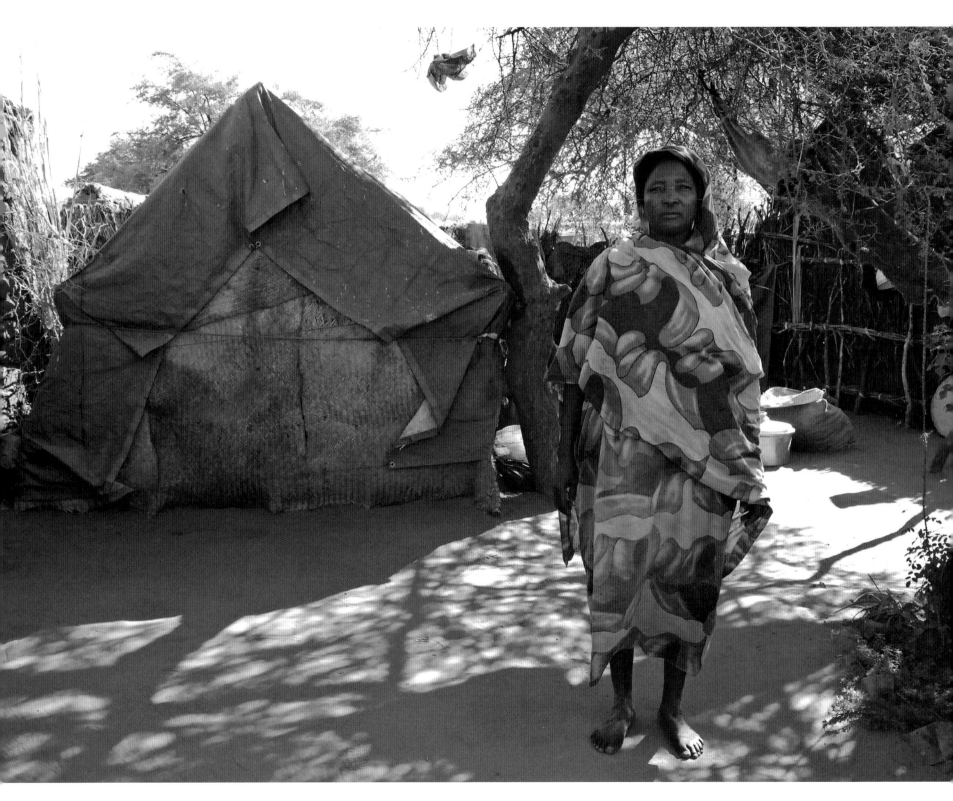

Temporary homes in Zam Zam Camp

flooding. There's even sad irony in the name of this camp for displaced people. Zam Zam refers to the sacred spring in the holy city of Mecca. But little appeared sacred about Zam Zam except for the lives of those forced to live there.

Their villages burned, their livelihoods destroyed, most of the families that arrive in camps such as Zam Zam are no longer intact. Someone has died along the way. Someone else has been raped. Another has been attacked by machete or has a bullet lodged somewhere inside a limb that no longer works right. The children, even the ones who can still smile or play, have witnessed things no adult or child should ever see. Their nightmare is their reality—armed men on horseback, mercenaries and soldiers sanctioned by a government they know little about and have little contact with who've been sent to rape, pillage, destroy, and burn what's left. For thousands of innocent villagers, the only offense to their attackers is their color, their tribe, their family, their culture, their faith.

If they survive an attack, it's by running to avoid their final breath or a wound too deep to heal. They may find an unfamiliar place to hide. A ditch. A dry riverbed. They may dive under the scratchy branches of a bush, behind broken lumber, a bent piece of tin, or a rusted vehicle with wheels planted deep in sand. Then, for the lucky ones, a relative may find them. Or maybe it's a Rwandan soldier, a Ugandan soldier, some soldier who's wearing the right uniform, whatever that is. UNAMIS? UNAMID? Sudanese Military? JEM? SLA? Janjaweed? Maybe a border guard from Chad? Sound confusing? It is. Most of the refugees have lived isolated, innocent lives, unaware of the significance of colors and camouflage, berets, helmets and insignias.

If they're fortunate enough in their flight from terror to reach the city of Al-Fashir or a border post to the west, they'll spend their first hours trying to figure out who to trust, the man in the blue helmet or the red beret? The man in the green fatigues or the beige ones? The man with the Chinese rifle, the Russian rocket launcher or the American M-16? The luckiest find an aid worker from an NGO, someone who's had the courage to show up unarmed with a simple goal in mind: providing the security of a doctor, nutrition, clean water, a mosquito net, maybe some kind of shelter.

After days, weeks, or months of separation, a reunion of survivors might be as basic as finding a lost sister or an uncle who somehow navigated the miles it took to get to Zam Zam. It could be a mother, her hands full with toddlers, and a newborn demanding food from a body that's had none of its own for a week. It could be a fourteen-year-old girl pregnant with the child of a rapist. Perhaps that explains the listless eyes of so many who are forced to call the Zam Zam refugee camp their home. Everywhere, the listless eyes.

Darfur is not like Afghanistan or Pakistan. It's not like anywhere else I've been to film or document. The conflict is man-made and if it can get worse each day, it does. There has been no getting better for years. Poverty, malaria, lack of education or clean water or food are not the worst of the problems facing survivors in a conflict many observers say began in 2003. Whether one chooses to call it a civil war, a crisis, or genocide is almost irrelevant because no matter what we call it, it is a nightmare for millions of innocent people. Whether we blame it on the Arab-backed government in Khartoum or oil infighting among China,

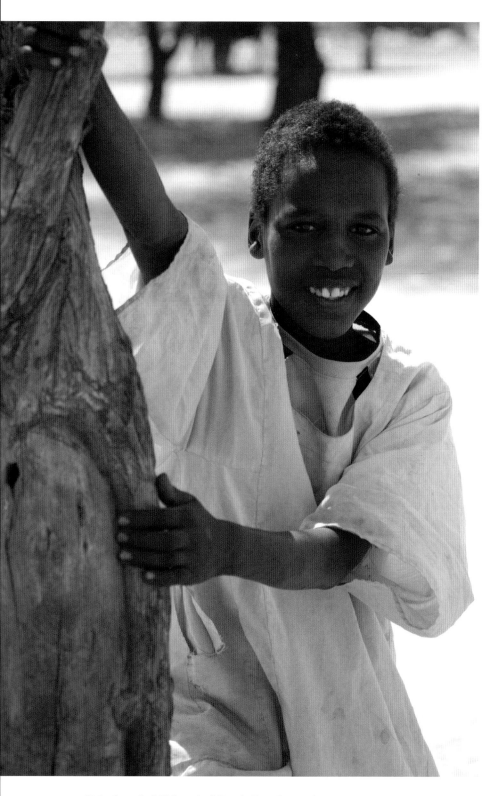

Displaced children in North Darfur

the U.S., or international conglomerates, or whether it's just a generation of violent conflict in south Sudan finally spilling to the north, is almost impossible to discern.

But this much is true: No matter who's to blame, it is a nightmare for those whose only alliance is to their family and a small community they'd never left before their forced departure. Whatever resources or possessions they once had—a one room hut, a few cows, an acre of wheat, a pet dog, an old bicycle—those things no longer exist. The likelihood is that they'll never return to whatever life they knew before. And if they didn't have an enemy before they were attacked, they do now.

By definition of the 1948 United Nations charter, many consider what's happening in Darfur to be genocide. That should provoke a significant international response. But, sadly, most governments including the United States (which has defined the atrocities as genocide) are doing what they did during genocides in Rwanda and Cambodia—which is basically nothing. Talking, even at the highest levels, has not solved the problem. The European Union has spoken as loudly (dare I say, louder) but fails to find the unity and will to respond.

Many governments, including the United States, have done little more than yawn at the notion of an empowered United Nations able to respond to crises like genocide. This has gone on for years. In part, it's due to the ego of each individual government and their notion that "we" know best. It's also because governments don't want to be held accountable to the standards set up by an empowered United Nations. Yet it's precisely in times of crisis, especially genocide, that an empowered United Nations could prevail, saving the lives of hundreds of thousands of inno-

cent people. In the U.S., most presidents don't actively call for U.N. action unless or until it becomes clear that our government can do nothing on its own or it becomes politically or economically expedient to have the U.N. step in instead.

We have also become very good at creating new global institutions and initiatives, such as the World Bank, G-20, and IMF, yet they often fail to respond as well.

A BRIEF HISTORY of the conflict in Darfur is difficult because it's hard to say precisely when the conflict began. While some would say February 2003, others see patterns of violence that long preceded the past few years. In some respects, it'd be easier to do a brief history of those times when Darfur and neighboring south Sudan were not in conflict.

Darfur means "land of the Fur." Fur is the name of the tribe of people who've populated this region for centuries and who, among others such as the *Masalit* and *Zaghawa* tribes, are currently under attack. Their attackers include the much-feared *Janjaweed* militia, a group that many international observers believe is acting on behalf of the Sudanese government. It is the Janjaweed, which some translate as "men on horseback" and others translate as "devils on horseback," that has perpetrated the systematic rape and killing of innocent people that constitutes genocide. What makes their attacks particularly sinister (as if there are degrees of sinister when speaking of genocide) is that the women are often targeted for rape while the adult men are simply murdered. The violence is anything but random. Combined, it's an act of ethnic cleansing with a shocking degree of barbarism. To be blunt, many observers say the intention of

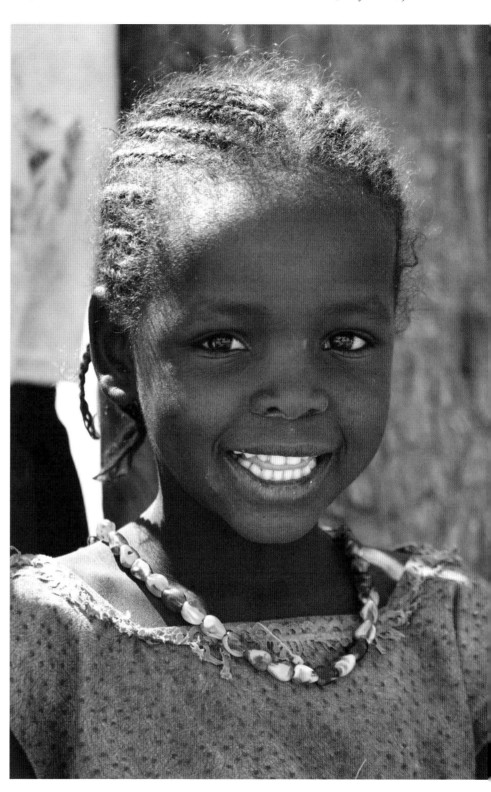

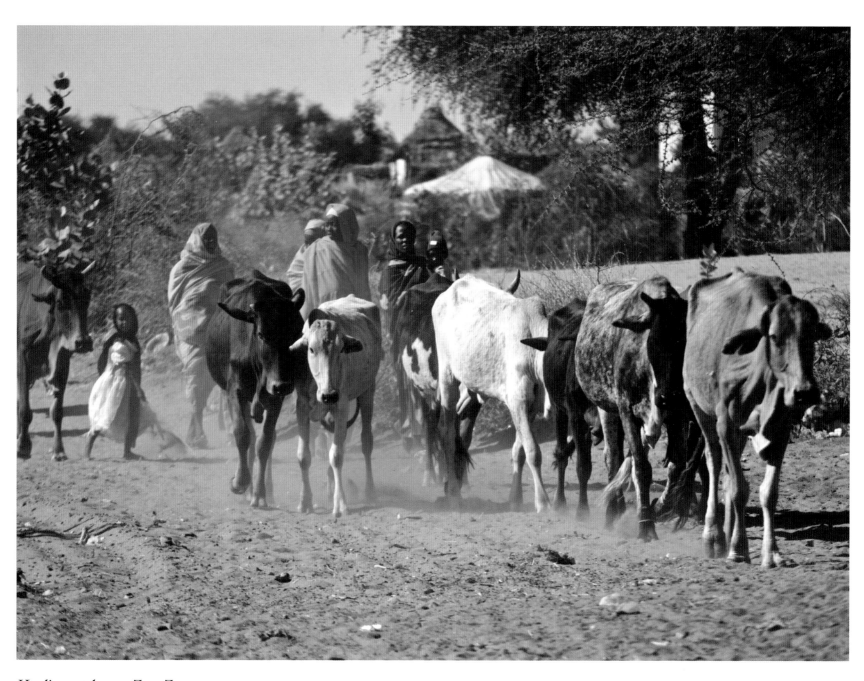

Herding cattle near Zam Zam

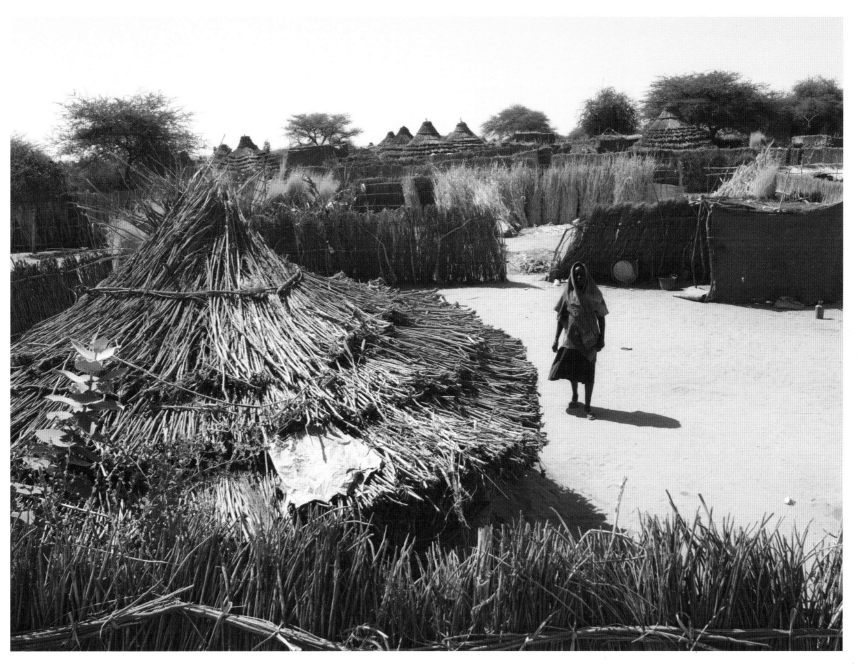

Zam Zam Camp

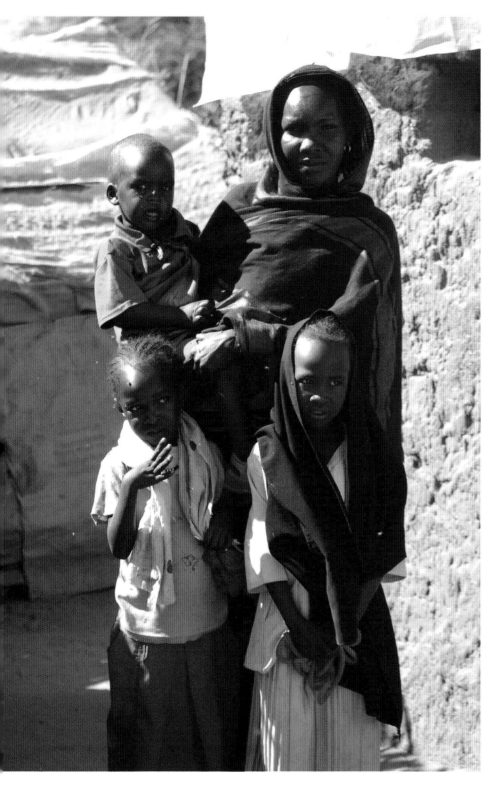

Recently resettled in Zam Zam Camp

the rape is to impregnate women of African descent with Arab blood.

While the government works to distance itself from the actions of the *Janjaweed*, the deception is loosely veiled. Genocide is genocide and to date governments have largely failed to respond. As recently as January 2008, Sudan's President, Omar al-Bashir, appointed a former Janjaweed commander, Musa Hilal, as a special advisor to the president. International protests at the time were countered with more Sudanese government denials.

AS A NATION, Sudan gained its official independence from Britain in 1956. For most of the early 20th century, parts of Sudan were ruled or overseen by the French, Belgians, British, and Egyptians. Today, much of the infrastructure of Sudan is a remnant of British rule, even in places as remote as the capital of North Darfur, the city of Al-Fashir. In simple terms, there's a roundabout in the center of town and an over-reliance on paperwork by the Sudanese officials who've been unfortunate enough to be stationed in Al-Fashir.

But the Sudanese government today is a far cry from that of the British. Its history is tangled and the entanglements go back a very long way. In recent history, many of the problems facing Sudan began shortly after World War II. The British, recognizing significant cultural, religious and ethnic differences between north and south, had begun a process of setting up two distinct governments under separate rule. In 1947, however, Sudanese and British officials got together for the *Juba Conference* (so named because it took place in the city of Juba) and used the conference to reorganize north and south Sudan under one governmental

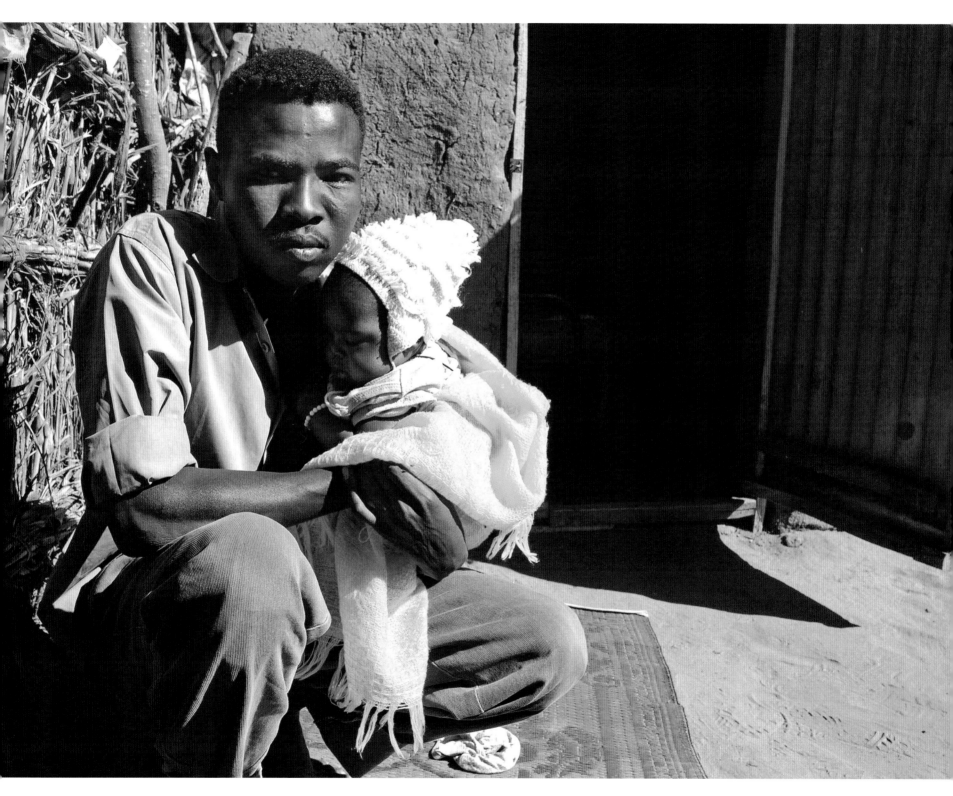

Father and child in Zam Zam Camp

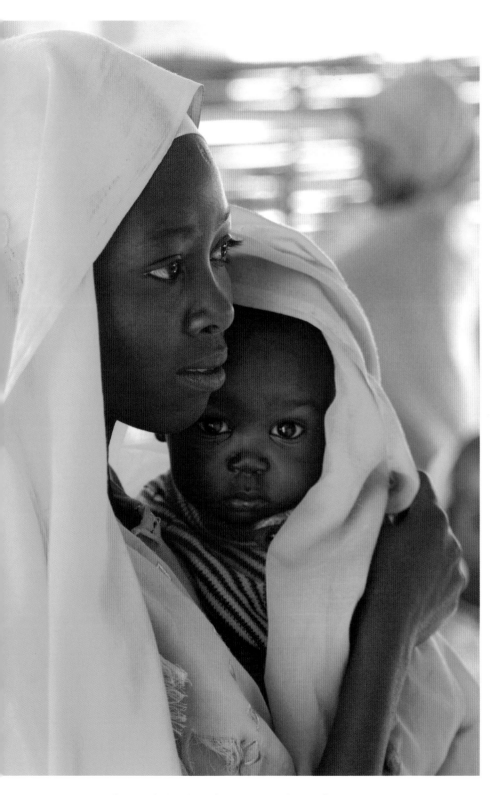

Mother and child at clinic in North Darfur

authority. Given that the north is primarily Muslim with significant Arab influence and the ethnic roots of the south are tribal with a mix of Christian and animist beliefs, the two sides have succeeded in little since 1947 except warfare. In other words, the Juba Conference, however remote it may seem in world history by today's standards, was a colossal failure with staggering repercussions.

The first civil war started before the ink was dry on deal papers for independence from the British. It ran from 1955 to 1972 and it was, of course, a bad time to be a northerner in the south or a southerner in the north. Most didn't make it out alive. On the other hand, it was a great time to be an arms supplier from the Soviet Union (everyone's got an angle, right?). A relative peace was negotiated that lasted about ten years, but with enough coup d'états to make good copy for another book. What finally ignited the second civil war was a spark too hot to handle—the institution of Islamic Law, also known as *sharia* (similar, in some ways, to the Islamic Law imposed by the Taliban in Afghanistan). Throw in ethnic and cultural differences, deforestation, climate change, and a battle over oil resources, and the second civil war lasted until a peace treaty was signed in January 2005. No one I've ever spoken with thinks the treaty will last; however, it does contain a clause calling for a referendum for secession if things aren't working according to plan. In the event peace is working (and during my visit it was not), there's language regarding shared oil revenues plus an elected assembly from the south will have the right to use or not to use sharia as their regional system of justice.

All this is a way of saying that the problems in Darfur are many and it's difficult to separate them from fifty years of

fighting between north and south. In many ways—ethnic, cultural, religious—the people of Darfur have more in common with the south than the north. Everyone from former President Bush to actress/activist Mia Farrow has called the atrocities in Darfur genocide, and it certainly fits the 1948 United Nations charter on genocide. But it also has the look and feel of civil war. There are so many different groups fighting that it's anarchy, anarchy with a staggering death toll for innocent civilians. Conservative estimates suggest that more than 200,000 people have been killed and more than 2 million left homeless.

The International Criminal Court has filed genocide charges against Sudanese President Bashir and issued an arrest warrant in March 2009. However, Bashir's government has long countered that they're merely responding to attacks by insurgents and rebels whose intent it is to take down the government. While much of the world and certainly those working directly to oppose the genocide would concur with the ICC charges, it is true that rebel movements from the region are fighting back. Both JEM (Justice and Equality Movement) and the SLA (Sudanese Liberation Army) are among those opposing the Janjaweed and Sudanese military. In some respects, it's north (Arab) vs. south (African). And yes, the intention, if successful, would be to overthrow the Bashir government. Any relatively sane person would have to say, "sure, why not overthrow it?" In Sudan, however, the second question would be "and replace it with what?" Despite President Bush's public declaration of genocide in Darfur, he did little to oppose the Sudanese government and did not make the push for democracy in Sudan that was the hallmark of his foreign policy elsewhere. The question is, why?

The International Criminal Court is based in The Hague, Netherlands. While more than 100 nations back the legitimacy of the court, two who are absent in their support are the United States and China. Given the abundance of untapped natural resources (including oil), both stand to gain or lose pending the outcome of the horrendous conflicts throughout Sudan and, in particular, in Darfur.

———

IRRESPECTIVE OF THE international political challenges to overcoming these conflicts, challenges that will require leadership and vision, one thing is clear. The needs of the people in Darfur are significant and humanitarian work must continue. Still, security in Darfur is even less predictable than in Afghanistan and the job of NGOs becomes more difficult by the day. As recently as March, 2009 and in response to ICC charges, more than a dozen international NGOs were thrown out of the Darfur region. While some may have operated in Darfur with a degree of acknowledgment of the genocide, none, to my knowledge, were what I would describe as politically active. Rather, they were there to provide day-to-day humanitarian relief, such as food, water, shelter, and medical assistance to millions of displaced people. This is not an idle statement. Darfur is a place of extraordinary need. It is not a place where the vast majority of aid workers engage in political discourse or action.

———

MY PRIMARY REASON for being in Darfur was to document the work being done there by Relief International. The RI team is among a handful of NGOs working in Darfur. It's a posting that requires extraordinary courage and tolerance. The conditions,

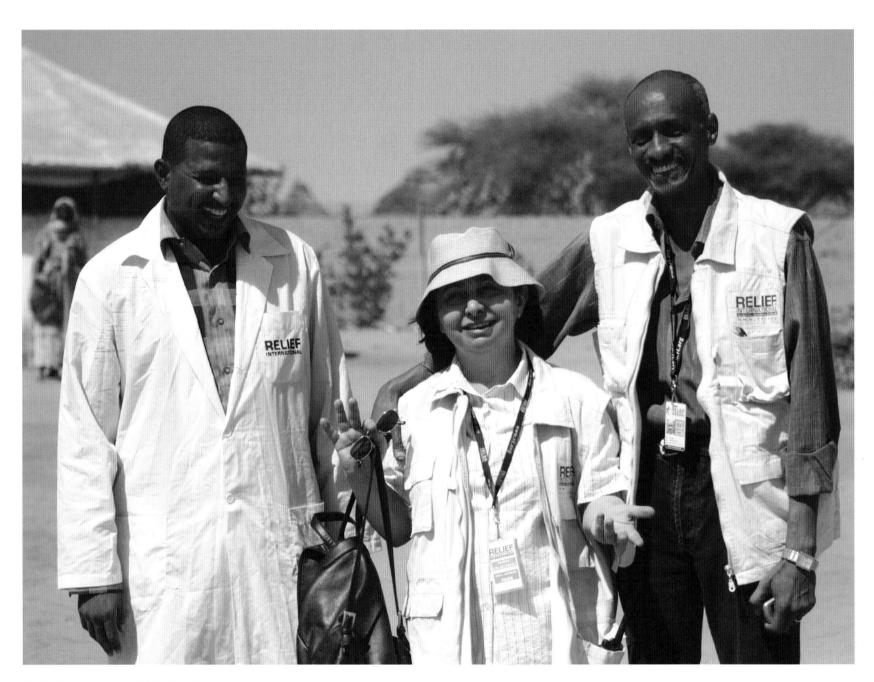

Relief International Medical Team

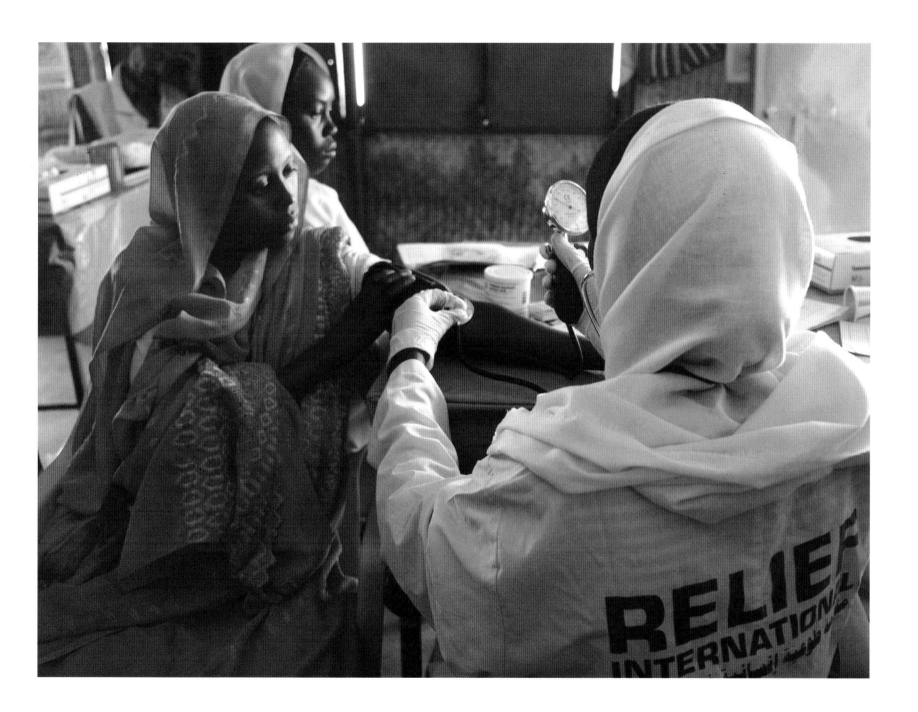

especially related to personal security, could not be much worse. Aside from extreme situations and dangers common to postings in other countries, such as the risk of malaria, oppressive heat, poor quality health care and sanitation, poor communication, and lack of opportunity for social interaction, the relief workers in Darfur are confronted daily with the foreboding sense of risk to their own lives along with loss of personal and professional possessions. Carjacking is so common in Darfur that most NGOs no longer use the standard 4x4 vehicle despite their many conveniences. Virtually all of the warring factions view the 4x4 as an asset, one easy to use for mounting heavy weapons or traveling off-road. In the case of the RI team in Al-Fashir, travel to and from their guesthouse to the Zam Zam camp less than ten miles away is done with poor quality vehicles that are not worth stealing. Anyone in a 4x4, regardless of its age or condition, is a target, including workers for the U.N. and the World Food Program (WFP).

During our daily trips to and from Al-Fashir and the Zam Zam camp, we passed through at least two checkpoints. The one on the edge of town was manned by what I gathered were city police officers (armed men, off-white uniforms) and the one situated roughly halfway to Zam Zam, five miles to the south, was located adjacent to the United Nations base (armed men, blue uniforms). The U.N. checkpoint was an actual roadblock that required identification to get from point A to point B. The driver was queried but no one else was questioned individually. Near the edge of camp, we were stopped each day by the SLA (armed men, green camouflage uniforms) who were surprisingly pleasant. We also saw soldiers wearing at least three or four differently styled uniforms in the area around Al-Fashir's central outdoor market. In my short visit, I wasn't able to figure out just who was who most of the time. And as much as I wanted to walk among the locals in the market, the best place in town to get information as well as food, it simply wasn't safe to do so. We stopped briefly near the edge of the market twice for our Sudanese hosts to purchase vegetables. Each time, I was asked to wait in the vehicle with the windows up. Nothing is worse for a photographer than to be held back from the chaos of an outdoor market.

———

IT TAKES AN uncommon person to do the work in Darfur and I was impressed with the RI team, the majority of whom, were then as now, Sudanese nationals. RI's international staff has helped to train Sudanese doctors, nurses, midwives and nutritionists to run the clinic at Zam Zam. The budget is tight but RI's executives say that as little as $5.00 can save a life, while $5,000.00 can rehabilitate an entire village health clinic. While I was there, the clinic was seeing as many as 400 patients each day between approximately 10 A.M. to 4 P.M. The days would be longer except for the curfew. Workers based in Al-Fashir aren't allowed on the road before 8 A.M. and have to be off the road and back in Al-Fashir before the sun goes down. To do otherwise is to risk your life.

The curfew that follows sunset means workers are confined to their own lodging until shortly after dawn. Nighttime in Al-Fashir offers little by way of excitement. When I asked the RI team if they ever socialized at night with other NGO workers, I received a polite smile (as in, are you kidding?). I wasn't in town long enough to test my naiveté with a venture through the neigh-

borhood, but I did, very quickly, get a sense of how solitary life can be for aid workers. They did have satellite television, but electricity is inconsistent and running a generator for all except emergency use is cost-prohibitive. We limited ourselves to BBC News each night for about an hour, which was just enough to stay up-to-date on the fighting in Kenya. The fighting in Nairobi and around the country was getting worse with a death toll approaching 200. As weird as it sounds, my hosts kept reassuring me that I could delay my return and stay with them in Darfur until the fighting subsided. What strange options.

After catching up on the news, I found myself lying in bed under the mosquito net and reading with a battery-powered headlamp on while counting the few random gunshots that resonated around the neighborhood. Sleep was uneasy at best. And as I had in so many other countries during the past decade, I awoke each morning at 4:00 to the reverberating sound of the Muslim call to prayer. Even then, it would be four more hours before we were allowed to venture outside the security of the guesthouse. Having a good book to read was a necessity.

For all that it lacks in accoutrements and nightlife, Al-Fashir is bustling during the day. A city of approximately 175,000 residents during more normal times, as many as 100,000 additional humanitarian workers, U.N. workers and troops and refugees have helped to create unique economic circumstances. Despite considerable risk, truck driver after truck driver transports in massive amounts of bottled water, food, and supplies. For some small shop owners and a few hawkers at the local market, legitimate business is the best it's ever been. Then, of course, there's

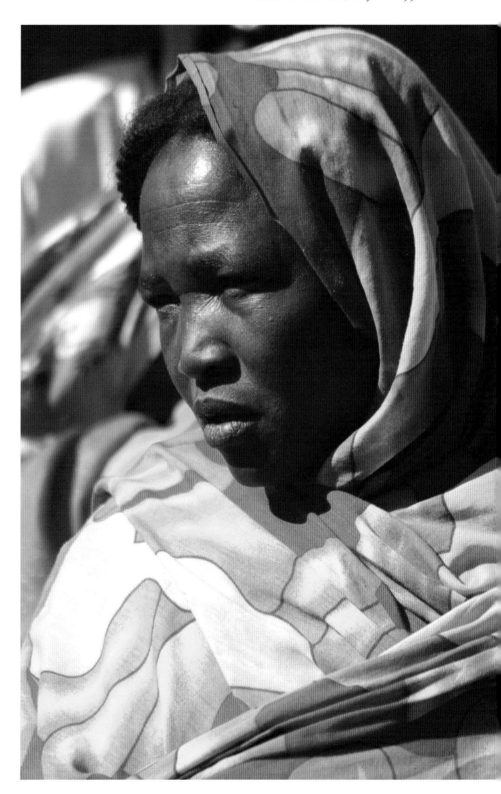

Displaced mother

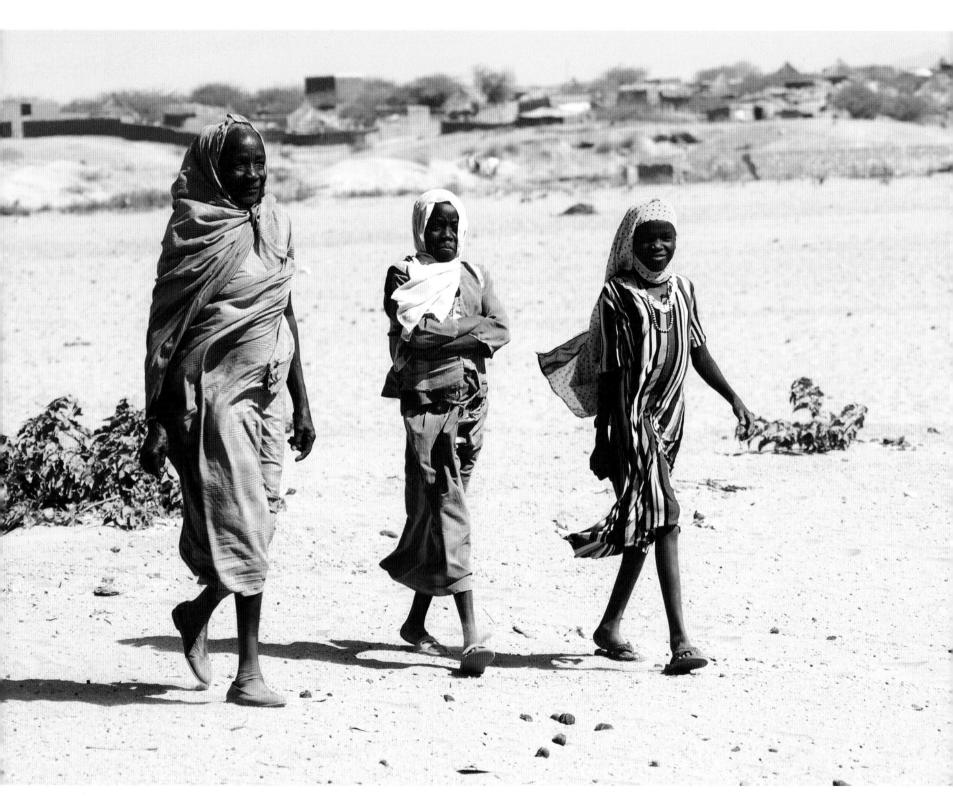

Women walking near Kabkabiyah

the extraordinary black market that makes available everything from Chinese weapons to Johnnie Walker Red.

Likewise, commerce is also springing up within the refugee camps. Anyone who's managed to arrive with a sewing machine or bicycle repair kit has set up shop in front of whatever dwelling they've been able to scrape together. While new arrivals to the camp can be found hovering under plastic sheeting held up by sticks, those who've been in camp longer have already begun to build more permanent structures from homemade mud bricks and tin. Discarded wood, plastic or rubber from Al-Fashir or the U.N. base quickly becomes a commodity in Zam Zam. Like so many refugee camps spread throughout the world, Zam Zam has become a city unto itself. Goods are sold, services performed, babies are born, and kids play king of the hill on heaps of garbage and debris. Life, death, and all their related rituals happen every day.

In an ideal world, camps such as Zam Zam should be considered temporary at best. Sadly, they're not. Relocation is difficult, even in post-conflict times. In places like Palestine, Congo, Ethiopia, Chad, and Somalia, second generation babies are being born into circumstances that would defy the imagination of many in the West. At least for now, security is foremost and NGOs are doing everything possible to overcome challenges related to malaria, HIV AIDS, malnutrition, clean water, and basic housing supplies.

In cities and villages where people are not displaced but continue to be threatened by the conflict, other needs are met that are intended to create sustainable solutions. For example, after a few days in Al-Fashir I flew on a WFP helicopter to the western

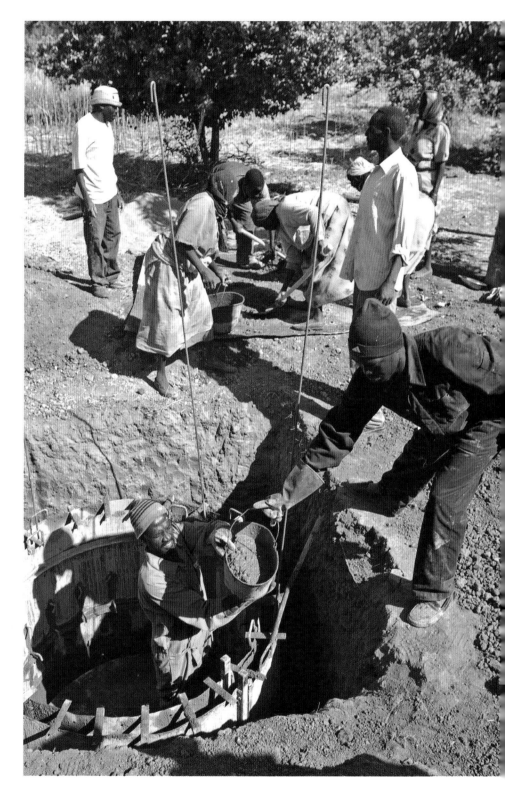

Well digging in Kabkabiyah

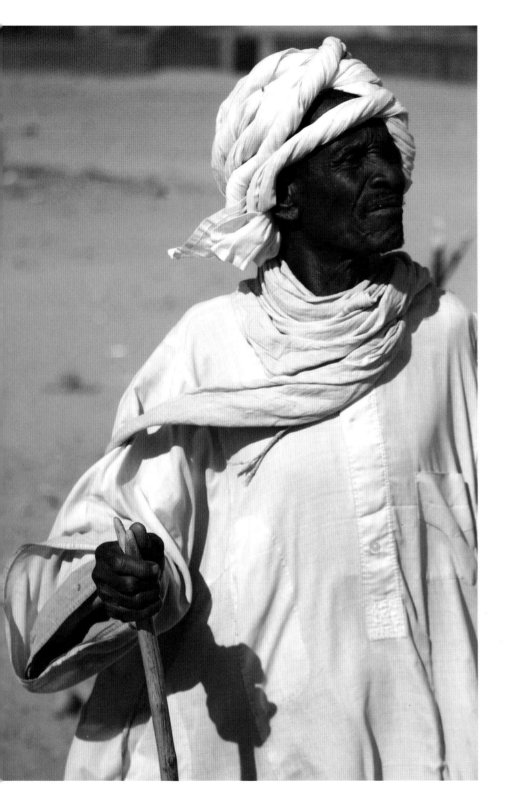

Shepherd in Kabkabiyah

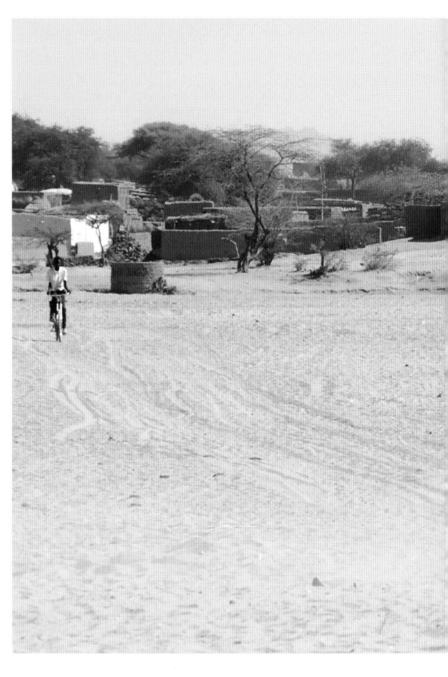

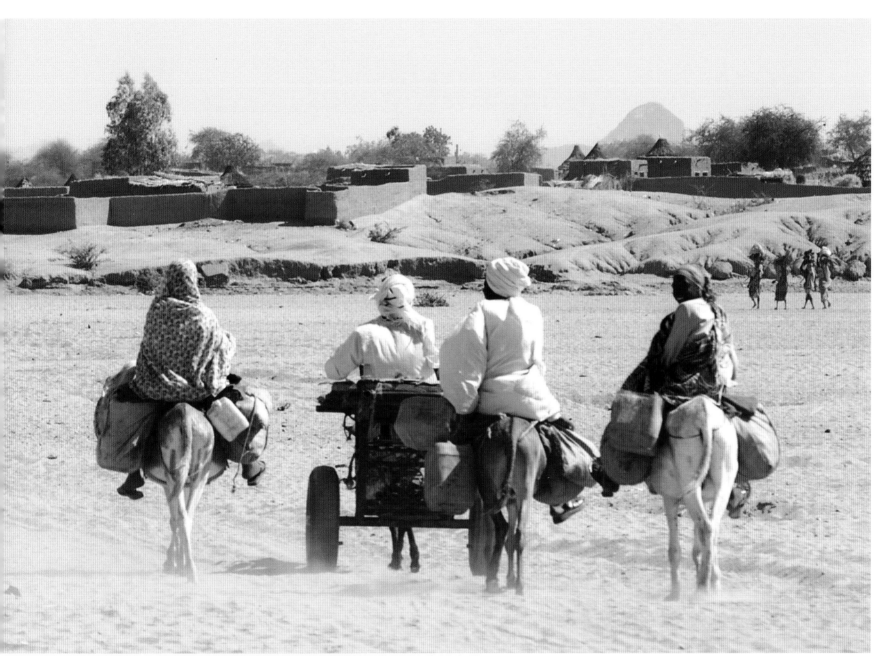

Road to Kabkabiyah

city of Kabkabiyah. In just one day on the ground with the RI team, I was able to witness and photograph projects as diverse as well building, agricultural education and veterinary programs designed to inoculate local livestock against disease. Where health care workers were essential in Zam Zam, engineers and agronomists were working to educate people throughout Kabkabiyah. Local RI staffers were also building and distributing fuel-efficient brick stoves so women in the area could get by on less firewood. The local economy, while challenged, was at least diverse.

———

SO JUST WHAT does constitute life in a refugee camp such as Zam Zam or a remote area like Kabkabiyah where conflict is a constant? Though I was limited to just a few hours of photography in Darfur, the pictures do help to tell the story. While there were signs of hope and empowerment in both Afghanistan and Pakistan, hope was harder to find in Darfur. What hope I did see—reflected in many of the images shown here—was in the faces of children too young to comprehend the challenges of their future. I also saw hope in the perseverance of women, tortured by their losses, who still managed to find love and beauty in what little they had.

On our last day in Zam Zam, I walked through the narrow, crooked spaces that divide the thousands of unremarkable makeshift dwellings. Most of the inhabitants were young women and children. Their belongings consisted of little more than the clothes they were wearing. Some had one or two random things they'd somehow managed to bring along: carpet, a bucket, a child's toy. A few had a family photo reflecting better times. Older

men were almost non-existent in the camp, but when we did find them, they sat huddled together as elders, discussing the challenges facing their relatives and their new community. It wasn't long before I came upon two survivors bound together by a father's love. A man who was perhaps twenty years old sat in front of a place he'd called home for only a few weeks, holding his infant son. How each had survived is a mystery. In a land where men have wreaked such havoc, he smiled at me with the same gentle energy that brought security to his child. Whatever it takes to rape or kill was not a part of him. With no job, no money, no relatives and a baby to feed, the limits of his future were hard for me to fathom. The innocence of his child was all he had to live for.

———

LIFE IN DARFUR is as difficult as anywhere on earth. Many of the global solutions for nations in crisis and people living in poverty are relevant in Sudan—micro-credit programs, improved education and health care, empowerment of women and girls—but getting to the point of implementation in Darfur presents significant challenges. It will take commitment and action from an international community willing to stand up to the tyranny of Sudan's current government. It will also take a plan of action that allows Sudan to create security, freedom and independence that can outlast NGOs and the feeding frenzy of conglomerates that fail to see beyond the market for natural resources such as oil.

———

AS I WAS preparing to leave Darfur, my hosts at Relief International extended a second invitation to stay on in Al-Fashir until the violence subsided in Nairobi and the rest of Kenya. It did

Woman attending lecture—Kabkabiyah

Man attending lecture

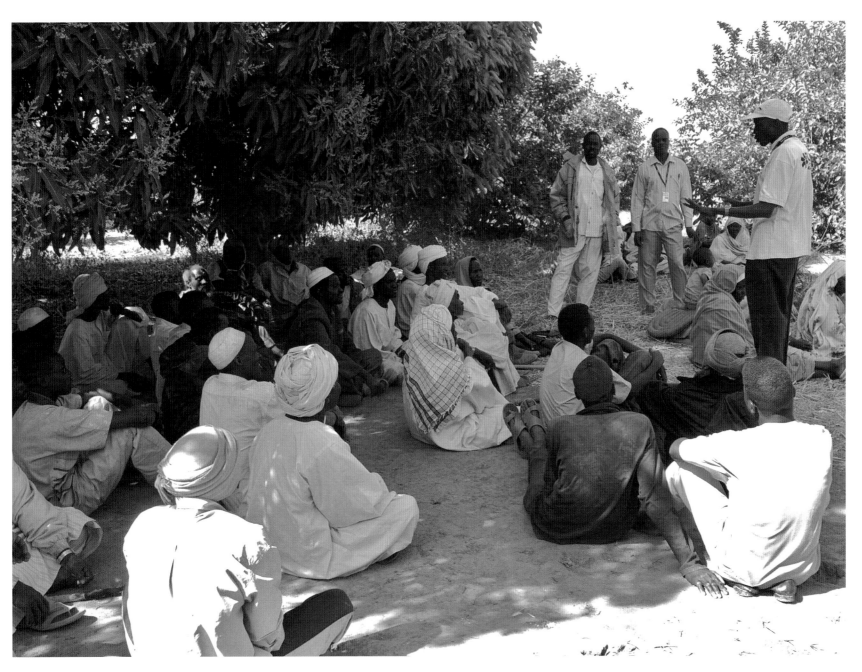

Lecture on sustainable agriculture near Kabkabiyah

Hamad El Nil Mosque—Khartoum

look bad in Kenya. People were dying and the situation between the two leaders was getting worse, not better. Somehow, though, I couldn't get my head around the notion of Darfur being safer than any other place in the region. In the end, I made the very human decision to opt for the familiar.

———

THE RETURN FLIGHT from Darfur to Sudan's capital city of Khartoum took about two hours on a United Nations jet. Khartoum, which is situated at the confluence of the Blue Nile and the White Nile rivers, is a city that shares a great cultural history with Egypt and, beyond that, the Arabian Peninsula. In some ways, it feels like the end of Africa and the beginning of the Middle East. There is genuine cultural, ethnic and spiritual tension between the north and the south in Sudan and in that sense, the confluence in Khartoum is a tangible, physical symbol of a much greater challenge. A world ends, a world begins, and there is little peace in between.

From the confluence, the Nile River continues north to Cairo. During our brief tour of Khartoum, it was the river system that I found most physically impressive. It has the same sort of gentle giant sensibility as the Mississippi River. But there was less development along the banks of the Nile in Khartoum than on any river in any city I'd ever visited. No sidewalk cafes, no board-walks with vendors or shops, very few parks, and surprisingly few warehouses serving the manufacturing of the city. Because of *sharia*, there was also very little nightlife in Khartoum to appease a Westerner. Other than two large weddings that we passed while driving through town, the city seemed to offer little to do after sunset. Though I did have a permit for photography, I was not

Sufi Elder

Sufi Elder

allowed to take random shots while traveling through town. The one time I was allowed to shoot, however, was a good one.

It was a Friday, the Muslim holy day, and my hosts offered the opportunity to attend a Sufi ceremony at a local mosque. Sufism is considered the mystical branch of Islam and I'd had the chance to film Sufi ceremonies previously in the United States. I knew the mood would be positive but beyond that, I had no real idea what to expect. Within minutes of arriving at the *Hamad El Nil Mosque*, there was an overpowering feeling of love and humanity that I'd not seen anywhere else in Sudan. It was a joy to see people reaching out and building bridges instead of destroying life. People of all backgrounds were not just welcomed, they were embraced. Whatever differences they had became irrelevant under the banner of love.

Shortly after arriving, I approached an elder who appeared to be in charge. He carried himself as a man of confidence and character. Distinguished by a long white robe that covered his head, he was also wearing an old pair of aviator-style sunglasses. As I often do when there are language differences, I held up my camera to him as if asking to take pictures.

"Do you want to take my photo?" he asked with a perfect British accent.

"Yes, that would be great," I replied.

"Only if you promise to send me one," he said, smiling.

"Consider it done," I said.

We shook hands and, for the next hour, I worked my way in and around the few hundred people who'd gathered for the service. As the sun set in the haze to the west, I photographed the transcendental prayers and movements of the many dervishes as

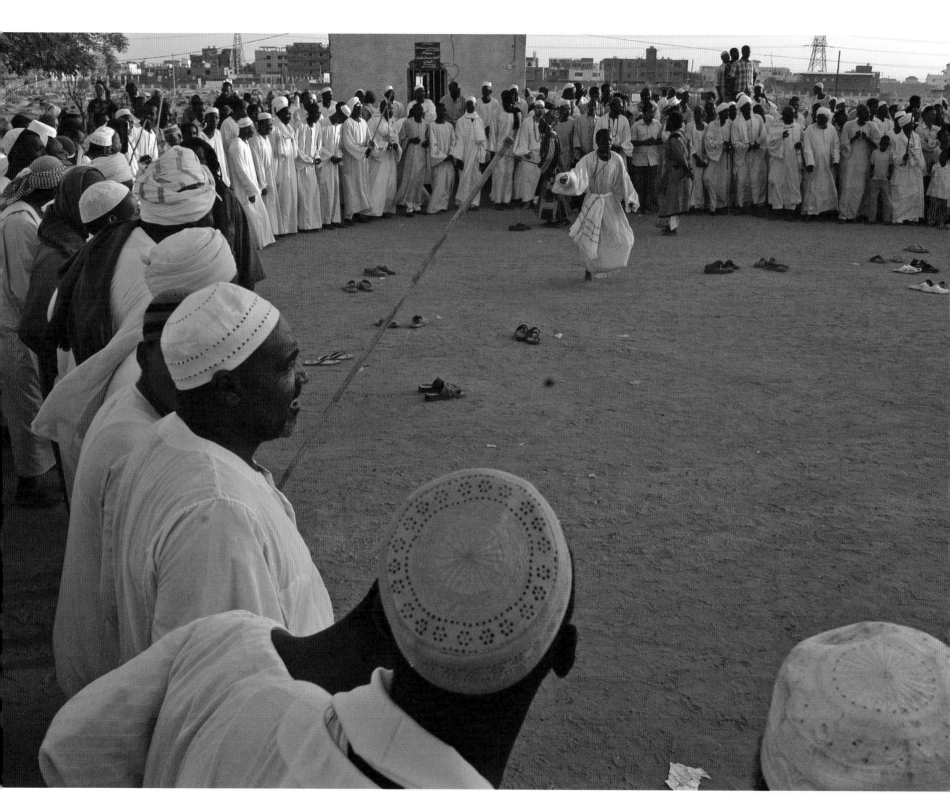

Sufi ceremony—Khartoum

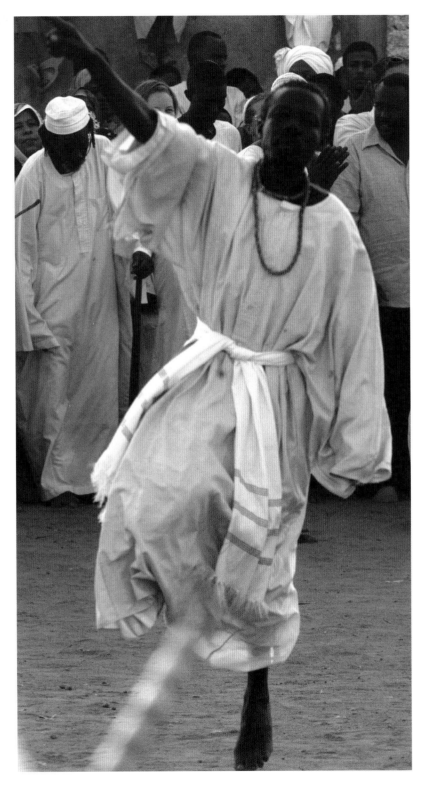

Sufi dervishes

they offered their unique celebration of life and spirit. The feeling was one of inclusion, compassion and hope for this life… and the life beyond.

Nairobi, Kenya » JANUARY, 2008

ON MY RETURN to Nairobi, things had, indeed, become worse. The death toll from violent protests was now in the hundreds and the international community was finally taking notice. In several communities outside of Nairobi, the killing was ethnic in nature and, in most cases, the reports indicated that the victims were unarmed. In simple terms, it was Luo killing Kikuyu and Kikuyu killing Luo or members of other minority tribes, including the Masai. As had been the case in Rwanda during the 1994 genocide, the ultimate weapon of mass destruction was, once again, the human imagination. All it took to create fear, chaos, and death was one man blinded by hatred and wielding a machete. Scores of people were left homeless in the fighting with women and children taking the brunt.

Former U.N. Secretary General Kofi Annan arrived in Nairobi the same day I did and, for a brief moment, there was hope. The fighting stopped for a day as both sides of the disputed election sat with him for discussion and negotiation. But Odinga wasn't about to budge and his followers were ready to respond on his command. It wasn't much of a fight because Odinga's followers, armed with rocks, sticks and the occasional slingshot were little match for Kibaki's police force, armed with riot gear, tear gas and live ammunition.

My reason for the extended stay in Nairobi was to work on a writing project about the late Mohamed Amin. "Mo" was the photojournalist responsible for capturing the extraordinary footage of the 1984 Ethiopian famine, footage that led to the unprecedented international humanitarian response as well as Live Aid. As Africa's foremost photojournalist, Mo Amin would have been in the thick of things. So I alternated my time between days of writing and days of "research" following (and filming) the riots alongside Mo's son, Salim. On one particularly eventful day, Salim and I were scouting about town with two members of his staff and a fellow journalist from Madrid, Pedro Lasuen. We'd tracked down the Odinga spokesmen for a soundbite early in the day, been to a Kibaki press conference handled by a surrogate, and made a couple of routine stops in Kibera where leaders of the protests had set up regular meeting spots for the press. Everything seemed fairly calm until we drove by the Serena Hotel on Nairobi's main street, Kenyatta Avenue.

There were about 200 police officers in riot gear across the street from the hotel so we decided to stop and see what was going on. We parked in the Serena parking lot, then walked a few feet to the street corner. It was a sunny, beautiful afternoon with no apparent tension. An inquiry with hotel staff confirmed that Odinga was inside the hotel in a meeting with his advisors. Still, his supporters were not massed outside, there were no protests on the street and very little traffic. Curfew or not, most people in Nairobi had been staying as far from the downtown area as possible. Many businesses were closed for security reasons and there were very few people walking on the streets.

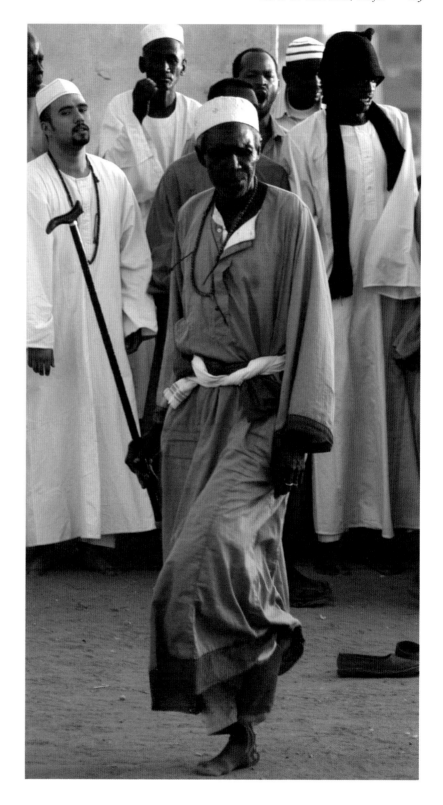

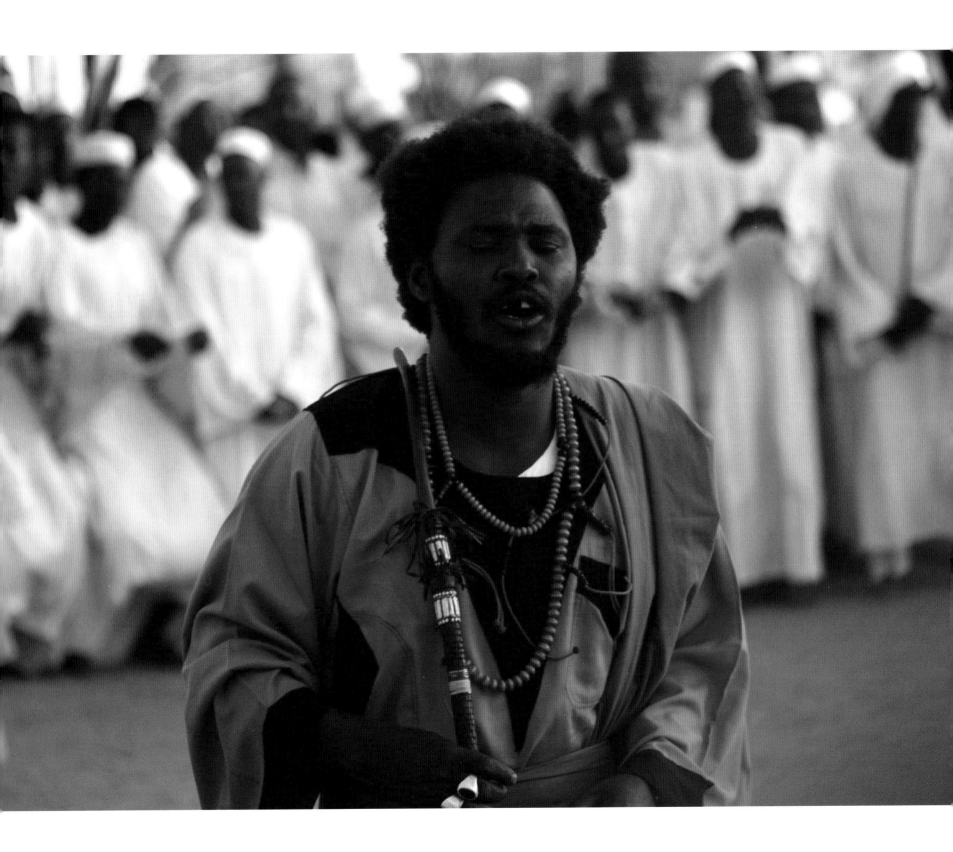

We took a few photos of the police in their assault formation, then waited. And waited. Fifteen minutes. Twenty. Suddenly, for no apparent reason, a group of roughly ten fully shielded officers on horseback armed with clubs came from behind the police line in a full gallop toward the hotel. Or so we thought. We turned our cameras toward them, fully expecting them to approach the entrance of the Serena. But they were after us! During a long career of news and documentary work, it was the first time I'd ever seen police openly attack journalists. We scattered within roughly 100 feet of the hotel entrance as they came after each of us wielding clubs. I positioned myself between a stoplight and a street sign (with the hope that I'd outwitted the horse) and tried to get whatever pictures I could. But the "attack" had a weird quality to it. After a few seconds, it was clear they were trying to scare and intimidate us but they didn't seem to have the clear intention of hurting us. One of the officers near me was even grinning, apparently enjoying himself. Within a minute, they had retreated back behind their police line and the five of us had regrouped on the street corner.

There's usually strength in numbers, even for journalists, and Salim was on his phone to all of his best contacts and friends, CNN, BBC, CBC, and others. In less than ten minutes about 100 journalists had gathered in front of the Serena. While there was a bit of solidarity going on, most journalists are really motivated by only one thing: the story. And on this afternoon, we had become the story.

There was no sign of Odinga or his advisors, but a mass of hungry journalists was enough to embolden the police. As they maintained their lineup on one side of the boulevard and we clustered together on the other, the situation escalated when the police launched the first canister of tear gas. Then a few more. At one point, they charged across the boulevard toward us, yelling a sort of battle cry. But once again, their assault was simply weird. They didn't come beyond the median strip. Then they fired more tear gas and a few cans of pepper spray. (For the record, pepper spray is more difficult to tolerate than tear gas. Most of the photographers in the crowd had, by now, covered their faces with cloth or bandanas. And I'd learned long ago while covering student protests on the UW-Madison campus that the best way to continue filming in tear gas is to close my left eye and bury my right inside the viewfinder.)

Suddenly, CNN and BBC were going live and worldwide from the street corner. Their reporters were just a few feet away, speaking to the folks at home through clouds of tear gas. Again, I couldn't help but wonder how I'd managed to get into this mess while en route to and from Darfur, but here I was. The story was simple: an unmotivated attack by Kibaki's police force against journalists armed only with cameras and notebooks. Amazing.

The whole thing might have died down except the CNN reporter, then Nairobi-based Zain Verjee, was hit in the shoulder with a tear gas grenade while in the middle of her stand up. Her first thought, like that of many viewers, was that she'd been hit by gunfire. She was clearly shaken and her shoulder was injured, but as soon as it was clear she wasn't bleeding, she kept going with her stand-up as the white gas circled around both her and her cameraman. Other networks quickly jumped in, making her the story—CNN reporter attacked by police in Nairobi!

LIKE SO MANY events escalated by chaos, fear and uncertainty, everyone seemed to be looking for a way out of a strange and dangerous situation. Hitting the CNN reporter was the cue for the police to break it off. Whether it was orders from the top or just a young sergeant getting smarter on the job, the police realized they were in a no-win situation. Not only were journalists not their enemy, by attacking us the police had become the bad guys—a very bad public relations move in a nation on the brink of civil war.

During the next two weeks, I spent considerable time in the field and working on my assignment. By the time I flew home, KLM was no longer using Nairobi as a destination. I had to take a Kenya Air flight to Dar es Salaam, then catch my KLM connection. It was late January and the two sides were talking but progress seemed distant. One month later, following a visit by U.S. Secretary of State Condolezza Rice and with the help of Kofi Annan and African Union leader Jakaya Kikwete, President Kibaki and the "newly appointed" Prime Minister Odinga agreed to a power sharing agreement.

Like many countries around the world, the underlying challenges of race and ethnicity in Kenya have roots in the colonial past. The differences will not go away soon, but the crisis in Kenya did lead to a modicum of progress. To witness the Luo sharing power with the Kikuyu was an unexpected outcome. This time, civil war and genocide were avoided. More than 1,000 people died during six weeks of fighting. More than 350,000 lost their homes. And within weeks, tourists began returning to one of Africa's most cherished destinations.

Facing Fear, Finding Hope

On several occasions, friends back home have asked whether I'm ever afraid when traveling to challenging places. It's a natural question, especially considering that most media is focused on events instead of people. Given the immediacy of the Internet and network newscasts it's become all too easy to view much of the world as threatening. We're exposed to the violence of the developing world but rarely to the simple joys that people everywhere experience around their family, work, play and faith. What makes "news" news, especially television news, involves conflict. But even in a war zone, conflict is not constant.

When media fails to focus on people and those things that unite us—music, art, faith, family and culture—it becomes easy to dehumanize and group others into stereotypes. Fear begins to feel natural. Those things that build bridges among people take a back seat and it becomes difficult to imagine that everyone in the world is ultimately more similar than different. The same desire for equality, opportunity and freedom that drove America's Civil Rights Movement is no different from the desire for equality, opportunity and freedom desired by most people in Afghanistan, Pakistan, Darfur or Kenya. No one wants to live a life defined by violence, homelessness, disease or despair.

Like any aid worker or journalist covering a crisis or visiting a war zone, I'm not immune from the fear of unfamiliarity or the uncertainty associated with the random violence of war and genocide. The bigger question for me is how does someone choose to navigate the world while feeling fear? The rational and experienced part of me understands that it's often the unfamiliar that inspires fear. Who are the people I'll be interacting with?

What are their religious and cultural beliefs? Will I be viewed as a threat? Can I trust the military, customs agents or border guards? How can I interact in a way that allows me to gather information and document events without offending others or worse, creating or attracting fear where none currently exists? Without personal or professional relationships, without knowledge of city streets or safe havens, without an understanding of how to meet the most basic survival needs related to food, water and shelter, any place beyond one's home can be difficult to navigate. In that sense, my own security is really no different from that of the people I've documented in this book except that I generally have it so much easier.

Imagine the fear a mother or father faces when confronted not only with the death of a spouse or a child but also with the loss of a home and forced relocation to an unfamiliar place—no resources, no money, nothing familiar to fall back on and nowhere else to go. Imagine the fear a child experiences when pulled from a dead mother's arms and thrust into a community of other displaced people who are all suffering from challenges they may never have considered. We are all asked to carry burdens in our lives, some greater than others, and managing fear begins with understanding that it's something everyone has to deal with. As simple as it may seem, the greatest asset we all have is the quality of our intention. On a simple physical level, that can mean beginning any new situation or relationship with a genuine smile and body language that's neither aggressive nor defensive. I also believe that people have the capacity to understand our intention through the energy we give off. That's not a New Age concept; it's a very real phenomenon. If we're hyper or pushy, even in

our physical language, we can invite suspicion. If we cross our arms, we're telegraphing our own insecurity, our desire to defend ourselves, or our own unwillingness to be either transparent or forthcoming. When we tower over children, we tend to be ignored by them or seen as a negative or an obstacle. But when we kneel in front of children with open arms, we reduce fear and suspicion almost immediately. Eye contact, as difficult as it can be for some people to maintain, helps to encourage a relationship and promote understanding. It's difficult for anyone to hide their emotion or their intention when someone is looking into their eyes. If the balance of our intention leans toward giving versus taking or, in the least, not wanting to disadvantage someone else by creating fear unnecessarily, then others will understand us through the energy we give off much more than they will through our language or words.

At the same time, familiarity can breed a level of false security. Whether it's in Kentucky or Kabkabiyah, it's the unexpected or unanticipated events that are often the most dangerous to personal security. For the people of Pakistan, the unexpected was a deadly earthquake that, within just 85 seconds, changed their lives forever. For the people of Darfur, it's the instantaneous shift that happens when attackers arrive in the middle of the night with no agenda except destruction, attackers who stand to gain little more than blood on their hands by destroying life and depriving hope. For the people of Afghanistan, some form of war or tyranny has gone on for so long that the shift from security to fear happened long ago. Navigating the minefield—literally—every day has become normal. It's one of the few places in the world where the worst is expected. The unexpected would be to live in a world of peace, prosperity and health where fear is no longer a constant and danger is not part of every waking moment.

Like the church bells that ring near my home, the giant gongs that sound in Buddhist monasteries in Myanmar, or the low moan that comes from a Hindu priest blowing a conch shell as the sun rises over the Ganges, I've always loved hearing the morning call to prayer during my travels. It's been a reminder to me that many people are committed to something greater than themselves. But while lying in my bunk in North Darfur, I felt something different, something that grew on me the longer I was there. While listening to the first call at 4:00 A.M., it was the first time I'd ever been confined to the security of a guesthouse. I couldn't leave until after the sun came up several hours later. But it was more than just the restricted freedom.

Lying in the darkness and listening to the ethereal chant of *Allahu Akbar*, I couldn't help but confront and question my own faith. I asked myself whether the genocide in Darfur is an act of divine intention. Is the suffering endured by the people somehow soothed by a belief that death might hold rewards not offered by life? Though I so often enjoy the call to prayer, in Darfur I found it haunting. The sound enveloped me as I lay there listening, enhancing the claustrophobia I felt. For the first time in a very long time, I felt hopeless, hopeless about the future of the people I'd been meeting and photographing. In that moment, the call to prayer wasn't a symbol of something greater for me, it was a reminder of how fragile we are.

I'm not big on guilt, but more than once I found myself feeling guilty because I had the freedom to leave. Then and now, I couldn't understand why the privilege of leaving behind an

active genocide for the safety of a Midwestern home would fall to me and not to others. It's not that I felt undeserving; it was that I believe we are all deserving. No one's life should be determined by unnatural borders that looked good a century earlier to a now forgotten British general or Belgian ambassador. No one's life should be confined, or worse, destroyed, by a tyrannical government, rebels, suicide bombers, or terrorists without regard for the innocent. Beyond its role in providing temporary security, no one's life should be lived within the confines of a refugee camp.

On my last day in Al-Fashir, my hosts asked me what else I wanted to see before leaving. I'd been to Kabkabiyah. I'd been to the Zam Zam clinic. I'd photographed well digging, stove making, agriculture lectures, medical exams, and nutrition programs. Was there anything else I wanted to photograph or experience before I departed? The answer was easy for me. I wanted to spend a couple of hours in the camp itself. Not the clinic that Relief International ran on the outskirts of the camp, but the camp itself. I wanted to see how people were living, how they coped, what their spirit was like.

We drove into the camp in our beat up minivan. What months earlier had been a nearly uninhabitable dried out field of sand had very quickly become a haphazard dwelling for 40,000 people. The road was a winding two track with no right angles that seemed to narrow and widen as if by chance. From the center, the huts or makeshift dwellings stretched as far in all directions as I could see. They were accessible by narrow walkways that had begun to take on character, a style that reflected simple statements of culture and convenience—a colorful fabric drying on a thorny tree limb, a playful sculpture of discarded water bottles, a scarecrow made of bent wire with a face molded by pieces of bicycle tire. Only a few feet separated the entrances to each dwelling, yet I saw several women with makeshift brooms cleaning the entryway to the spaces that had become their homes. Desperation did not equal loss of dignity. Lack of possession did not equal a lack of pride. Torn plastic for a rooftop or stained cardboard for a floor did not mean the people living inside didn't care. No matter where I looked I did not see garbage. I did not see laziness. I did not see anyone complaining. There were no tears.

Instead, what I did witness was hope. While I was struggling with the existential questions of a privileged Westerner and witnessing challenges greater than I could fathom, the people inside Zam Zam camp were not. Instead, they were doing what displaced people do everywhere; they were taking one step at a time in a positive direction. Like the people who'd suffered during Hurricane Katrina, the Asian tsunami, the Pakistani earthquake or war zones around the world, they had not lost hope. They had not lost their ability to look forward and to imagine a future that was better than the present.

How people perceive and accommodate hope may be an individual thing. Some people may find a convenient way to exist in the past and the future at the same time by using denial for the only thing it's good for: a bridge to something better. Others manage to experience the suffering of the present by pursing an even higher purpose—that is, by finding a way to put the needs of others on a par with their own, and in so many cases, above their own. Even in a camp like Zam Zam, a community of

displaced people destined to exist with limited resources and enormous challenges for years to come, there are still people who share their sandwich without expectation of something in return. As little as they may have, they find a way to share. It's the reason there are still smiles on the faces of children. It's the reason there's still love in the expression of a mother holding her child. It's the reason there is still hope.

A Brief History of the NGO

The term NGO is an acronym for *non-governmental organization*. There is no exact definition for the modern NGO and most NGOs vary significantly from one to another. Though non-profit, secular and non-secular humanitarian groups have been around for hundreds of years, use of the term NGO in association with humanitarian aid groups began to pick up momentum following the creation of the United Nations in the late 1940s. The International Red Cross is among the best-known NGOs with a long history. Even during war, the Red Cross has managed to navigate across borders for more than a century when governments could not.

NGOs are generally non-profit and most are engaged in the mission of trying to improve living conditions during manmade and natural disaster or long term crisis. Many work toward grassroots, sustainable solutions while promoting self-determination for disenfranchised or displaced people. What that means and how that manifests itself is, of course, subjective. Some provide assistance or relief following earthquakes, floods, tornados, or natural upheaval. Many others work toward assisting in long term solutions to poverty and post-conflict disparities by providing education, schools, libraries, and community development. Some NGOs are religious, some are not. Some are political, some are not. Some operate in close proximity to government, some do not. Many specialize in creating grassroots, sustainable campaigns to further economic development and job creation while some are specifically geared toward health concerns such as malaria, HIV AIDS, dysentery, or tuberculosis. Many NGOs are engaged in conservation and energy programs that include reforestation, providing clean water or building wells, providing solar energy or solar stoves and ovens, or helping create sustainable agriculture programs. Some are geared toward human rights issues and many work on issues related to child labor violations, overcoming economic disparity, and assisting workers faced with unsafe working conditions. Although they are often confronted with obstacles imposed by governments or religious organizations, there are many NGOs working to provide reproductive health services and rights that empower women and girls. Some NGOs specialize in a type of bridge building or consensus building designed to bring different but like-minded organizations together in community-based problem solving and economic development.

Most of the major international NGOs have websites that include their mission statement and financial information. Today, some countries have national councils and associations as well as audit and watchdog groups designed to monitor the cost effectiveness and overall success of various NGOs and their program initiatives.

It's important to note that not all NGOs are located in the West. Many successful NGOs are headquartered within the regions or countries facing a particular need. Many successful organizations from the global South operate worldwide alongside Western groups. Just because an organization is big doesn't mean it's the best or that it's doing great work everywhere that it is operating. The success of any humanitarian program hinges not just on the quality of the organization, its infrastructure and staff, but also on circumstances over which an individual NGO may have little control. For example, changes in the conduct of war in places like Afghanistan, Sudan, Lebanon, or Iraq can have a

dramatic impact on NGO program success. Some NGOs are huge (the Christian NGO World Vision has an annual budget in excess of $2 billion) while others are lean and less institutional, yet quite capable and successful in the areas they serve (Relief International has an annual budget of approximately $30 million). In some cases, smaller NGOs or those headquartered in the nations in need may have greater impact by being able to respond more quickly or effectively to crisis. It may take some homework, but the likelihood is that readers can identify a group that celebrates the ideals they find inspiring and worthy of their support.

The modern NGO movement has seen significant growth during the past thirty years for many reasons. It's my opinion that the movement is, in large part, fulfilling needs that are not being adequately addressed by the member states of multilateral institutions. Many governments lack the ability to help their own people. Some, such as Sudan or Myanmar, are complicit in creating the very problems or crises to which the NGOs are responding.

Of course, humanitarian aid doesn't work seamlessly. There are plenty of examples of failed or misguided programs, bloated overhead expenses, and corruption and intervening parties that siphon off distribution of goods for black market purposes. Foundations, which like individuals are largely unaccountable, can also play a role by funding faulty agendas or facilitating misguided intentions.

Among the conflicts I've witnessed within NGOs is their desire to perpetuate themselves. Just as governments don't always function rationally or responsibly, NGOs can fall victim to similar institutional malaise. An irrational need for growth sometimes happens at the expense of maintaining a focus on the quality of existing programs. It can also result in high staff turnover. The desire for growth can manifest itself in a strange, competitive dance for dollars as NGOs compete for support from foundations, philanthropic individuals or corporations, government groups such as USAID, U.N. affiliated resources or grants from governments. We're coming off the bloodiest, most violent century in human history, so it's hard to imagine a 21st century in which NGOs are so successful they put themselves out of business. That said, the majority of NGOs I've encountered are staffed by highly educated, determined and genuinely committed people with the best of intentions. None of the field workers I've encountered are "doing it for the money" and virtually all of them could use more vacation time. My hope is that each NGO can begin to find more ways to collaborate and streamline both services and information in a world where resources are more challenged each day by corruption, climate change, abuse, disease, natural disasters, illiteracy, war, and poverty.

Relief International Mission Statement as stated on RI.org

FOUNDED IN 1990, Relief International provides emergency, rehabilitation and development services that empower beneficiaries in the process. RI's programs include health, shelter construction, education, community development, agriculture, food, income-generation, and conflict resolution. RI employs an innovative approach to program design and a high quality of

implementation performance in demonstrating deep and lasting impact in reducing human suffering worldwide.

RI dedicates itself to seeking and addressing the long-term developmental needs of its beneficiaries even while in the emergency phase. The agency recognizes that disasters have the most negative impact on the lives of the poor; yet disasters, and especially the movement of the populations, can also bring about unexpected, positive social change. This context can therefore serve as a window of opportunity for eradicating poverty and social injustice.

RI focuses on serving people who typically have not received due attention, and in several large-scale crises RI has been the first U.S.-based agency to provide high-impact development emergency programming to communities in need. RI believes that as a humanitarian agency one of its main functions is to communicate the pronounced needs of the vulnerable and affected populations to the international community. RI thus consults closely with the local communities it serves in order to ensure that its programs do not impose solutions from the outside but rather address their needs and requirements for the long term. This grassroots approach proves effective in fostering an environment of self-help and sustainability.

Save the Children USA Mission Statement as stated on SaveTheChildren.org

SAVE THE CHILDREN is the leading independent organization creating real and lasting change for children in need in the United States and around the world. It is a member of the International Save the Children Alliance, comprising 27 national Save the Children organizations working in more than 110 countries to ensure the well-being of children.

The history of Save the Children is a story of positive change and people—millions of people in thousands of communities around the globe—working together to create opportunities for the world's children to live safe, healthy and fulfilling lives. In January 1932 in a small room in New York City, a group of concerned citizens gathered to respond to the needs of the proud people of Appalachia hard hit by the Great Depression.

The inspiration and vision for Save the Children came in part from the international children's rights movement begun in England in 1919 by Eglantyne Jebb, founder of the British Save the Children Fund. From this early effort in the hills and hollows of Harlan County, Kentucky grew a self-help philosophy and practice still at work today in more than 45 countries, providing communities with a hand up, not a handout.

This approach—working with families to define and solve the problems their children and communities face and utilizing a broad array of strategies to ensure self-sufficiency—is the cornerstone of all Save the Children's programs. Through the decades, Save the Children has evolved into a leading international relief and development organization. Countless events and achievements have shaped the development of the organization and helped change the lives of the children they serve.

Things We Can Do

If you're reading this book, there's a pretty good chance you're already doing your part to assist people in need or you're interested in finding a way to get involved. You may already be working in your own community or through your church, synagogue or mosque to help overcome poverty locally, to mentor a child, or to support those in need during a crisis. Perhaps you do what you can to make a difference with your ideas and the ways you inspire and motivate those around you. If you're already active, you probably contribute what you can to the non-profit groups who are working to meet the specific problems that have moved you to action. It could be a contribution to public radio, a check to the Boys & Girls Club, support for a group committed to conservation of your favorite park or ecosystem or volunteer efforts on behalf of the Salvation Army. Maybe you regularly share your sandwich with someone near you who is hungry or work to create a partnership with a family whose members are trying to pull themselves out of poverty. In some ways, solving the difficulties facing the developing world is as simple as that. It starts with being awake and understanding the power of your own spirit and drive to facilitate change and spur self-empowerment. Denial isn't the answer.

So, yes, it is sharing. It's sharing without thinking about it. *Ayni*. But it's more than that. All too often we writers are great at articulating problems but we're lacking in our ability to toss out meaningful solutions. We can be good at satire or sarcasm because we often lack hope ourselves. Cynicism comes with the turf, and I have my share of it. It's a price we've paid for our curiosity and the number of times we've been burned in the process of extending ourselves. But my own experience after visiting challenging spots from Morocco to Myanmar is that we cannot lose hope. Though we were taught differently, it really is okay to go back into the fire. Walking on hot coals without getting burned feet is a matter of belief—belief in whatever makes you tick, belief in your God, belief in your self, belief in your ability to impact the world in a positive way. Too many Americans and Europeans have been born into privilege to allow helping others to be someone else's challenge. It is our challenge. Even the middle class upbringing I had in the '60s offered an array of resources that still do not exist in nearly half the world. We had indoor plumbing with tap water that was clean, abundant and virtually free. We had a school nurse (not to mention a school) and doctors and dentists who helped us maintain health standards unheard of in places like Haiti, Niger or Liberia. We had three meals a day, almost every day.

Of course, I could be dead wrong here—and if this book finds an audience then some pundit will likely try to prove that point. But whether it's the lessons of my personal experience, or my faith in the power of goodness, I'll take the risk. Here are a few simple things I believe can help turn hope into action:

1. *Avoid the same mistakes twice.* Too few of today's global leaders study enough history or current events to chart a better or more progressive course in foreign policy. Some have no experience at all beyond their own borders and, as we saw during the first part of this century, ignorance and a lack of curiosity can have disastrous consequences in foreign policy regardless of the philosophical approach to governance. Many of the difficult situations facing virtually all developing world nations stem

from the rule of their former colonial power. Often, the rise from colonialism into independence is marked by compromises made without regard for large segments of the population. It's true in Sudan, Afghanistan, Pakistan, and Kenya, but it's also true in Haiti, Zimbabwe, Iran, Iraq, Congo, and elsewhere. In some cases, it gets harder not easier to right old wrongs, especially without admitting or apologizing for them. In that sense, we all bear the burden of our past.

2. *Empower girls and women.* There are many ways to do this and many non-profit organizations from both the West and the global South are doing just that. It could be micro credit programs or education around reproductive health. It could be as simple as ensuring that girls are allowed the same educational resources and access as boys. It could be working to end child slavery, human trafficking or creating meaningful job alternatives to prostitution. Our work in Pakistan and the related fundraisers for Relief International helped the organization administer micro-credit programs allowing women who'd lost their livestock during the earthquake to purchase cows. Why? Because it's been proven time and again that women, when empowered, do a great job of managing resources that sustain themselves and their families. This idea was first introduced to me during site visits with Abraham Bongassi for Save the Children. Among their programs in southern Ethiopia, they had partnered with villagers and were teaching women how to churn butter. It's a nomadic region that relies significantly on dairy resources. Why butter? Because butter lasts longer than milk and is easier to transport to market without spoiling. But it went beyond that. Once the butter was

sold, Save the Children was teaching the same women how to open and manage a bank account. Women (not men) were building equity in their own future and the future of their children.

3. *Support initiatives to provide and manage clean water.* There may be no more significant issue in the 21st century than those surrounding the use and availability of water. In some places such as Kabkabiyah in Darfur, underground water is abundant. In fact, water is abundant in many parts of Africa. But accessing that resource requires teaching skills and purchasing the hardware for building and maintaining local wells and irrigation systems. It's also important to partner with local communities in the design and building process so the resource and management continue to thrive long after the NGO has departed. Beyond that, it's important to find ways to clean water in a fast, cost effective way. Clean water will help reduce dysentery, a significant killer of children throughout the developing world. Maintaining water as a resource will also help in eradicating malaria.

4. *Support organizations that practice sustainability.* It doesn't help to create aid scenarios that fail to empower local initiatives that can't exist on their own. When initiatives fail to involve the community and its leaders there's a risk of NGOs becoming another model of colonialism. Instead, it's important to support strategies that engage the local stakeholders and create a lasting impact that can be managed locally. There are many NGOs working worldwide who understand that giving means more than a handout. Handouts rarely, if ever, work. Whether it's

Save the Children's midwife program in Mazar-e-Sharif or Relief International's well building and irrigation program in Kabkabiyah, humanitarian relief efforts that are successful employ local staff who help envision solutions, who manage programs and who teach others how to manage long after the NGO is gone. The global financial commitment, from foundations, individuals, institutions and governments is essential in facilitating the building of infrastructure and capacity.

Schools and educational resources are also essential to community development and sustainability. But that means more than just building schools. It also means working to provide access to real educational content. Libraries and books are as important as the buildings in which they're used. In that regard, Relief International is supporting library initiatives in both Pakistan (PakistanLibraries.org and Afghanistan (AfghanistanLibraries.org).

5. *Help facilitate awareness and consensus.* It's not enough that you may be aware. It's important that you make others aware too. Blogging, public speaking, urging your teacher, professor, rabbi, mullah, or pastor to create lesson plans around a potential topic such as Darfur or Afghanistan—all of these are ways to help get the word out. As for consensus, the more individuals are moved to action that invites their government to work with other governments, their church to work with other churches, their community to work with other communities, the more likely the path toward stopping genocide, restoring basic human rights and dignity, or facilitating self-determination will come to pass. The opportunity to facilitate awareness has been greatly enhanced by the Internet. There is, at present, no better means of international communication than what the Internet provides.

6. *Host aid workers, students or scholars who are experts at specific problems and have a story to tell.* You can do this for events at your home, church, mosque or synagogue, or rent a meeting room at the downtown YWCA. If you can get friends to show up for a Tupperware party or to work the latest pyramid scheme for cosmetics or hair care products, maybe you can open a bottle of wine and have fifteen pals over to listen to people who've helped distribute mosquito nets in rural Tanzania or provided medical relief after an earthquake in Guatemala. It could be a relative who rescued homeless dogs after Hurricane Katrina or a student who spent the summer helping build homes in Chiapas. Make it fun and ask them to articulate their own call to action. Their experiences will not only inform you, they may inspire you and the people you invite to become more actively involved.

7. *Understand what you consume.* Americans are the world's greatest consumers. But is that something to be proud of? As our landfills overflow with two year old cell phones and even older answering machines, computers deemed "too slow" and a massive amount of old tires, appliances, standard definition televisions and clothes that are no longer fashionable, only we can decide when we've had enough. There are certainly repercussions based on the amount we consume including the amount of space we now allocate to garbage and the toxic results of everything we discard as it works its way through the soil and into our groundwater.

But it's more than that. Thoughtless consumption has extraordinary consequences even with the best of intentions. We are all on the hook when it comes to our failure to recognize the extraordinary hardships facing both children and adults who are taken advantage of throughout the supply chain. This includes forced labor, child labor, or workers who toil under inhumane or unsafe conditions. On the one hand, we may ask whether there's really anything we can do to help a copper or gold miner in Papua New Guinea or a textile worker in Guatemala. It's a good question and the reality is, solutions are not easy. Our choices are made especially difficult when we're faced with our own economic hardship. Paying more for organic, fair trade food, clothes made from bamboo or a refrigerator or automobile designed for energy efficiency is much more difficult during times of recession. That's a given.

My proposal includes two small steps. First, eat close to home. By that I mean, do what you can to support your local farm community including feeding yourself and your family with seasonal fruits, vegetables, meats, poultry, dairy and baked goods. Many companies and cooperatives are working to reduce the number of miles a product must travel to find its way into your hands. Second, ask Congress to create a regulatory system that oversees imports so that we are no longer importing products or parts produced by companies that take advantage of their workers by ignoring their safety or compromising their health during the mining, farming or manufacturing process. The American consumer is far too powerful for any manufacturer to ignore. Changing the standards we use around our purchasing of goods will, in the long run, help everyone.

8. *Work to overcome fear and stereotypes.* As a kid in Iowa, I still remember doing the "duck and cover" drill every couple of weeks in our grade school classroom. We'd hear a bell, then dive under our desks to avoid the make believe fallout and debris from a make believe nuclear attack. The bad guys? Russians. Just ask Miss Decker, the 30-something June Cleaver look-a-like who supervised our "duck and cover" drills. As unlikely as it might have been for the Russians to drop an A-bomb on the Lincoln Park Elementary School, I learned to live in fear of just that. Russians became the bad guys in my dreams. Russians, I was taught, were without feelings, without regret, without hope. They didn't believe in freedom or family and they never had time for fun. Does any of that make sense forty-five years later? No. The myth was not the full truth; it was a story designed to support a government policy.

But those fabrications didn't end with the Cold War. The use of fear to control people has a long history and, no doubt, a future as well. The people who wanted to use fear after 9/11 succeeded in replacing the old dark enemy with a new one. Both terrorists and our own government worked to perpetuate fear—albeit for different reasons—but it really is time to get over it. Whether it's billions for the latest in weapons design or legislators hell bent on locking down the borders with wire fences and surveillance cameras, the costs of escalating fear are simply too high. The world may have its share of evil, I've seen it firsthand in places like Darfur. But the world is overflowing with people who are fundamentally good, decent, generous and caring. They do not all look or act the same. They do not all have the same history or the same economic status. We may not understand the meaning

of their last name. They may not all practice the religion in which we find comfort. What I do know is this: It is impossible to experience the good in people or their spirit of hope when fear pushes us into hiding.

These are just a handful of solutions and the likelihood is that more will come to mind as soon as I turn off the computer.

Readers and experts with far more experience than I have will, I hope, complement this short list of things we can do with a broader agenda filled with effective ideas that can reach the people they know. We can all contribute, and we should. There really is enough to go around.

Ten topic-related websites recommended by the author:

RI.org

SaveTheChildren.org

PIH.org

PakistanLibraries.org

GirlEffect.org

Synergos.org

Brac.net

WorldForumFoundation.org

IsThereSomethingICanDo.com

A24Media.com

Ten topic-related books recommended by the author:

Collapse Jared Diamond

Mountains Beyond Mountains Tracy Kidder

A Problem from Hell Samantha Power

Fixing Failed States Ashraf Ghani & Clare Lockhart

The Bottom Billion Paul Collier

The Zanzibar Chest Aidan Hartley

No god but God Reza Aslan

Three Cups of Tea Greg Mortenson

*A Billion People: An Eyewitness Report from the Frontlines
of Humanity* Jan Egeland

*Emergency Sex & Other Desperate Measures: A True Story From
Hell on Earth* Kenneth Cain, Heidi Postlewait, Andrew Thomson

Twenty percent of the author's net proceeds from the sale of
this book are donated to charitable causes directly related to
the empowerment of women and girls.

Special thanks to Chris Spheeris for his assistance as a photo editor and his contributions to the cover art for this book. Special thanks as well to Janice Benight for her creative book design and layout, and to Nancy Sugihara for her editorial work and art direction.

The author would like to thank the following for their assistance and inspiration:

Patricia Ostermick

Claudia Haack

Dennis Walto

Kevin McCarey

Bob Rainek

Susan Templin

Farshad Rastegar

Michael Speaks

David Crouse

Jon Bendis

Bob Dunn

Peggy Dulany

Salim Amin

Theran Pfeiffer

Rubina Shafi

Tracy Dorsey

David Robinson

Reza Aslan

Jeanette Yoder

Marc Vaccaro

Cathy Ryan

Joslyn Barnes

Bob Huck

Jennifer Buffett

Peter Buffett

Ben Kingsley

Salman Naqvi

Tim Hiller

Kamran Elahian

Zohre Elahian

Elaine Joli

Gulnaz Zohrabbekova

Joel Pfeiffer

Chip Donohue

Dan Markley

Bob Kendall

Peter Mulvey

David Martin

Colleen Martin

Astrid Vaccaro

Abraham Bongassi

END IRRATIONAL FEAR